IMAGES
of America

TULSA

WHERE THE STREETS WERE PAVED WITH GOLD

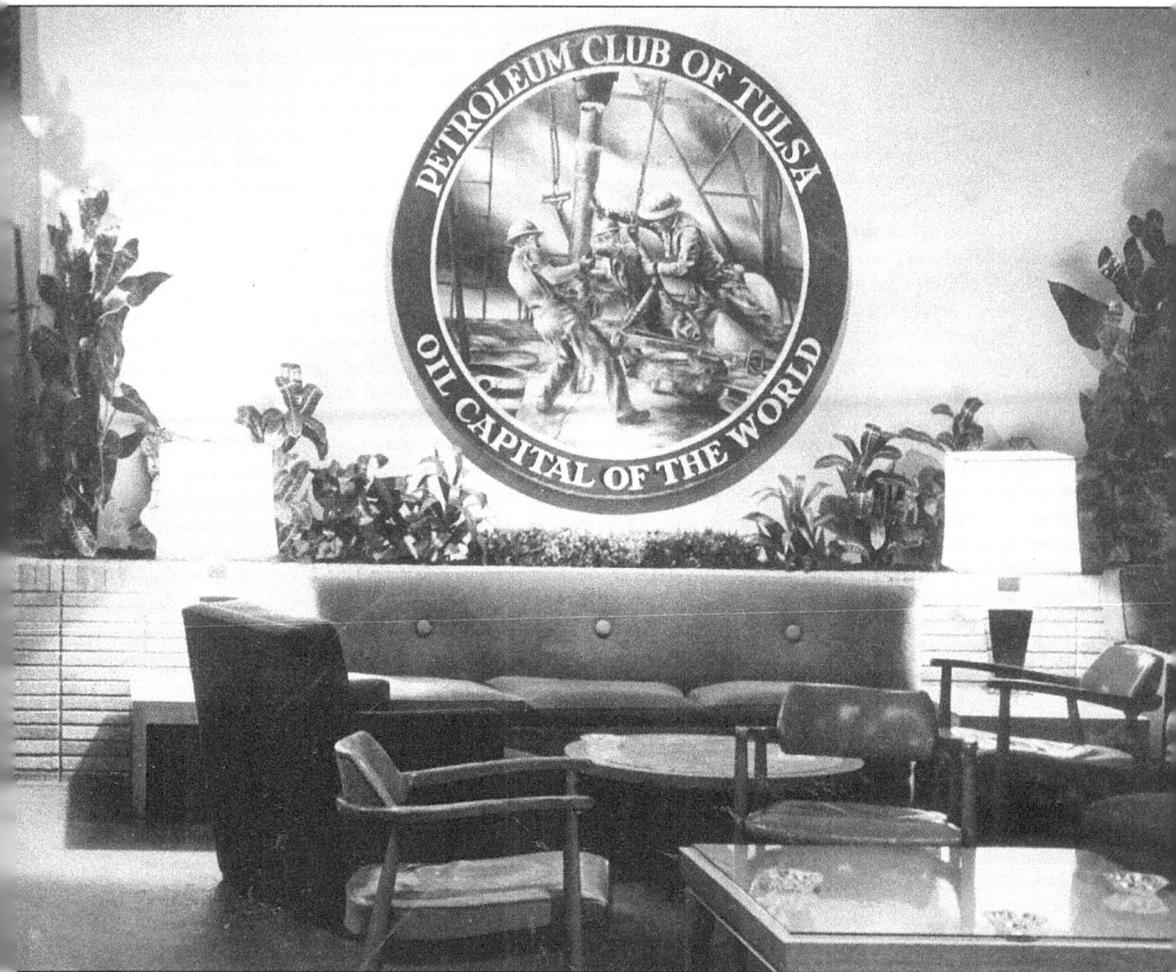

On the wall of the entrance lobby to the Tulsa Petroleum Club is the club's symbol, representative of Tulsa's beginnings as a thriving metropolis. The words "Petroleum Club of Tulsa" (on top) and "Oil Capital of the World" (on the bottom) are on a circular picture of three roughnecks on the drill floor of a rotary drilling rig, wrestling to lower a drilling bit into the well hole. (Courtesy Beryl D. Ford.)

IMAGES
of America

TULSA

WHERE THE STREETS WERE PAVED WITH GOLD

Clyda R. Franks

ARCADIA
PUBLISHING

Published by Arcadia Publishing
Charleston, South Carolina

Library of Congress Catalog Card Number: 00106929

For all general information contact Arcadia Publishing at:
Telephone 843-853-2070
Fax 843-853-0044
E-mail sales@arcadiapublishing.com
For customer service and orders:
Toll-Free 1-888-313-2665

Visit us on the Internet at www.arcadiapublishing.com

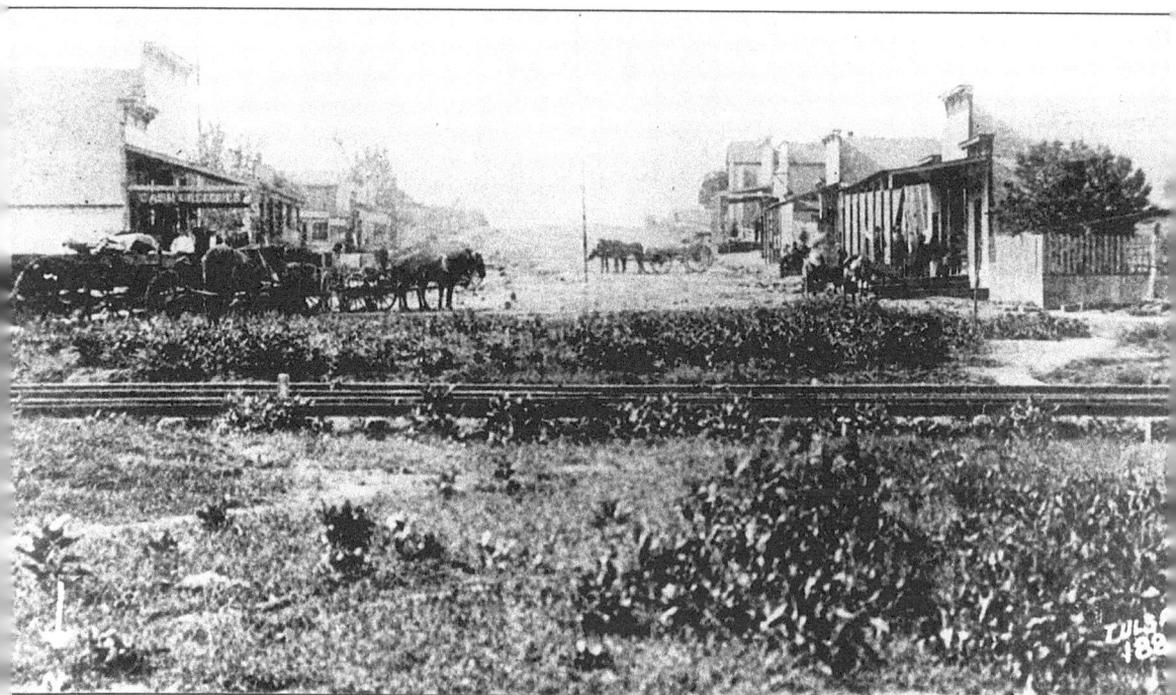

Tulsa's population in 1889 was just two hundred. Looking south across the St. Louis and San Francisco Railroad tracks down the main street that year, one can see a flagpole in the center of the street in front of the J.M. Hall store, which is in the right foreground. (Courtesy Beryl D. Ford.)

CONTENTS

ACKNOWLEDGMENTS

The purpose of this book is to provide a brief glimpse into the varied and exciting history of the colorful city known as the "Oil Capital of the World", Tulsa, Oklahoma.

Without the encouragement of my husband, Kenny A. Franks, I would never have undertaken this project. He has given me the wings to fly on my own. A great deal of thanks also goes to my mother, Euladean Goodson Redman, who encouraged me first to read, and then to write, and gave me the courage and confidence to ask others to read what I had written. For many of the photographs, I am most grateful to the Oklahoma Heritage Association, Fred Marvel of the Oklahoma Department of Tourism and Recreation, the Oklahoma Historical Society, *The Daily Oklahoman* and a great many others mentioned throughout the book. And finally, credit must be given to my employer, The First National Bank of Pawnee and its CEO, Everett E. Berry, who have also provided much encouragement and support.

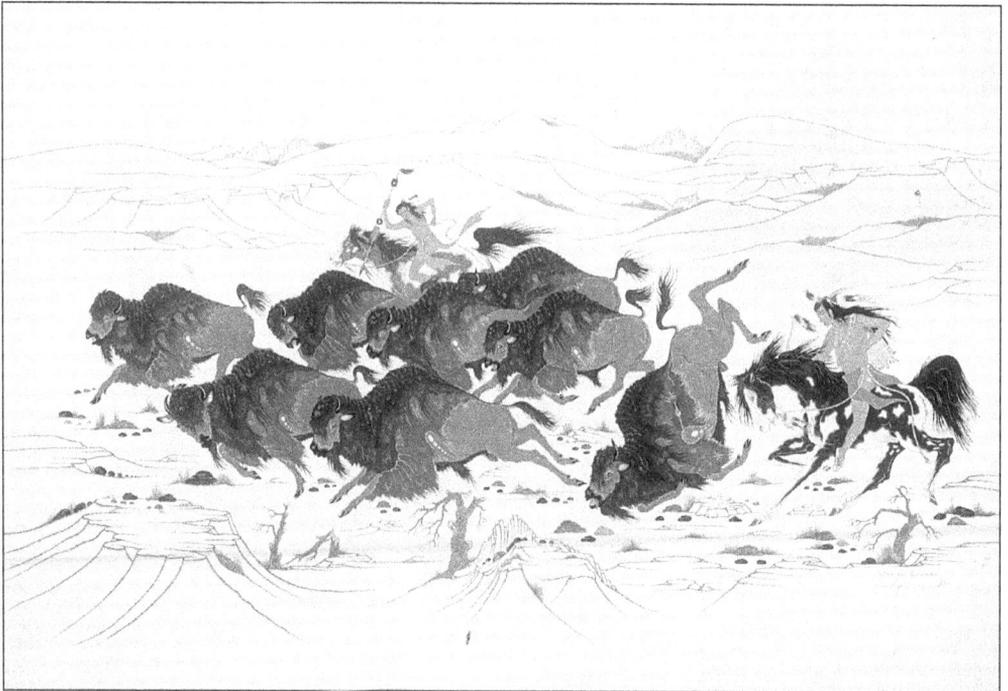

The Osage Trail, which ran through Tulsa, was used to reach the rich buffalo-hunting grounds to the west. *The Buffalo Hunt* by Woody Crumbo depicts such a hunt. Raised as a "Miko-gee" or boy king by the Creeks, Crumbo used such paintings to preserve traditional life and beliefs. During his youth, Crumbo often visited friends and relatives in Tulsa where he listened to older Creeks speak of the past. (Courtesy Minisa Crumbo Halsey.)

INTRODUCTION

From a small, muddy settlement, to a rowdy oil boomtown, to a multi-cultural, high-tech, cosmopolitan city of more than a quarter-million people, Tulsa has a unique and colorful past.

The first American explorer to visit Tulsa was James B. Wilkerson in 1806, as part of Zebulon Pike's expedition that was bound for the Rocky Mountains. His reports provided some of the earliest reports of the Osage Indians of the Tulsa area.

In 1831 Washington Irving toured the region. Irving's book, A Tour of the Prairies, was the earliest popular description of the area. That same year, 1831, First Lieutenant James L. Dawson marked a military trail from Fort Gibson along the north side of the Arkansas River through Tulsa to the U.S. Crossing. Dawson's report was the first scientific investigation of the region that became Tulsa.

Osage ownership of the Tulsa area was challenged by the Western Cherokees early in the 19th century. Bitter warfare raged between the two tribes until 1825, when the Osage ceded their claim to the United States. In 1870, the Osage returned to the area when they were granted present-day Osage County as a reservation. Tulsa became a part of the Creek Nation in 1832 when federal officials removed that tribe from Alabama and Georgia.

During the Civil War the Creeks sided with the south, and between 1861 and 1865 Tulsey Town, as it was then called, was a part of the Confederate States of America. When the Confederates launched a campaign to drive pro-Union Creeks under Opothleyahola out of the area, Confederate Colonel Douglas H. Cooper used the settlement as a supply center. On November 11, 1861, the battle of Chusto-Talasah, or Caving Banks, was fought along the banks of Bird Creek just north of Tulsa, in which Opothleyahola was forced to continue his flight toward Kansas.

When the war ended, a number of ranches were started in the area. One of the earliest ranchers was Lewis Perryman. An Upper Creek, Perryman and his four wives arrived in Tulsa in 1828 and founded a ranch, named Tallahassee, along Cow Creek. In 1848 he established the Perryman Family Cemetery at what is now the intersection of 31st Street and Utica Avenue. During the Civil War Perryman and his family fled to Kansas where he died. His son, George, returned to Tulsey Town and expanded the family's ranch holdings to include the area between Twenty-first Street on the north and Seventy-first Street on the south, between the Arkansas River and present-day Broken Arrow. Perryman's home, called the "White House," was at the intersection of Forty-first Street and Troost Avenue. In 1879 a post office was opened in the Perryman's home, and his brother Josiah served as postmaster.

Three years later, in 1882, the Atlantic and Pacific Railroad built into the region. Originally, the railroad owners planned to build a terminal just northeast of Tulsa in the Cherokee Nation, but Cherokee law prohibited trade except by tribal members. Because non-Indians were permitted to trade in the Creek Nation the rails were extended a mile south to Tulsey Town. A terminal, roundhouse, and livestock loading pen were built and the settlement became a major cattle-shipping point.

In the following years, wooden shacks and plank stores with false fronts were built, a community water well was dug, and streets were laid out. Many of the early streets were 100

feet wide, but local residents soon discovered that the dirt thoroughfares quickly turned to mud when it rained, and 100 feet was too far to wade in the quagmire. Thus, Main Street was only 80 feet wide. Gamblers, bootleggers, and other undesirables flocked to Tulsa. The closest court was Judge Isaac Parker's, the "hanging judge," at Fort Smith, Arkansas, and he only had jurisdiction over federal crimes. Because tribal authorities had no authority over non-Indians, the rules of civilization were often flaunted.

It was petroleum that transformed Tulsey Town from a rural frontier community where hogs, goats, and cows wandered along Main Street into a modern, bustling, urban environment. Early settlers had long been aware of natural oil seeps south and west of Tulsa near Red Fork, Sapulpa, and Glenn Pool. Oil often dripped from rock outcrops and frequently coated the surface of streams. In the spring of 1902, Jesse A. Heydrick and John S. Wisk hired Luther and Perry Crossman to sink a well on the northwest edge of Red Fork. When Heydrick and Wick were unable to pay the $300 freight charge for hauling the rig to Red Fork, Dr. Fred S. Clinton and Dr. J.C.W. Bland advanced the money in exchange for shares in the well. The well, the Sue A. Bland Number 1, was drilled on the Creek allotment of Dr. Bland's wife, Sue. It blew in as a gusher on June 24, 1901.

One of the most important arrivals was Patrick C. Boyle, president of the Petroleum Publishing Company, bringing with him the *Oil and Gas Journal* that became known as the "Bible of the oil industry." The Journal and such pioneer oil men as Harry Rogers, Harry Sinclair, Waite Phillips, W.G. Skelly, James A. Chapman, and Joshua Cosden transformed Tulsa into a major oil center.

Skelly's concept of a worldwide gathering of oil men to share ideas and technology took shape as Tulsa's International Petroleum Exposition and Congress (IPE), the largest gathering of oil men in the world during its heyday. Ironically, although Tulsa was in the midst of a sea of oil, the drilling of oil wells was banned within Tulsa's city limits. However, undoubtedly numerous wells were drilled without the knowledge of city officials and at least one drilled with their knowledge. Once, during the IPE on the Tulsa County Fairgrounds, a rig that was used to demonstrate drilling equipment struck oil.

Tulsa's oil boom provided the capital to develop the new state as well as the impetus for Tulsa to become "The Oil Capital of the World."

One

TULSEY TOWN

Located on the banks of the Arkansas River, Tulsa, Oklahoma, is bounded by the Osage Hills on the north and the Osage Plains on the south. Prehistoric Tulsa was covered by several shallow seas and ringed by swamps and subtropical forests. As the land dried, lush grasslands attracted huge herds of prehistoric mammals, which in turn attracted early hunters. Among the first were the Clovis Mammoth Hunters. Their killing shafts, tipped with a distinctive fluted projectile called a Clovis point, have been found along the Arkansas River near Tulsa. Just to the west of Tulsa, 4,500-year-old petroglyphs can be seen on the ceilings of cliff overhangs. After the Clovis Culture came the Folsom Bison hunters.

Following the prehistoric peoples were the tribes that made up the Wichita Confederation, whose bands settled along the Arkansas River before being forced to the south by the more powerful Osage.

Both the Spanish and French claimed Tulsa as part of their colonial empire. In 1763 France ceded its claim to Spain, who regained the region in 1800, only to sell it to the United States as a part of the Louisiana Purchase in 1803.

In 1831, Tulsa became a part of the Creek, or Muscogee, Nation when federal officials removed that tribe from Alabama and Georgia.

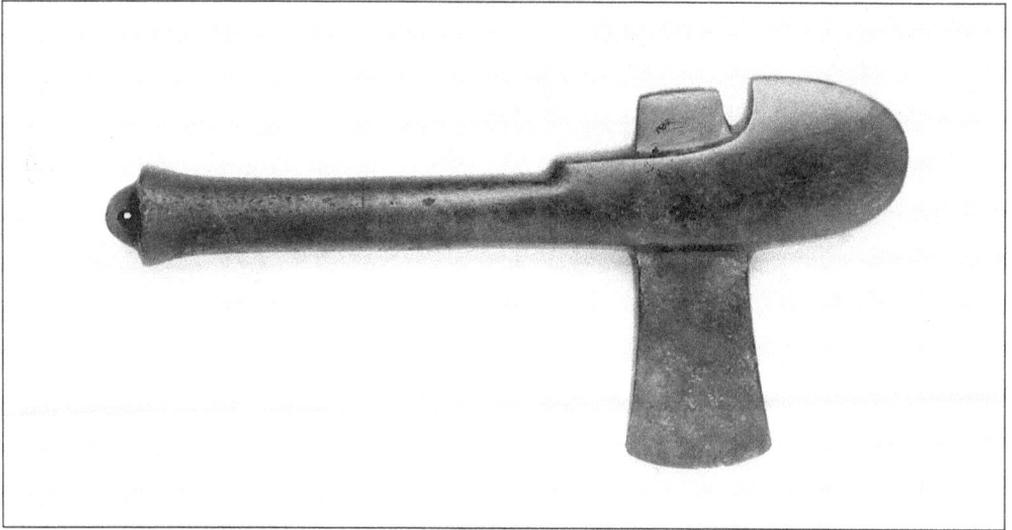

This is a stone-edge axe from the pre-historic period of the Mound Builders who lived along the Arkansas River. Just before the arrival of the first European explorers, these Mound Builders disappeared and left little evidence except for ceremonial and other mounds scattered up and down the river. (Courtesy Gilcrease Museum.)

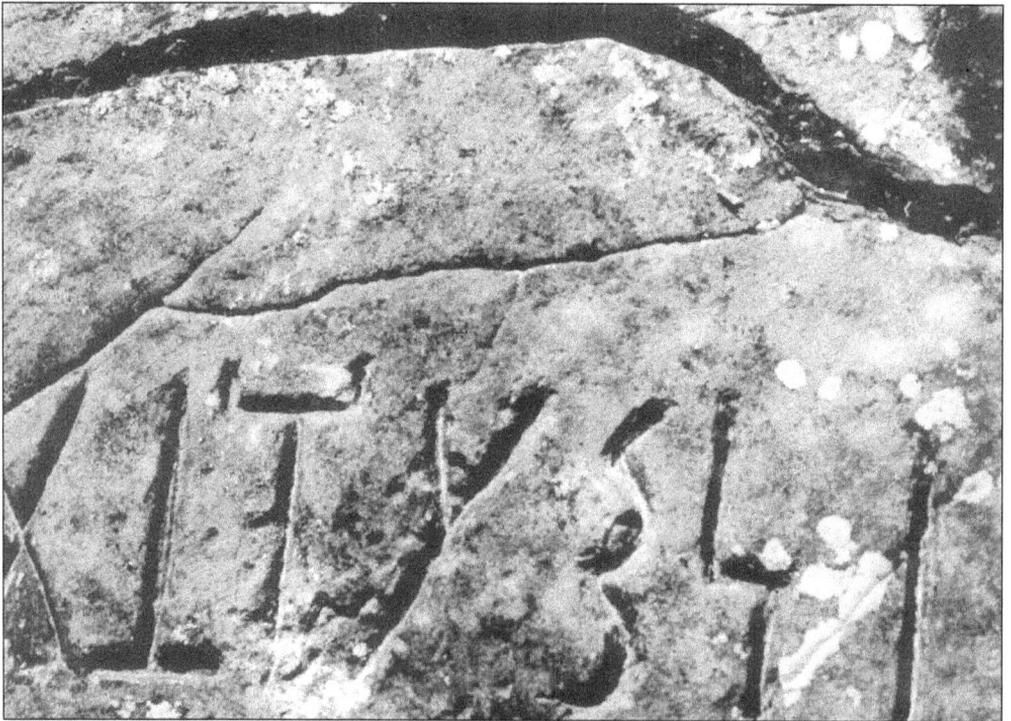

Rune-like carvings on stones have been found in Oklahoma as early as the 1830s. Many believe that they indicate a Norse presence in the state eight hundred to one thousand years before Christopher Columbus' 1492 voyage. In 1965 this rune stone was discovered in Tulsa. The seven characters have been translated as the date December 2, 1022. (Courtesy *The Daily Oklahoman*.)

About 2,000 years ago Oklahoma's primitive people abandoned their cave and ledge dwellings and began building more permanent structures. These people were called the Mound Builders. The disk pictured was made by cutting incisions, then filling them with red oxide of iron to give them color. (Courtesy *The Daily Oklahoman*.)

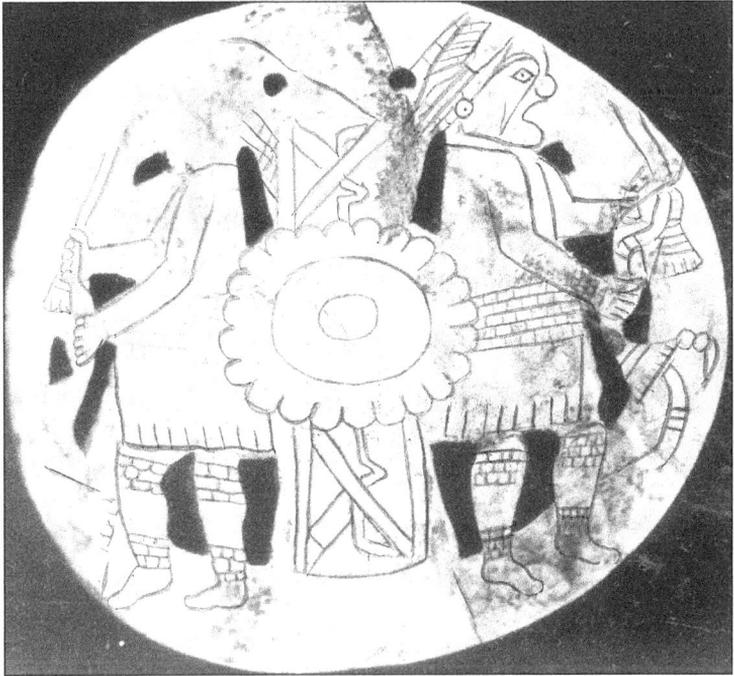

Among the earliest Tulsa area inhabitants were members of the Wichita Confederation, who lived in dome-shaped grass huts (as seen left). They were living in the area in the 1540s when Spanish conquistadors arrived and claimed the land for Spain. (Courtesy Oklahoma Department of Tourism and Recreation; photograph by Fred Marvel.)

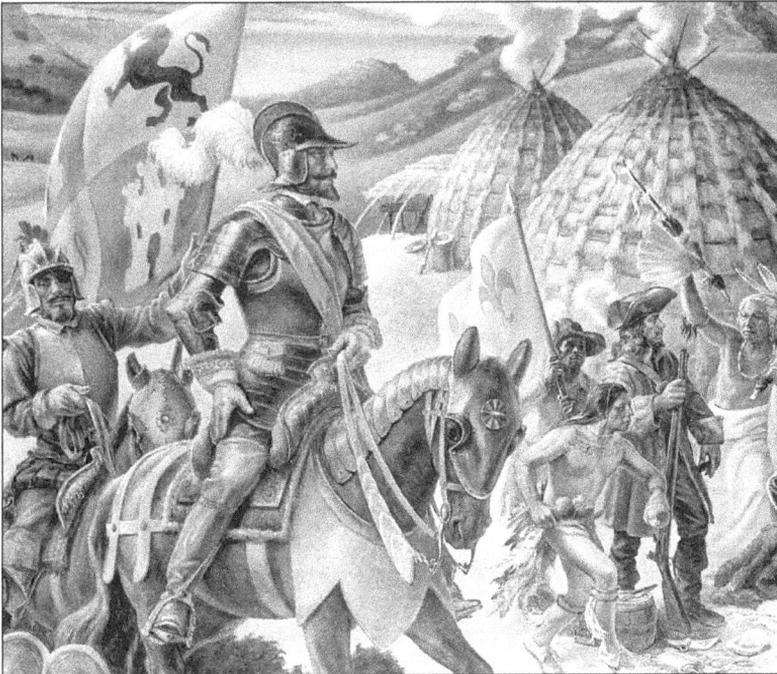

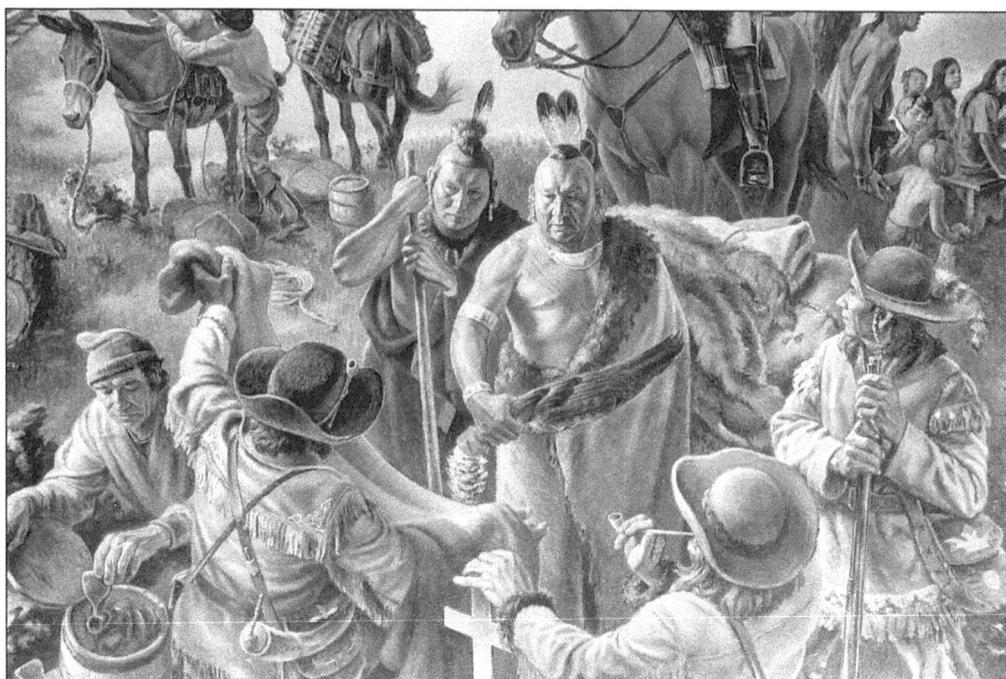

French trappers, shown here in a detail of a Charles Banks Wilson mural, frequently traveled up the Arkansas River from French Louisiana to the vicinity of Tulsa to trade cloth and tomahawk heads to the Osage in exchange for furs. (Courtesy Oklahoma Department of Tourism and Recreation; photograph by Fred Marvel.)

The rich grasslands along the Arkansas River around Tulsa were once home to huge herds of American bison, usually called buffalo, and were considered by the Osage as their hunting grounds. However, by 1874 most of the buffalo were gone. This photograph is of one of the last Osage buffalo hunts in the area. Note that the Osage on the extreme left is holding a bow, while most of the others are armed with rifles. (Courtesy Phillips Petroleum Company.)

12

World-recognized Creek artist Woodrow Wilson "Woody" Crumbo once lived along Shell Creek northwest of Tulsa. Crumbo's paintings were dedicated to documenting the history of Native Americans before their culture and customs faded into the past. (Courtesy Minisa Crumbo Halsey.)

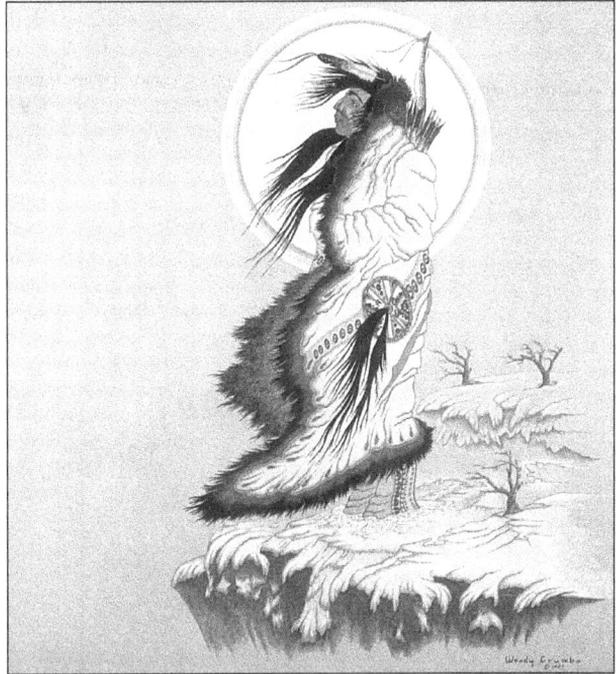

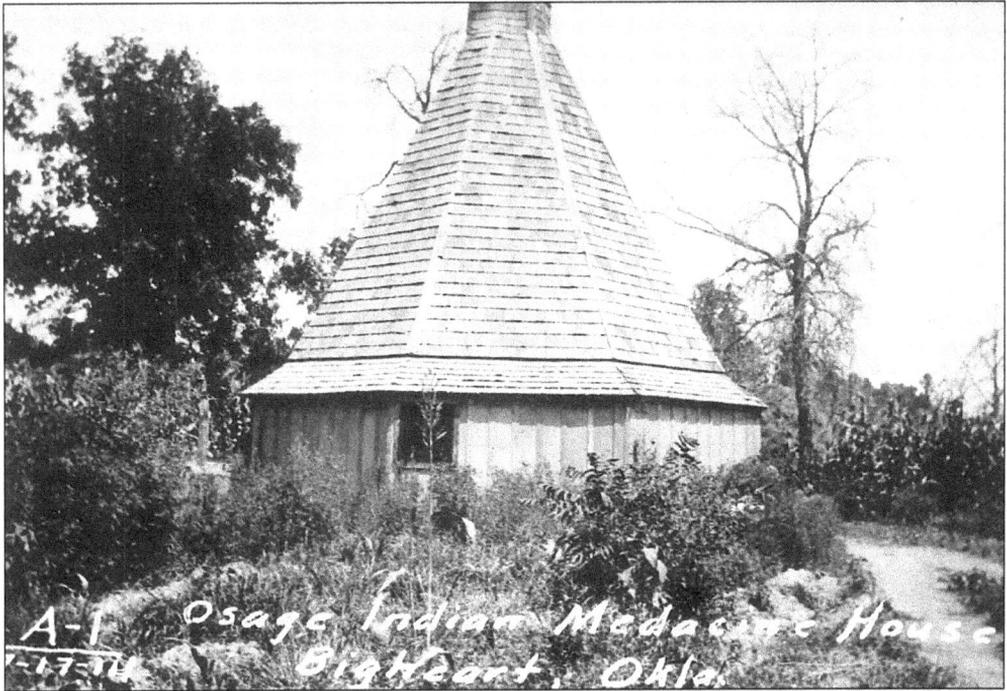

Pictured is an Osage Indian Medicine House, traditionally used by the Native American Church as the site of tribal peyote ceremonies. These churches were eight-sided, and faced east. The Native American Church has undergone a rebirth among Oklahoma tribes, helping to restore ancient Native American beliefs. (Courtesy Oklahoma Heritage Association.)

13

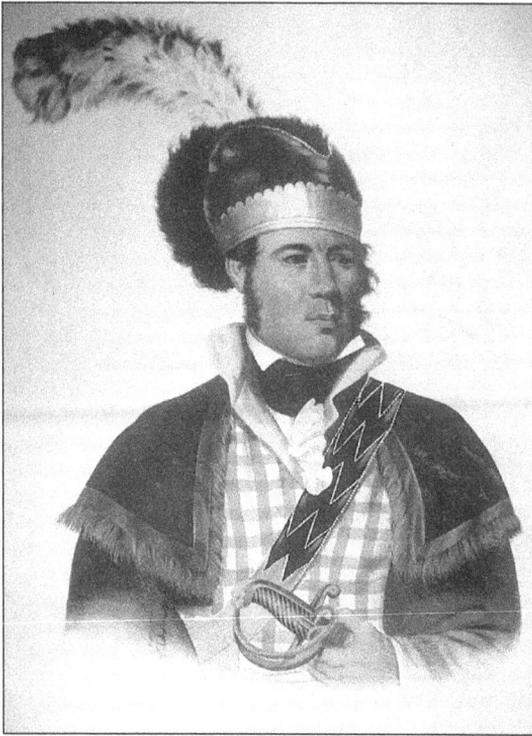

William McIntosh, a leader of the Upper Creeks, signed the Treaty of Indian Springs in 1825. The treaty traded tribal land in Alabama for a new homeland that included Tulsa. As punishment for the sale of tribal land, McIntosh was sentenced to death. Following his execution, Lewis Perryman, a supporter of McIntosh, moved his family to what became Tulsa in 1828. (Courtesy Everett and Jean Berry.)

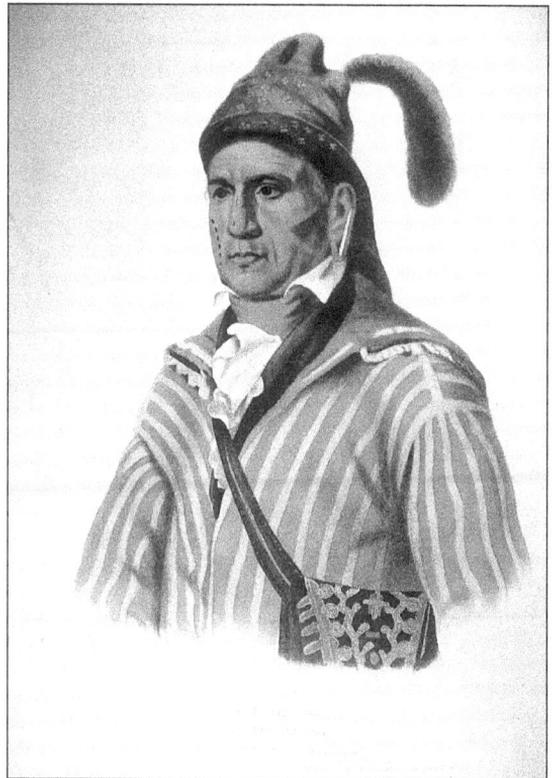

Menawa was charged by the Creek National Council with the execution of William McIntosh for signing the Treaty of Indian Springs. On April 29, 1825, Menawa and his band of Creeks surrounded McIntosh's home. After allowing the women and visitors to escape, Menawa ordered the house set afire. McIntosh opened fire on Menawa's band from the front door, but was wounded and fled upstairs. When the flames forced him to flee the house, he was shot and killed. (Courtesy Everett and Jean Berry.)

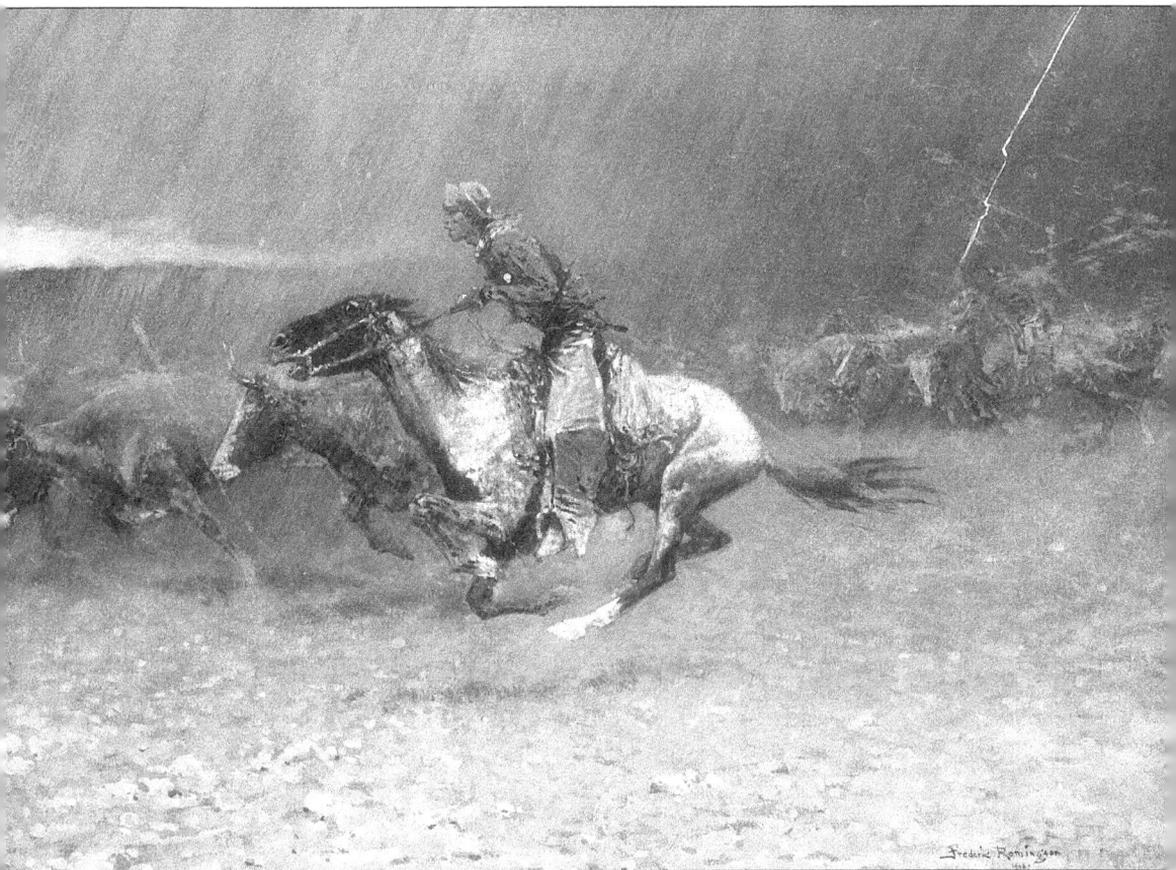

Two well-known cattle trails ran past Tulsa during the cattle-driving heyday of the nineteenth century. One was the Arkansas River branch of the Shawnee Trail, which split from the major north-south trail at Fort Gibson and followed the north side of the Arkansas River along the waterway through Tulsa and into Kansas. The other was the Osage Trail that ran from Texas north to the Osage Agency at Pawhuska, north of Tulsa. One of the things most feared by cowboys was being caught in a lightning storm while on a trail drive. At the first sign of a storm the cowboys got rid of anything metal—pistols, spurs, belts, everything—in the hope of not attracting lightning. One such storm near Tulsa was described by one of the trailhands. The cowboys noticed the storm moving in from the southwest. When the storm struck, balls of fire danced between the horns of the cattle. Fortunately the herd did not stampede, but nine were killed by lightning, and one cowboy was struck, but survived. This Frederic Remington painting portrays the danger of a cattle drive caught in a lightning storm. (Courtesy Gilcrease Museum.)

The Wichita, and other members of their confederation, were pushed out of the Tulsa area by the more powerful Osage. This detail from a stained glass window in the Catholic Church in Pawhuska shows the Osage in their colorful, traditional tribal dress. (Courtesy Oklahoma Department of Tourism and Recreation; photograph by Fred Marvel.)

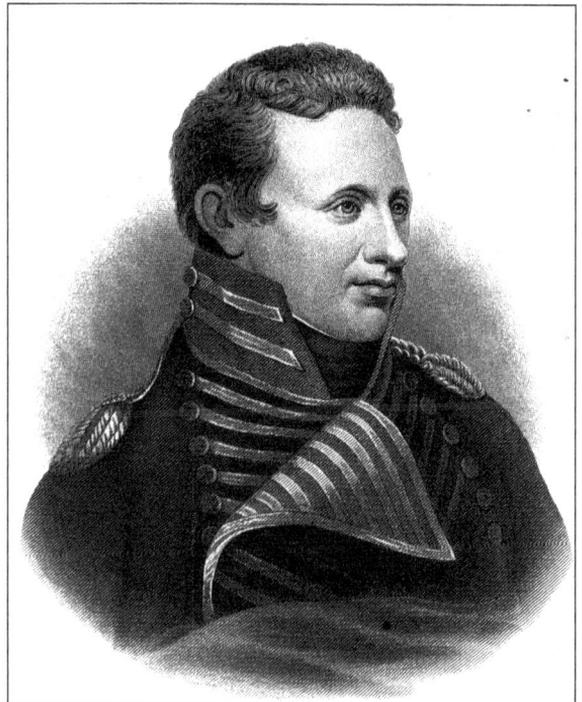

The first American official to visit Tulsa was a part of Zebulon M. Pike's (pictured) expedition that left St. Louis, Missouri in the summer of 1806 bound for the Rocky Mountains. Near Great Bend, Kansas, one of the expedition's members, James B. Wilkinson, became ill. Wilkinson and six other men were ordered to return by way of the Arkansas River. They started down river in late October and, after suffering numerous hardships, reached the site of Tulsa on December 10, 1806. (Courtesy Oklahoma Heritage Association.)

16

When the Civil War broke out, many members of the Five Civilized Tribes—the Creeks, Cherokees, Choctaws, Chickasaws, and Seminoles—fought under a modified Stars and Bars flag of the Confederacy. The flag, which had three alternating stripes of red, white, and red, also had a blue field in its upper corner. Within the field were 11 white stars representing the states of the Confederacy and five red stars representing the Five Civilized Tribes. (Courtesy Oklahoma Department of Tourism and Recreation; photograph by Fred Marvel.)

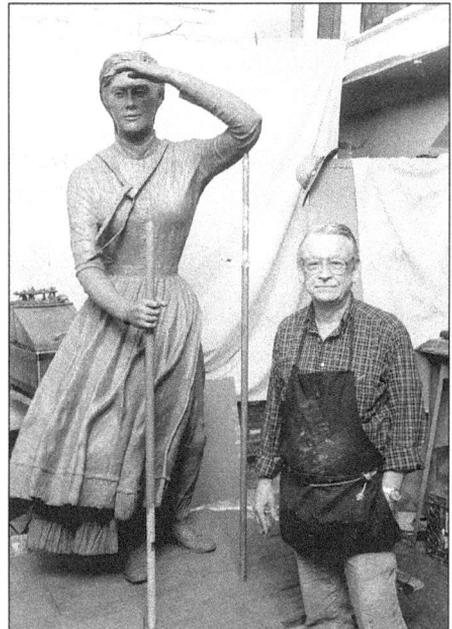

Renowned Tulsa artist Jay O'Meilia puts the final details on his sculpture *Frontier Woman* in his Tulsa studio. The statue, which represents the role of women in the settlement of the American West, is displayed at Gilcrease Museum. (Courtesy Fred Marvel.)

This is one of the many "whiskey caves" that dotted the Arkansas River upstream from Tulsa. Upstream from Tulsa was Cleveland, located in "wet" Oklahoma Territory, which once boasted 13 saloons and 2 distilleries inside its city limits. Bootleggers would purchase liquor in Cleveland and float it downstream to Tulsa, then hide it in caves until it could be sold in Tulsa, located in "dry" Indian Territory. (Courtesy Robert Jordan.)

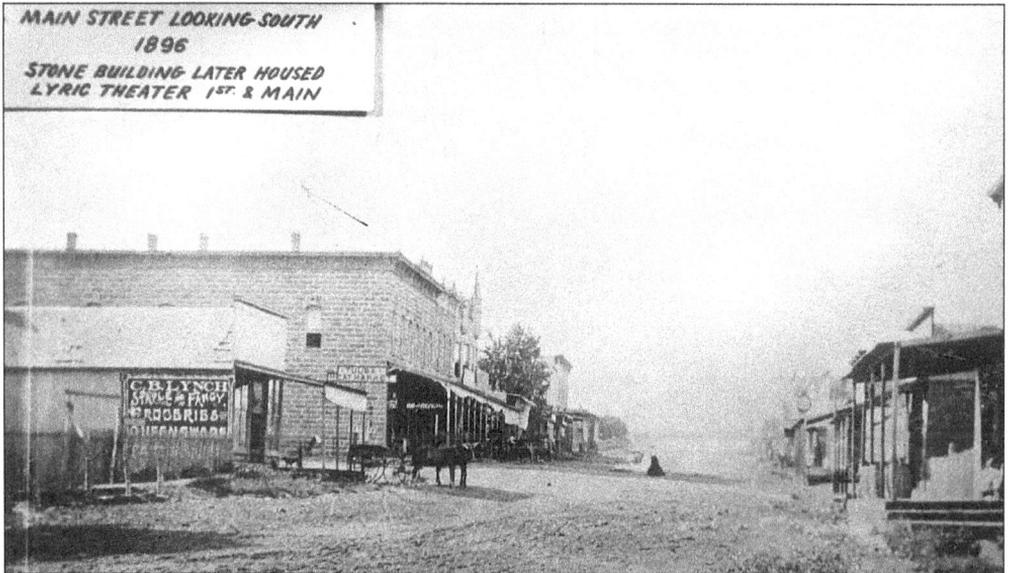

MAIN STREET LOOKING SOUTH
1896
STONE BUILDING LATER HOUSED
LYRIC THEATER 1ST & MAIN

Although the caption for the photograph says "Main Street looking South—1896," Tulsa's Main Street actually runs slightly from the northwest to the southeast because the original streets were laid out parallel to the railroad tracks, and not oriented to true north and south. Prior to the oil boom, Tulsa was a rural agriculture community and cattle-shipping point. (Courtesy Beryl D. Ford.)

18

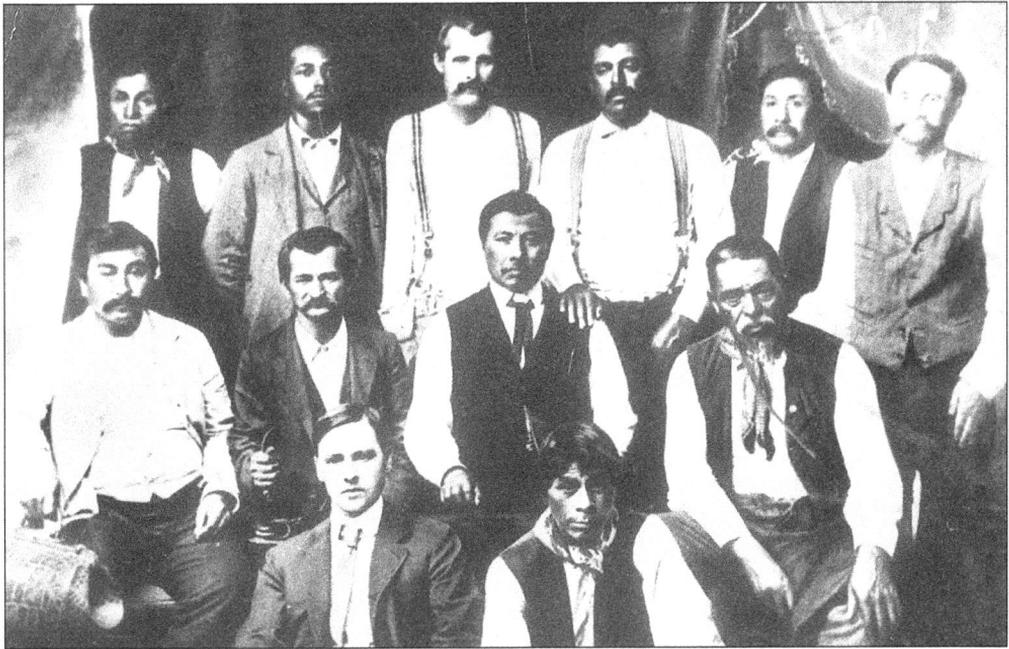

This 1900 photograph pictures members of the Creek National Council, as well as other tribal members who helped obtain the 500,000-acre oil and gas lease on which the Red Fork discovery well was drilled in June 1901. Red Fork, which is now part of Tulsa, was the site of the Red Fork Oil Field, which launched Tulsa on the road to becoming recognized as the "Oil Capital of the World." (Courtesy the Oklahoma Historical Society.)

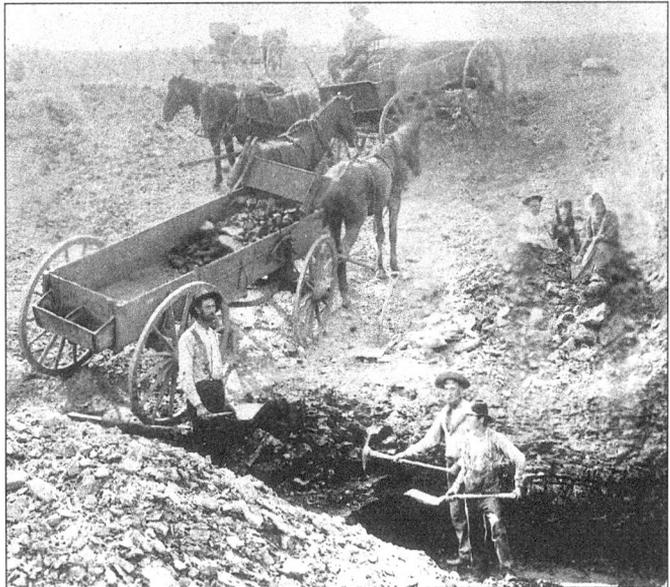

These men are digging coal out of a strip pit in Indian Territory. Commercial mining in Oklahoma did not begin until 1872, but by the time of statehood, 1907, it was an integral part of Oklahoma's economy. Frank W. and William R. Podpechan started the Hickory Coal Company in Tulsa in 1929 at Twenty-sixth Street and Pittsburg Avenue. (Courtesy Oklahoma Heritage Association.)

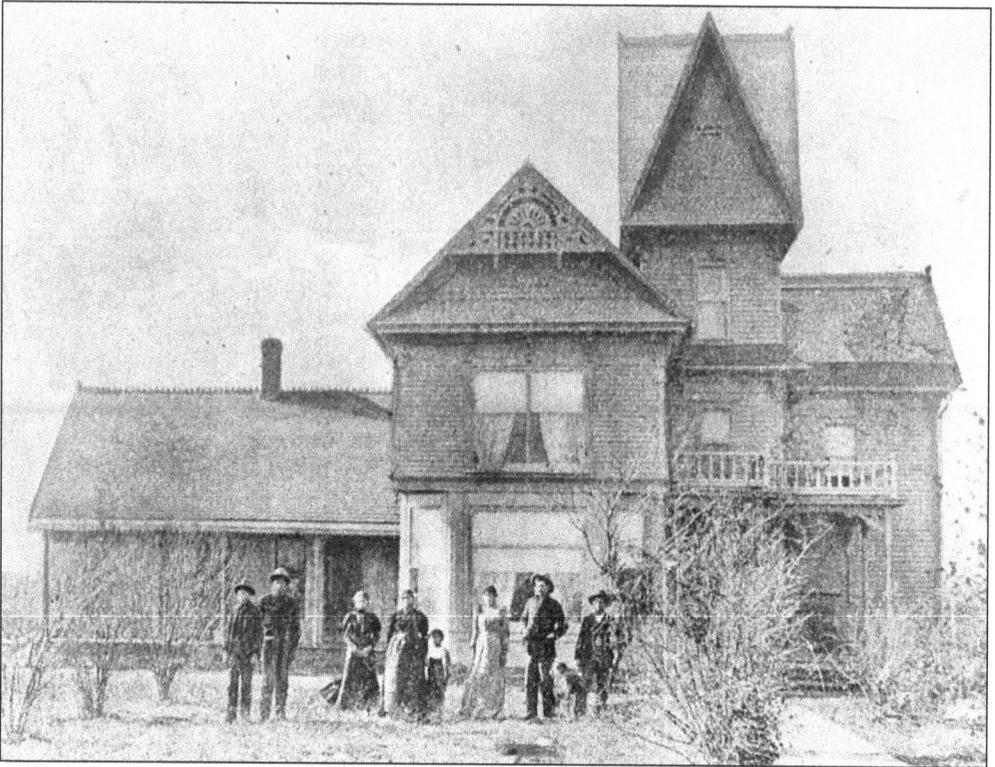

The home of George B. Perryman was built on South Main Street, one of the highest spots in early-day Tulsa. Often called Tulsa's first family, the Perrymans arrived in Tulsa in 1828. (Courtesy *The Daily Oklahoman.*)

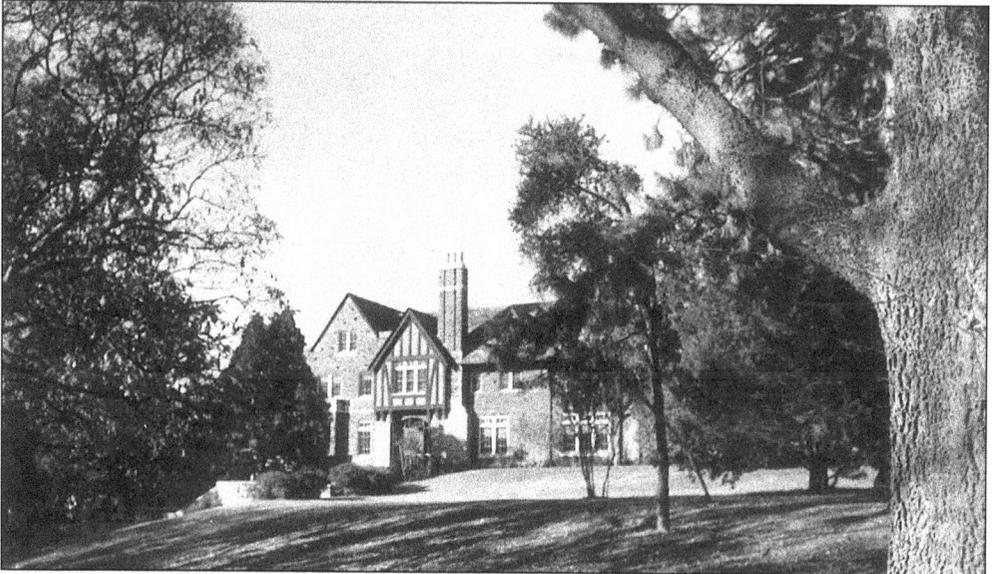

The McBirney Mansion on Riverside Drive is a three-story Old English half-timber mansion, occupying a 3-acre site where Washington Irving and his party camped around a spring during Irving's Tour on the Prairies in 1832. (Courtesy *The Daily Oklahoman.*)

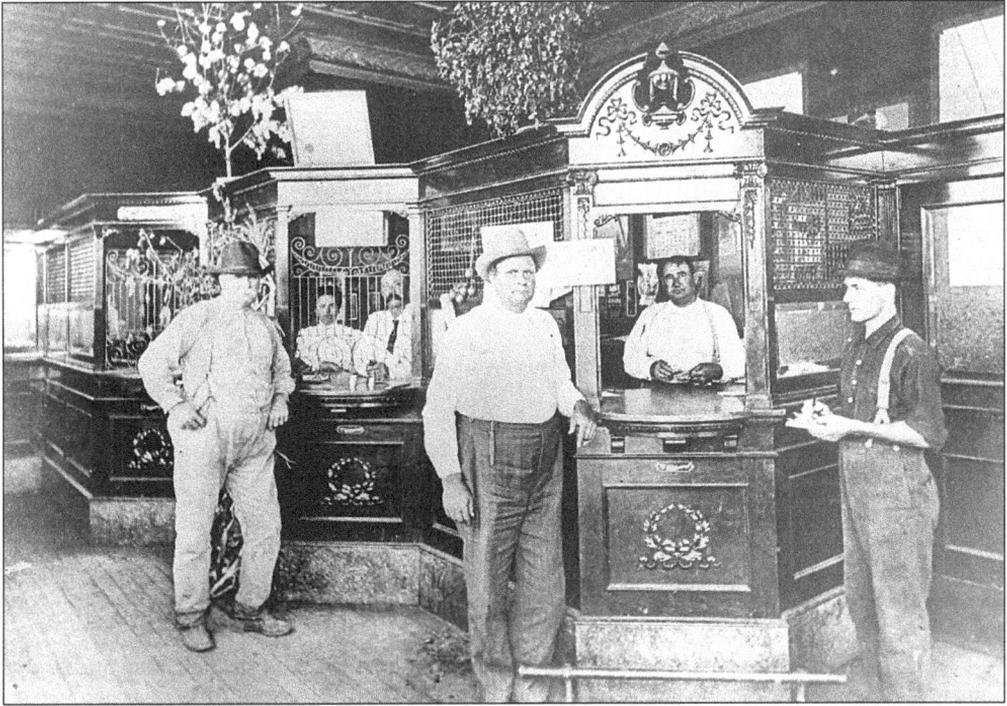

In 1902, The First National Bank of Tulsa was one of several oil-related banks in Tulsa that provided much of the capital needed to develop the surrounding oil fields. (Courtesy American Petroleum Institute.)

Turners Department Store, at the intersection of First Street and South Main Street in downtown Tulsa, is pictured here in 1904. It was touted as "the big store with the little prices." It was owned by F.F. Turner. (Courtesy *The Daily Oklahoman.*)

Al Spencer, shown here working as a cowboy on the Sherman-Moore Ranch, was one of the numerous Twin Territories outlaws who roamed the Osage Hills around Tulsa. It was rumored that he often used Ma Barker's Tulsa home as a hideout. Spencer was shot and killed north of Tulsa in Osage County in 1895. (Courtesy Edgar E. Weston.)

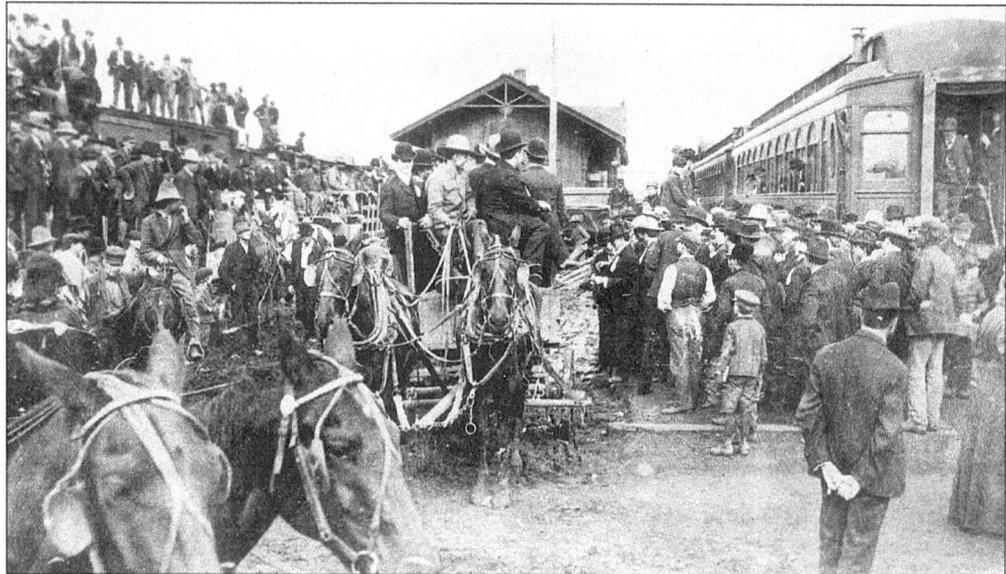

This was a common scene at Tulsa's St. Louis and San Francisco Railroad Depot in 1905. In 1897, the Atlantic and Pacific Railroad was taken over by the St. Louis and San Francisco Railroad. The railroad's charter required it to cross the Arkansas River near the mouth of the Cimarron River, which at the time was called the Red Fork of the Arkansas. The crossing at the Cimarron was not suitable, and to satisfy its charter the railroad built a bridge at Lochapoka Crossing and then named it Red Fork. (Courtesy Beryl D. Ford.)

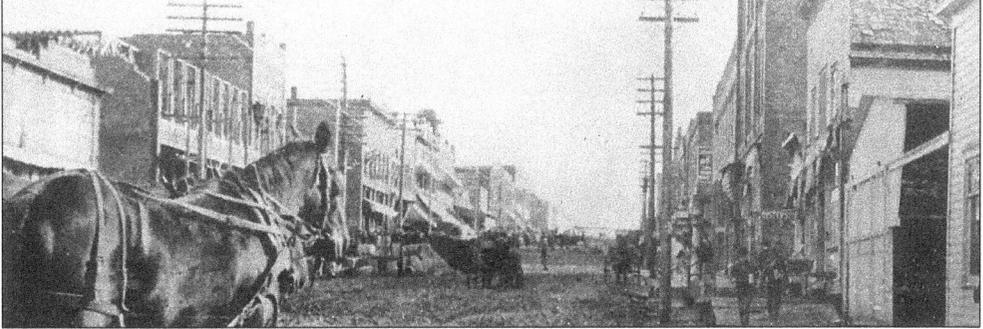

1905
Looking South on Main
From R.R (Mud & Horses)

By 1905, within half a decade of the discovery of nearby oil fields, Tulsa had mushroomed into a city. A multitude of establishments, such as the New State Hotel and Cafe (which featured oysters on its menu) catered to the hordes of oil men rushing to the latest discovery. (Courtesy Beryl D. Ford.)

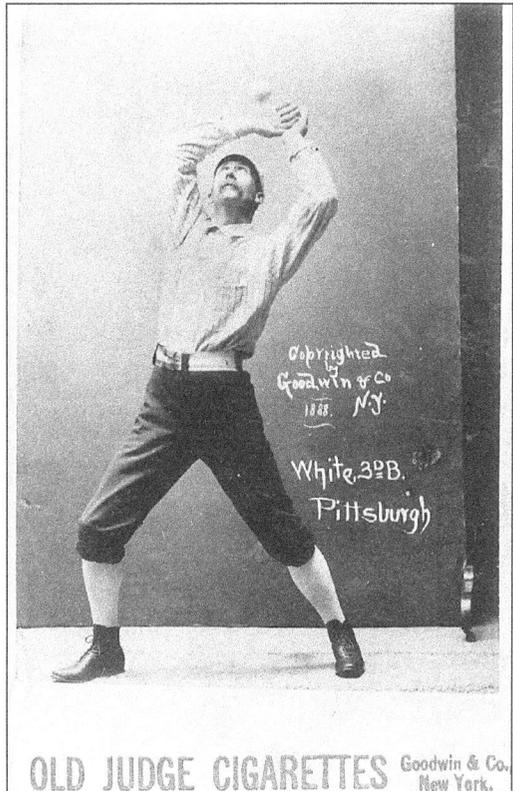

One of the best known professional baseball players of the early twentieth century was James L. "Deacon" White, manager of the Tulsa Oilers in 1908 when they won their first championship pennant of the Class D Kansas-Oklahoma League. Note that he is not wearing a glove. (Courtesy National Baseball Hall of Fame Library, Cooperstown, New York.)

23

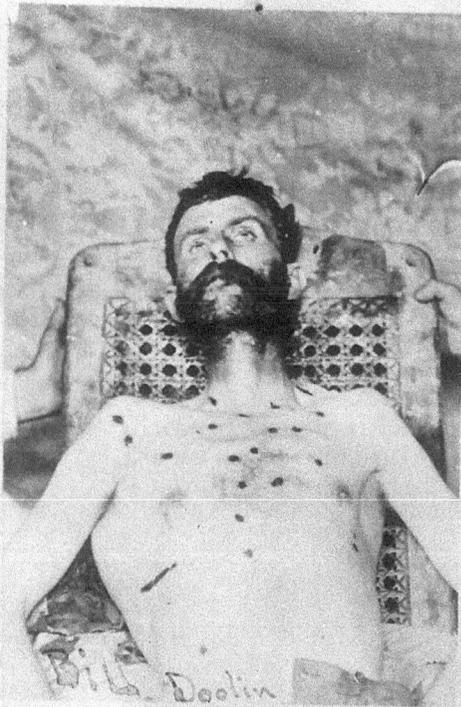
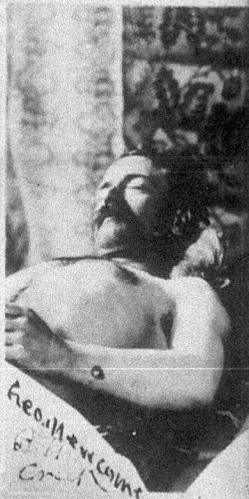
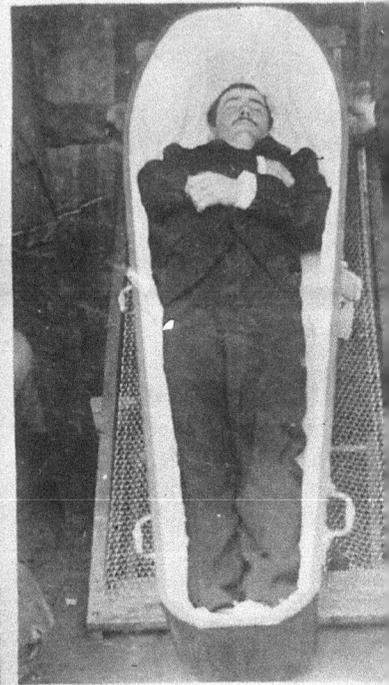

Following the ill-fated bank robbery in Coffeyville, Kansas, Bill Doolin formed his own outlaw band. Within three years, however, most of the Doolin Gang were either killed or jailed. Pictured here are Bill Doolin, killed by a shotgun blast in 1896 near Lawson, in Pawnee County; George "Bitter Creek" Newcomb, who died in a gunfight near Ingalls in Payne County in 1895; and Ol Yantis, who was killed in Logan County in 1892. (Courtesy *The Daily Oklahoman*.)

Matthew Kimes, left, a well-known Tulsa gangster, his accomplice Ray Doolin, and Kimes' brother, George, formed the Kimes Gang. The Gang terrorized banks throughout the state in the 1920s. On January 10, 1927 Kimes robbed the Sapulpa State Bank of $42,950. (Courtesy *The Daily Oklahoman*.)

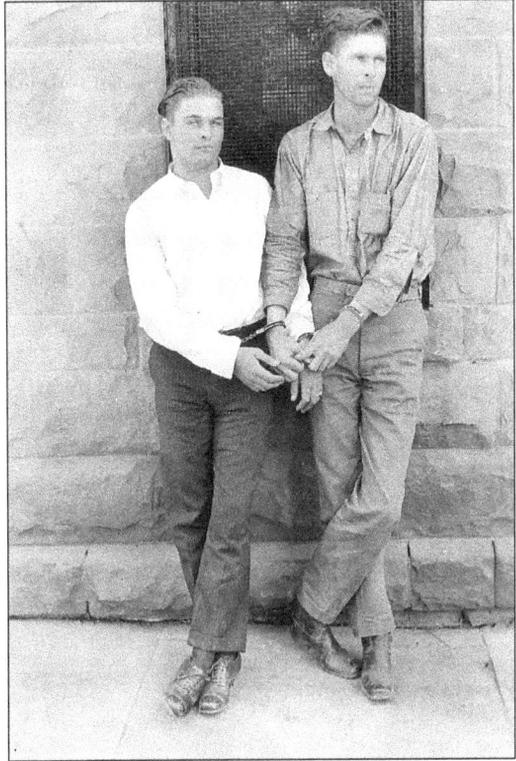

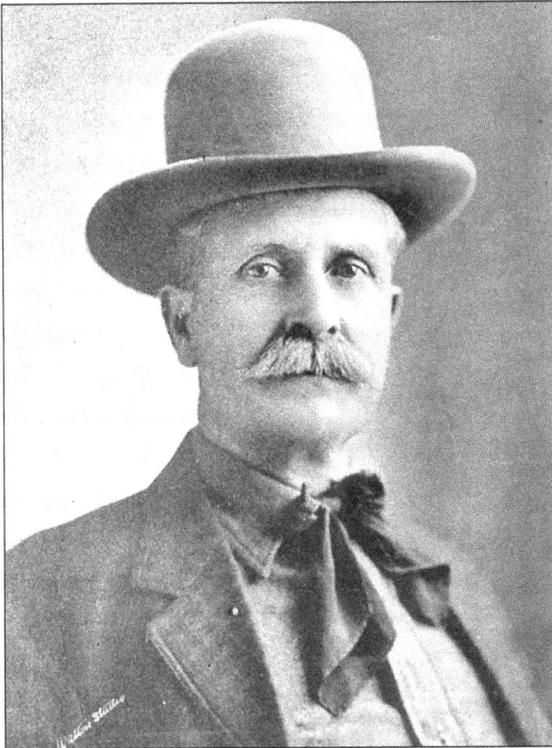

William "Bill" Tilghman captured outlaw Bill Doolin in a bathhouse in Eureka Springs, Arkansas, and took him to Guthrie. However, Doolin escaped on July 5, 1896, and in the following manhunt was shot and killed by Deputy Marshall Heck Thomas on August 25. (Courtesy *The Daily Oklahoman*.)

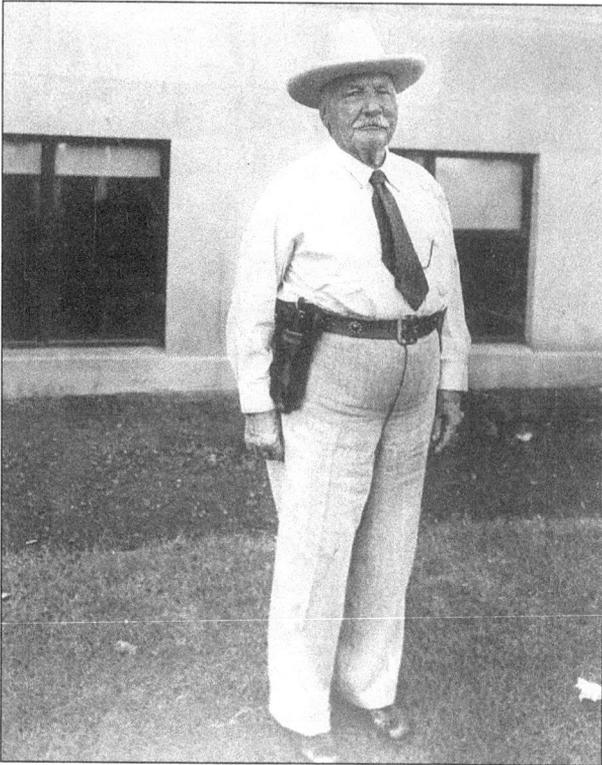

Chris Madsen, one of the legendary United States Deputy Marshals in the Twin Territories, retired from federal law enforcement in 1916 and then served as an auditor for the Tulsa Police Department. (Courtesy *The Daily Oklahoman.*)

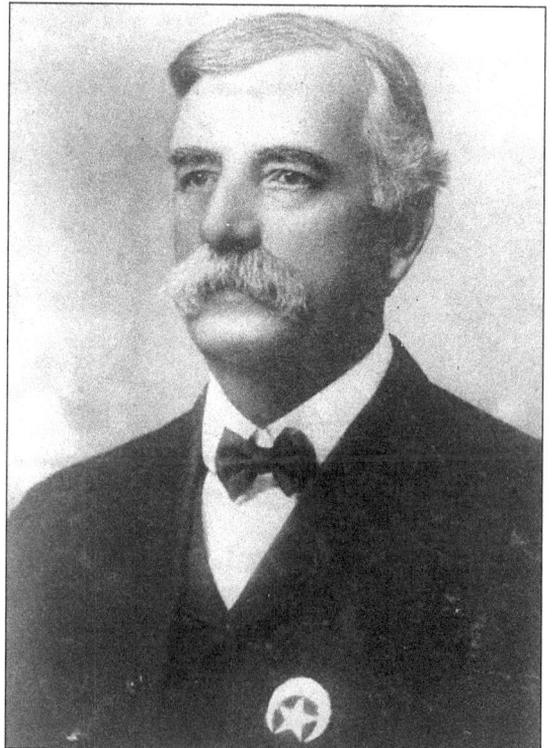

United States Deputy Marshal Heck Thomas was one of the legendary Three Guardsmen (consisting of Thomas, William "Bill" Tilghman, and Chris Madsen)who helped bring law and order to the Tulsa area during the height of lawlessness in the Twin Territories. (Courtesy Western History Collections, University of Oklahoma Library.)

The Twin Territories were a haven for outlaws in the last decades of the nineteenth century. One of the region's most infamous bandits was Henry Starr, shown here on the right with his friend, Ed Newcom. (Courtesy Oklahoma Heritage Association.)

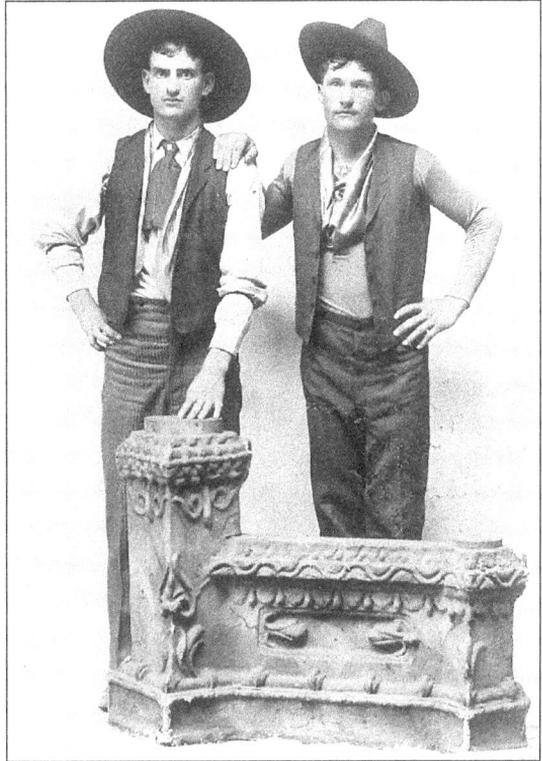

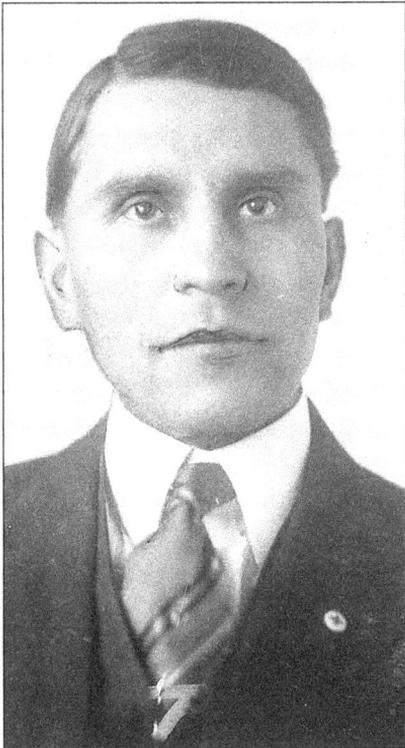

A well-known bank robber, Henry Starr was the nephew of Sam Starr, husband of Belle Starr. He began his outlaw career when he was 16 years old, and by 1915 was one of the most hunted men in the region. Starr and his female companion often hid out in Tulsa. Calling themselves the "Williams family," they rented a small house on East Second Street in Tulsa in 1914 while he planned his next bank robbery. (Courtesy *The Daily Oklahoman*.)

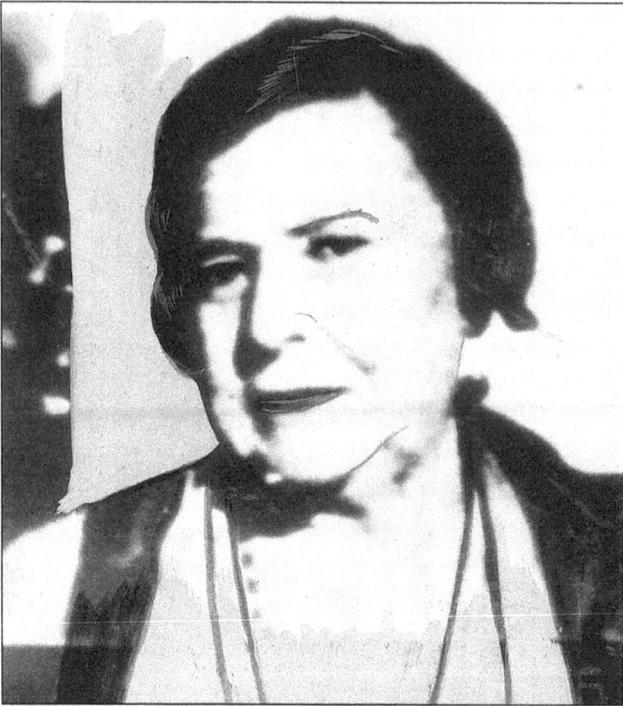

Kate "Ma" Barker was the mother of Freddie, Herman, Lloyd, and Arthur (called "Doc") Barker, who together formed the infamous Barker Gang of the 1930s. In 1915, she moved her family to a two-room shack at 401 North Cincinnati Avenue in Tulsa. Although Ma Barker never publicly participated in their crimes, she often provided them hideouts. J. Edgar Hoover described her as a "monument to the evils of parental indulgence." (Courtesy *The Daily Oklahoman.*)

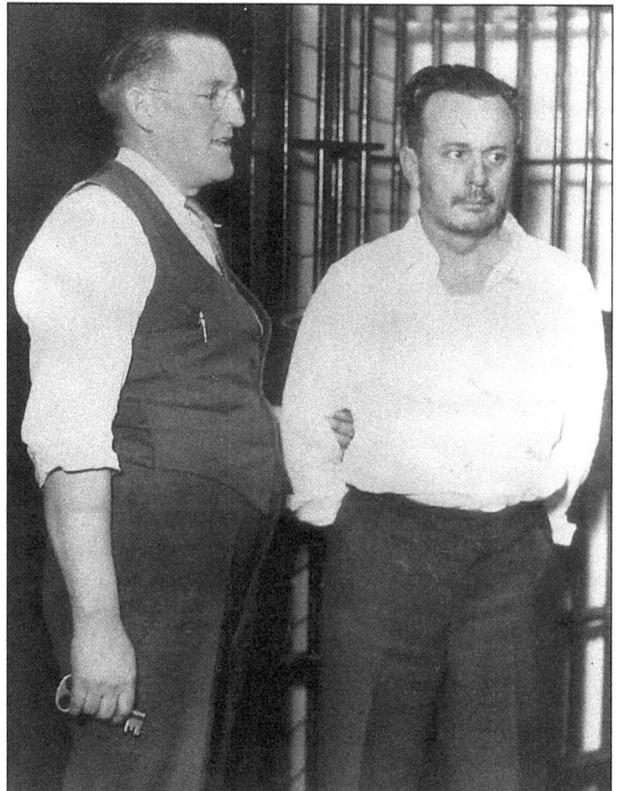

One of "Doc" Barker's first crimes was stealing a government-owned automobile in Tulsa during the 1918 Fourth of July celebration. In 1922, he was sentenced to the State Prison for murdering a night watchman at Tulsa's St. John's Hospital. In this photo, Barker is at the right. (Courtesy *The Daily Oklahoman.*)

Clyde Barrow, of the infamous Bonnie and Clyde Gang, and his partner, Bonnie Parker, often passed through Tulsa during their crime spree of the 1930s. Here Barrow poses with a portion of his arsenal of weapons on the front bumper of his getaway car. Leaning against the grill is a sawed-off 12-gauge shotgun. Barrow is holding two rifles. (Courtesy *The Daily Oklahoman.*)

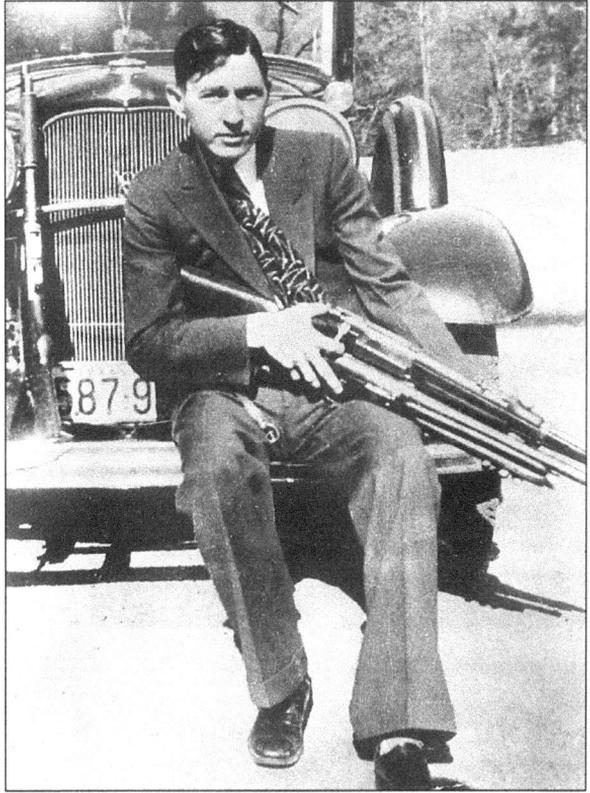

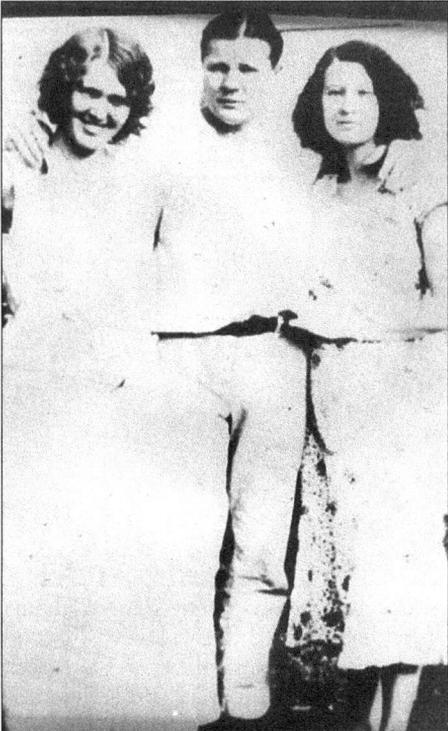

Charles "Pretty Boy" Floyd was one of the most hunted criminals of the 1930s, and often sought refuge from lawmen in Tulsa. On February 11, 1932, two Tulsa detectives, "Blackie" Jones and Earl Gardner, located Floyd's hideout at 512 East Young Street. With Floyd was his partner George Birdwell. Calling for reinforcements, Jones, Gardner, and more than 20 other lawmen surrounded the house, but before the outlaws could be captured they escaped out the back door. (Courtesy *The Daily Oklahoman.*)

George Kimes was tried for the murder of Luther Bishop, an Oklahoma State Crime agent who had been instrumental in the arrest of several Oklahoma outlaws in the 1920s. (Courtesy *The Daily Oklahoman*.)

George "Machine Gun" Kelly and his wife Kathryn are shown here being sentenced in Oklahoma City for the kidnapping of oil man Charles Urshel. Urshel had married the widow of Tulsa oil man Tom Slick. Kelly was a frequent visitor to Tulsa during his early criminal career. On March 24, 1927, he was arrested for vagrancy by Tulsa lawmen, and then on January 12, 1928, the Tulsa County sheriff's office arrested him for bootlegging. (Courtesy *The Daily Oklahoman*.)

A huge party was scheduled in celebration of the opening of the Robertson Hotel in downtown Tulsa in 1905, complete with liquor and beer. When Carrie Nation, pictured, one of the leaders of the National Women's Christian Temperance Union, learned of the party she took the train from Kansas to Tulsa and announced her intention of stopping the festivities. Unfortunately, when she arrived the invited guests were already inside and had locked and bolted the doors. (Courtesy Kansas State Historical Society.)

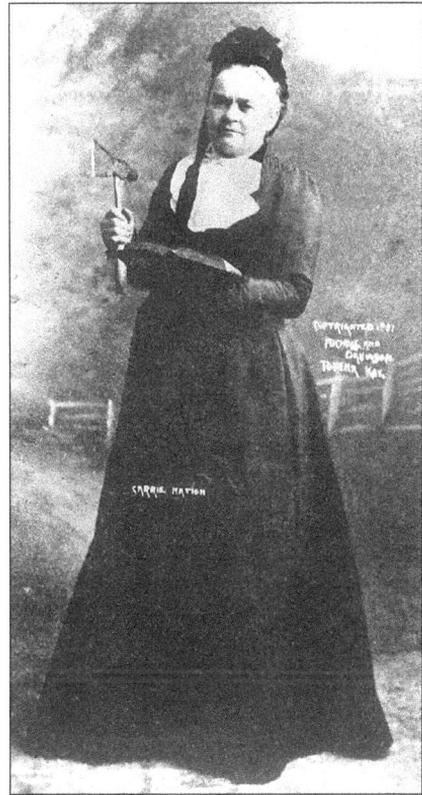

In an effort to end bootlegging in the state, local lawmen did their best to close down the illegal liquor traffic. Here, Tulsa vice squad detective Bruce Baldwin, being supported by Tulsa Police Captain Louis Skinner, kicks in the door of a Tulsa-based bootlegging operating. State Safety Commissioner Joe Cannon (left) and an unidentified man are observing. (Courtesy *The Daily Oklahoman*.)

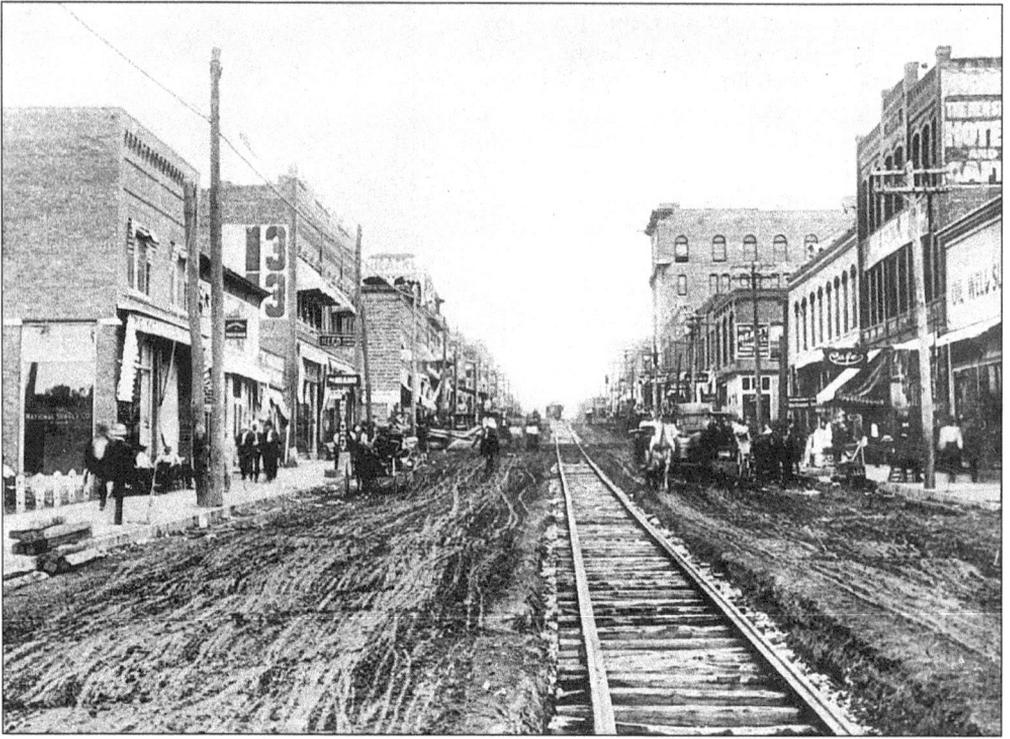

This view looks south on Main Street in 1907. The interurban line, which allowed oil men to live in Tulsa and commute by rail to their jobs in Glenn Pool, is clearly visible. The nearby oil strikes at Red Fork and Glenn Pool had stimulated the growth of the community, but the street remains unpaved. (Courtesy Beryl D. Ford.)

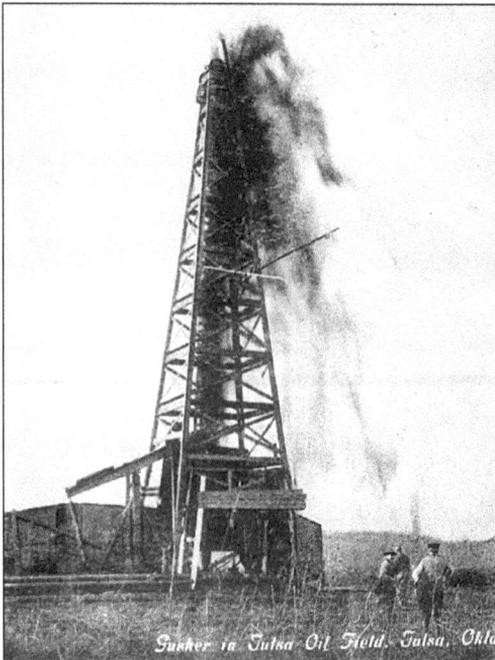

By 1906, three producing wells a day were being completed in the Glenn Pool oil field. Such production quickly touched off a rush to the area. Tulsa and the surrounding countryside were about to undergo a major change. (Courtesy Beryl D. Ford.)

Two

BLACK GOLD IN THE LAND OF THE RED MAN

The Creeks were divided over the question of removal from their ancient homeland to Oklahoma. The Lower Creeks, mostly mixed-bloods, began moving to Oklahoma as early as 1825. However, the Upper Creeks, mostly full-bloods, delayed until they were forced over the infamous Trail of Tears in 1836–1837.

It was mostly the Upper Creeks who settled the area around Tulsa. Among them were 469 members of the Lochapoka (place of the turtles) Clan, or Turtle People. They called their new settlement "Tallassee Lochapokas." Eventually, "Tallassee" was corrupted into Tulsey Town.

During the Civil War the Upper Creeks sided with the South, and between 1861 and 1865 Tulsey Town was part of the Confederate States of America.

After the war, a number of ranches were started. One of the earliest ranchers was Lewis Perryman, an Upper Creek, who had arrived in Tulsa with his four wives in 1828. The family's ranch included the area between Twenty-first Street on the north and Seventy-first Street on the south, between the Arkansas River on the west and present-day Broken Arrow on the east.

The Atlantic and Pacific Railroad built into the region in 1882, and the settlement became a major cattle-shipping point.

Tulsa was incorporated on January 18, 1898. By then it stretched for a block along both the east and west sides of Main Street, and south of the St. Louis and San Francisco Railroad for five blocks between First and Fifth Streets.

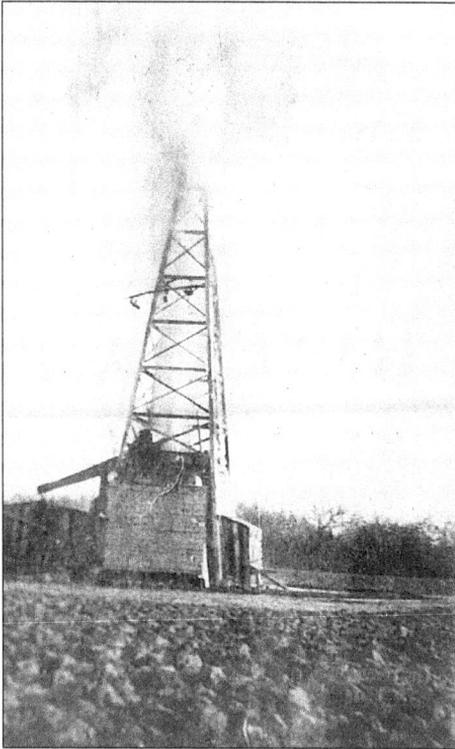

Typical of the wildcat wells in and around the Tulsa area near the turn of the century was this wooden derrick in Glenn Pool. (Courtesy Sapulpa Historical Museum.)

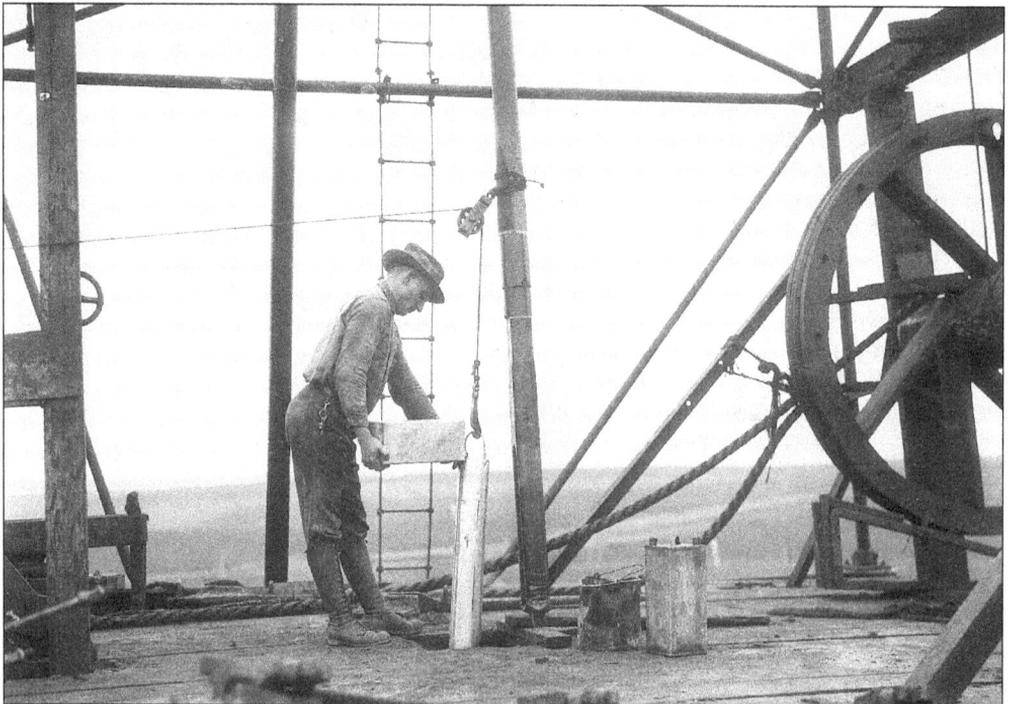

Nitroglycerin is being carefully poured into a well by C.C. Rupert, a "shooter." Shooters were extremely vulnerable and often short-lived. (Courtesy Oklahoma Heritage Association.)

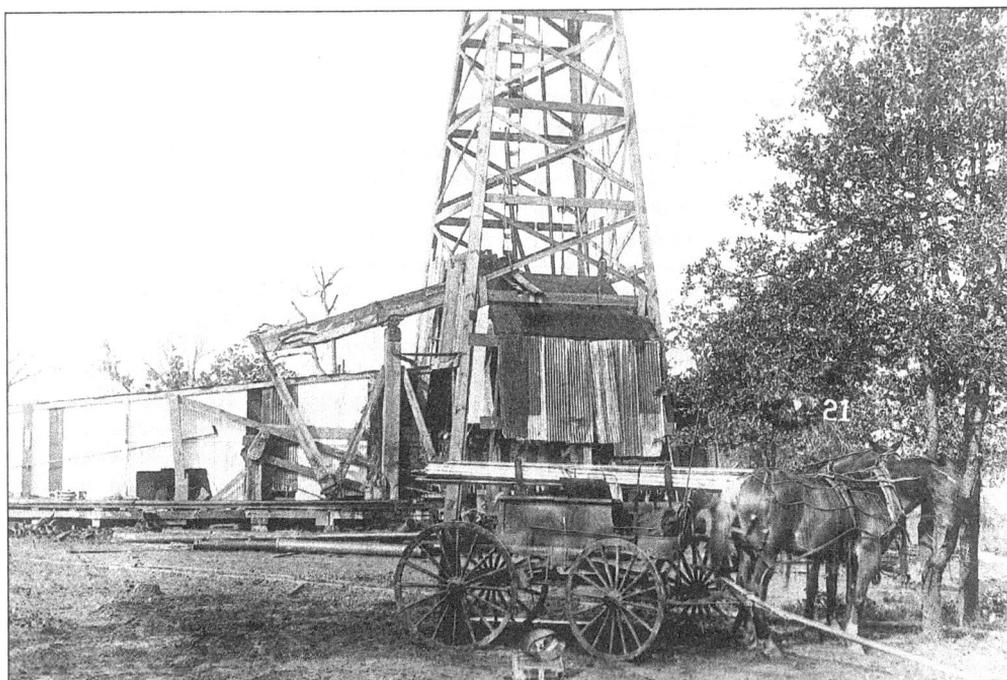

Nitroglycerin was stored in isolated storage sheds and taken to the drilling site in special wagons such as the one above. Most of the wagons had separate padded compartments, or the nitro was packed in sawdust to prevent the explosive from being shaken. (Courtesy Western History Collections, University of Oklahoma Library.)

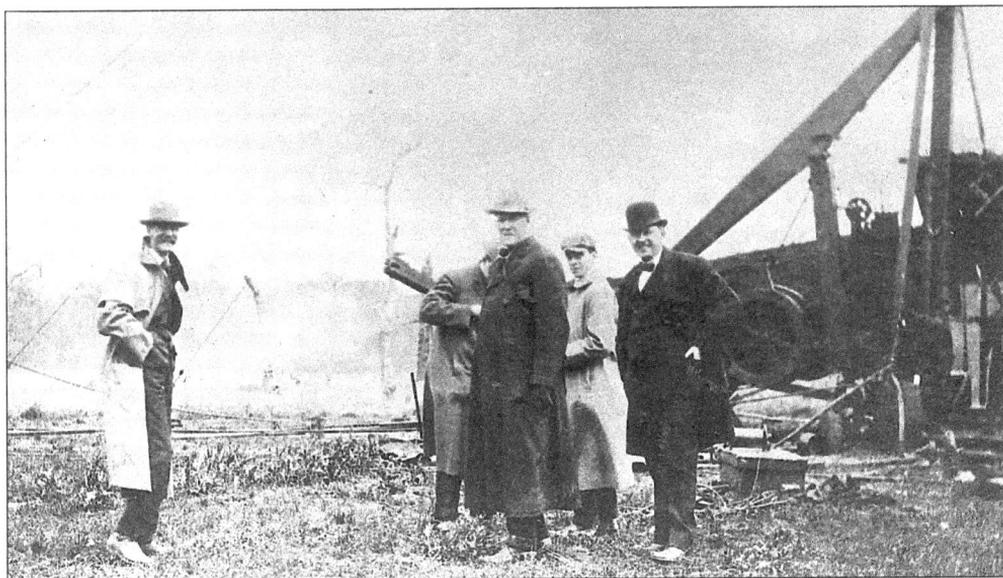

Pictured are smiling promoters of one of the wells at Red Fork in 1901. Because the railroad stopped at Tulsa on the east side of the Arkansas River, the community became a mecca for oil men rushing to the strike on the other side of the river at Red Fork. In 1904, Tulsa's Eleventh Street Bridge was constructed to connect the two settlements. (Courtesy University of Tulsa, McFarlin Library.)

The Sue A. Bland No. 1, the discovery well at Red Fork in 1901, is shown after the derrick and drilling equipment had been removed and a pumping unit installed. It was several days after the well came in that Sue Bland, a Creek Indian, actually made application for a homestead allotment in the quarter section in which the well was located. (Courtesy Oklahoma Publishing Company.)

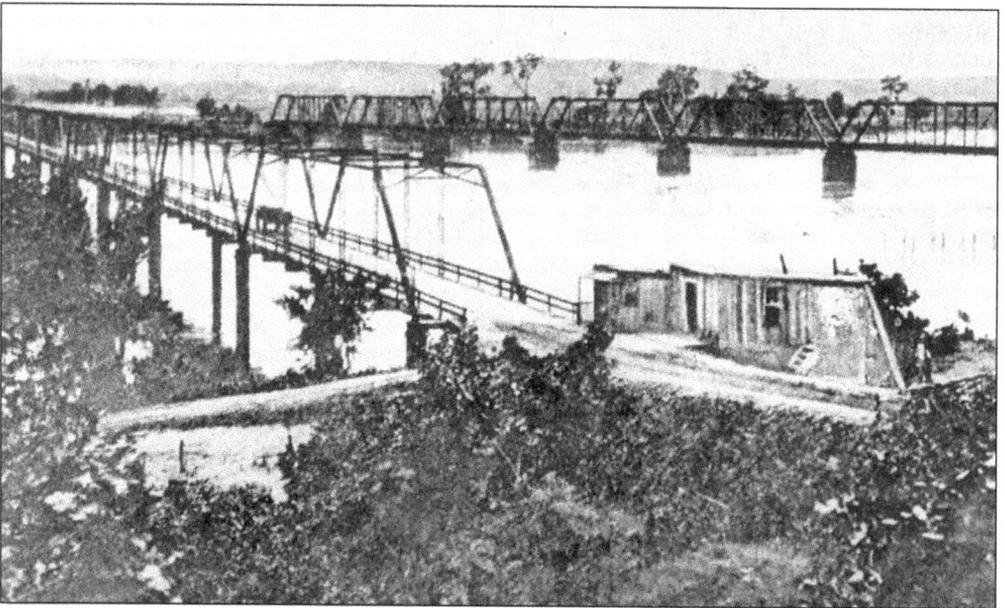

When the Tulsa oil boom era started, Tulsa was separated from the strike at Red Fork by the Arkansas River. The only access from Tulsa to Red Fork was over the St. Louis and San Francisco Railroad bridge. Tulsa businessmen feared that the inconvenience of getting to the wells would make other communities more attractive to oil men. When a bond issue to build a bridge failed, George T. Williamson, J.D. Hagler, and M.L. Baird agreed to finance the bridge privately. Ignoring engineering reports that the river bottom would not support the bridge, they filled old boilers with concrete and lowered them into the water to form piers. At a cost of $50,000, the bridge was completed on January 4, 1904. Placards at the tollgates read: "You said we couldn't do it, but we did." (Courtesy Oklahoma Historical Society.)

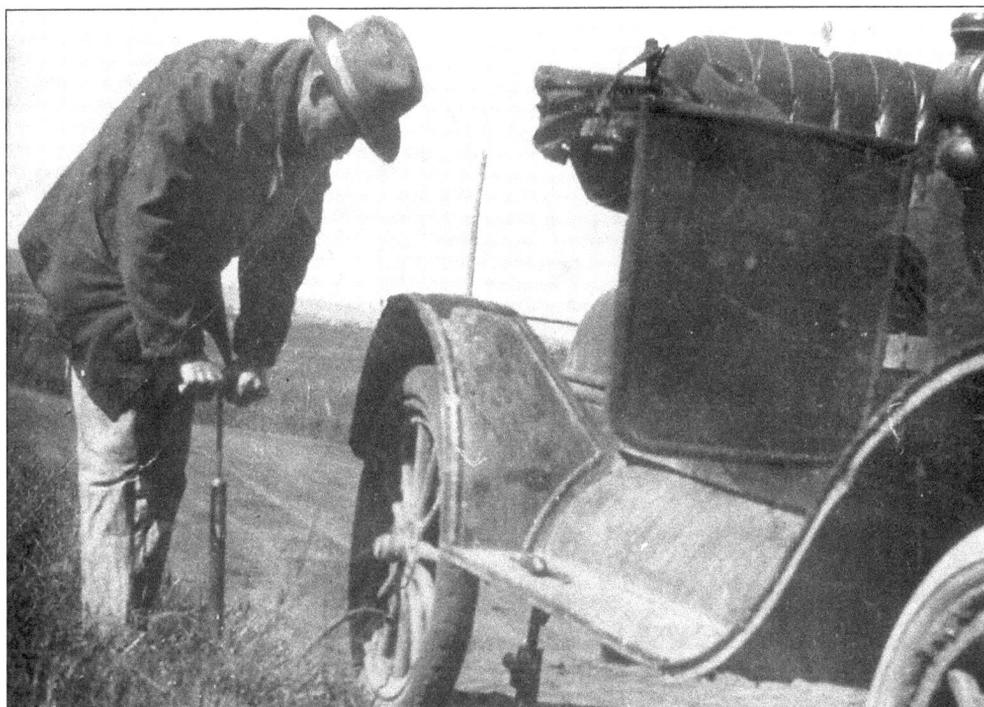

Although Tulsa was the center of oil during the first quarter of the 20th century, oil scouts often had difficulty getting from the city to the wells on the unpaved roads. (Courtesy *The Daily Oklahoman.*)

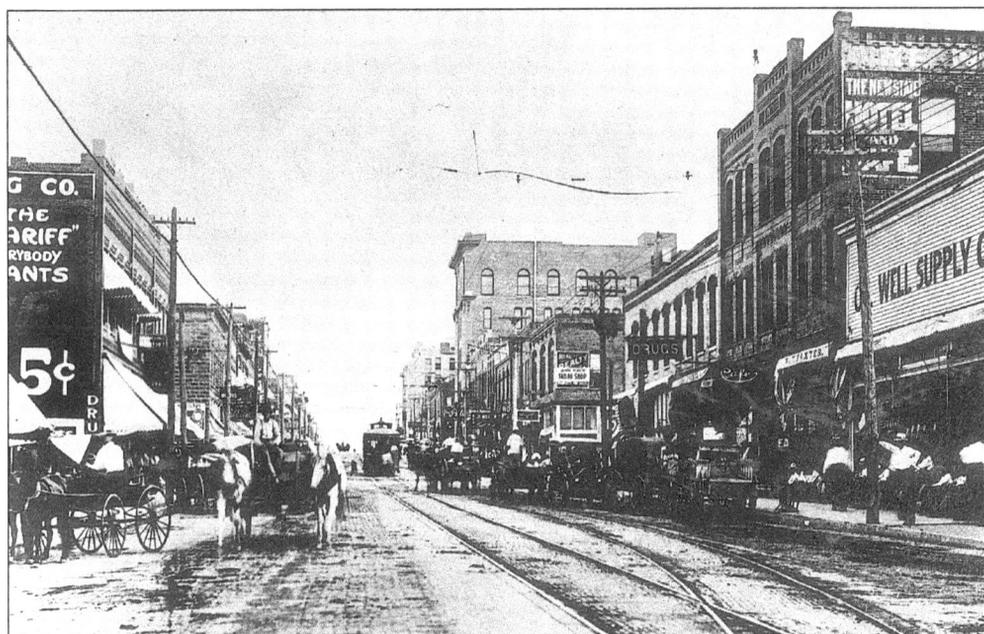

By 1909 Tulsa was already a major oil and natural gas center. Note the Oil Well Supply Company building on the right and the electric-powered trolley in the center of the photograph. (Courtesy *The Daily Oklahoman.*)

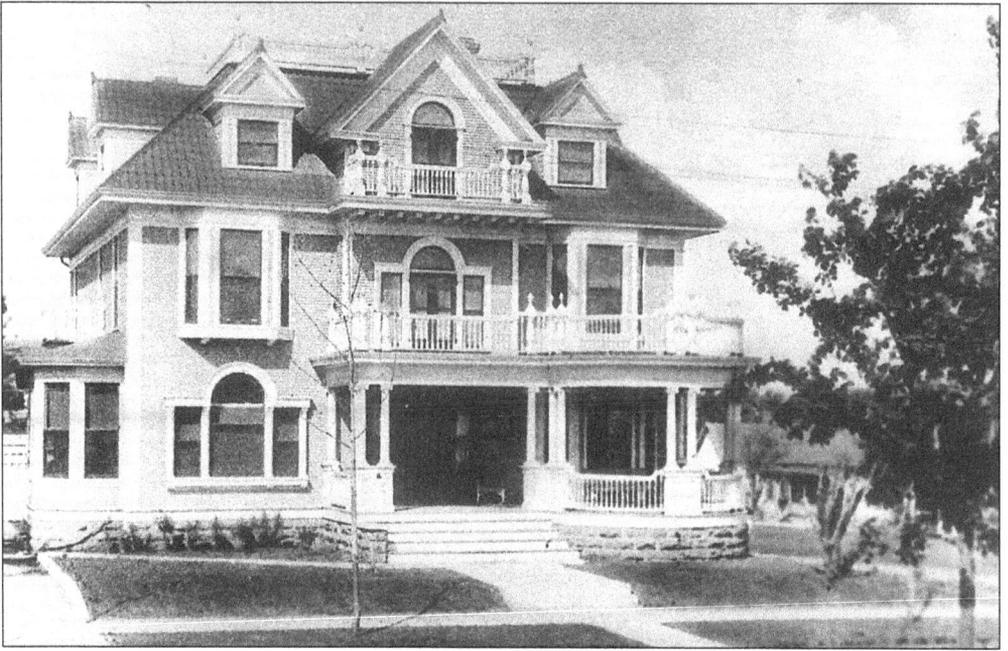

This is the Tulsa mansion of Dr. and Mrs. Fred S. Clinton. Clinton, who helped drill the discovery well at Red Fork, like many other Tulsa-area oil men, chose to live in Tulsa. (Courtesy Oklahoma Historical Society.)

Dr. Fred S. Clinton (second from right) and Dr. J.C.W. Bland (far right) played a major role in the drilling of the Sue A. Bland No. 1, the discovery well at Red Fork named for Bland's wife. (Courtesy Oklahoma Historical Society.)

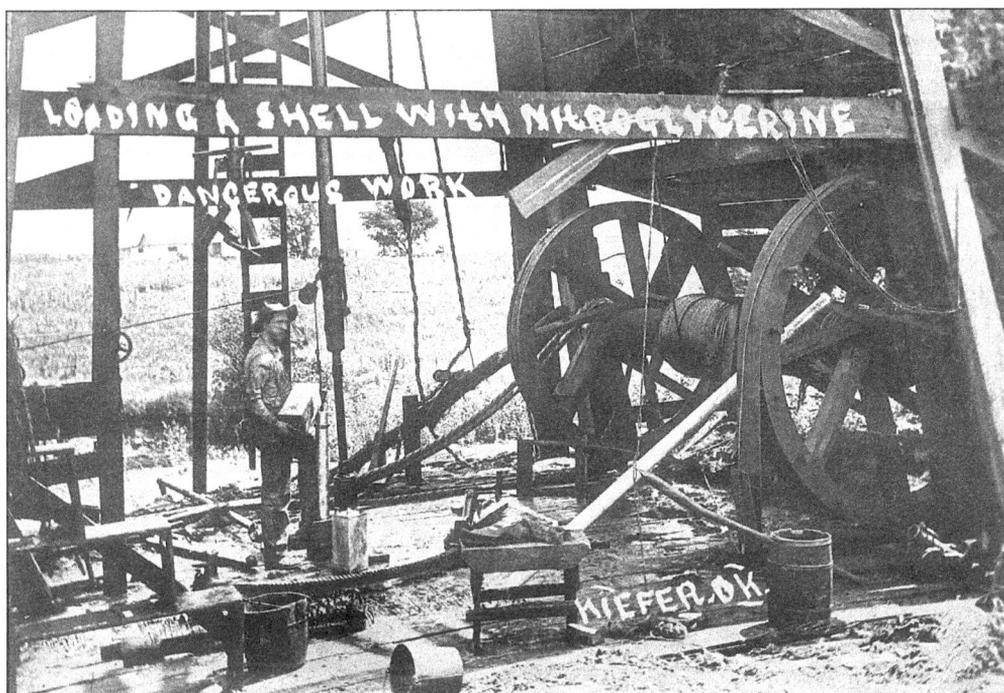

A "shooter" is loading a torpedo with nitroglycerin in the Kiefer Oil Field south of Tulsa. Once the tin container was filled with the explosive it was lowered to the desired depth by a wire, and a "go devil" was sent down the wire to touch off the explosion. (Courtesy University of Tulsa, McFarlin Library.)

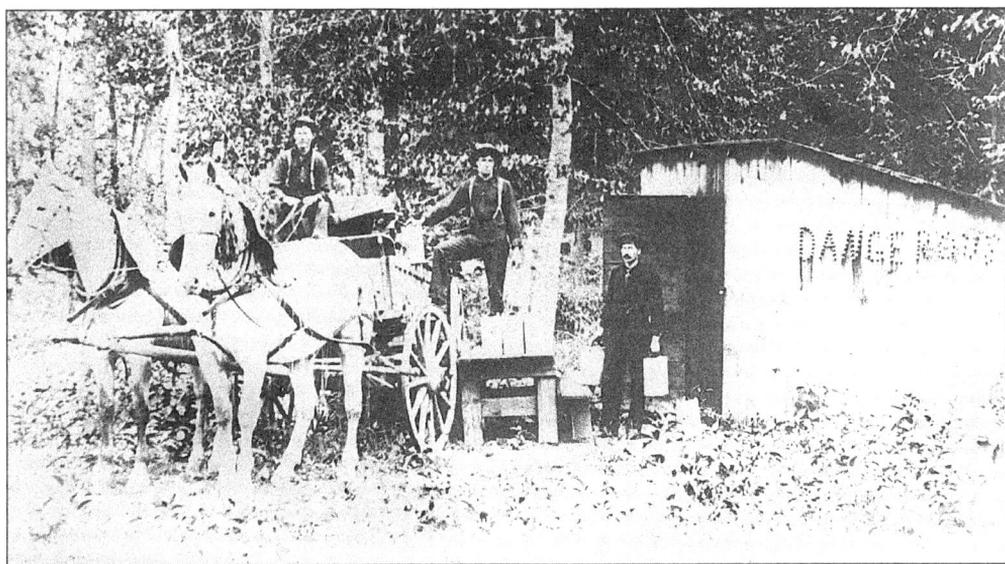

Because nitroglycerin was so unstable, its storage inside Tulsa was prohibited. However, the surrounding countryside was dotted with nitroglycerin sheds like this one. The shooter and his helpers transported the nitroglycerin to the wells in special wagons containing padded boxes. Nonetheless, the life of a shooter was often short, as the slightest jolt or spark of electricity could touch off an explosion. (Courtesy American Petroleum Institute.)

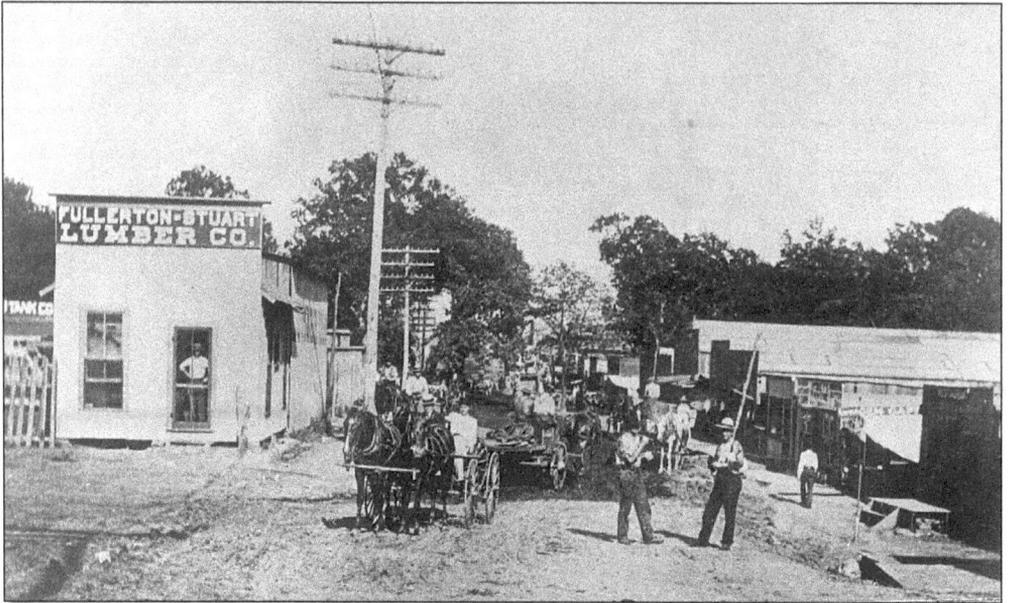

Kiefer, just to the south of Tulsa, was another area boomtown created by the rush for black gold. Its mud streets and wooden sidewalks were filled with oil field workers, promoters, and oil scouts, as well as a host of gamblers, prostitutes, bootleggers, and con men. Most of the undesirables concentrated in a section known as the Bowery. Here a worker could find saloons, brothels, dance halls, and gambling dens. (Courtesy PennWell Publishing Company.)

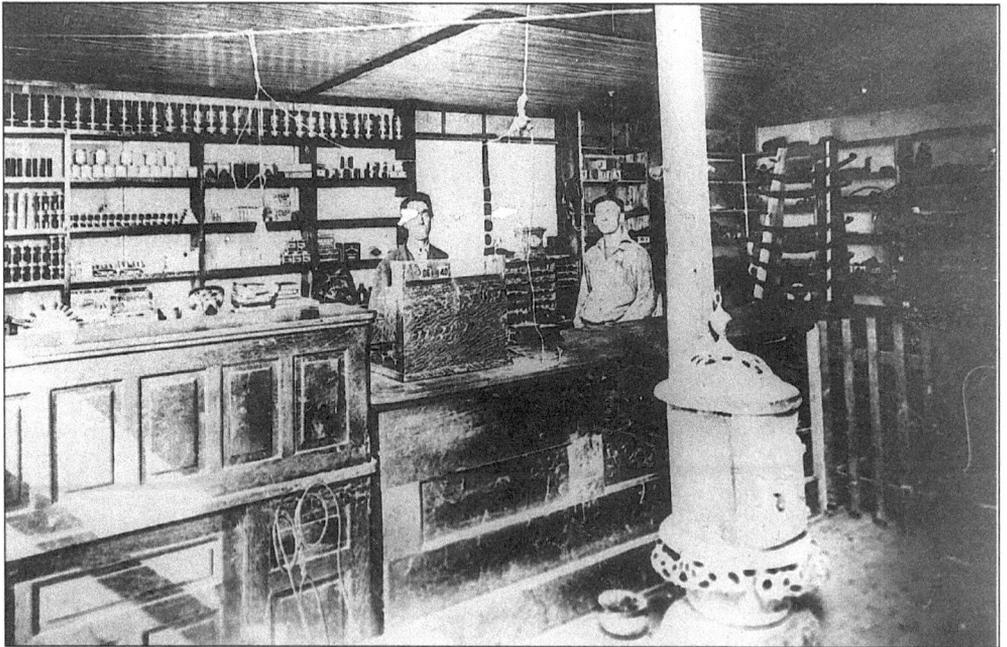

Such establishments as this general store at Kiefer carried a myriad of supplies for the oil field workers. A large stove dominated the store and although a cuspidor was provided, it is obvious from the tobacco stains on the floor that not all took advantage of it. (Courtesy Sapulpa Historical Museum.)

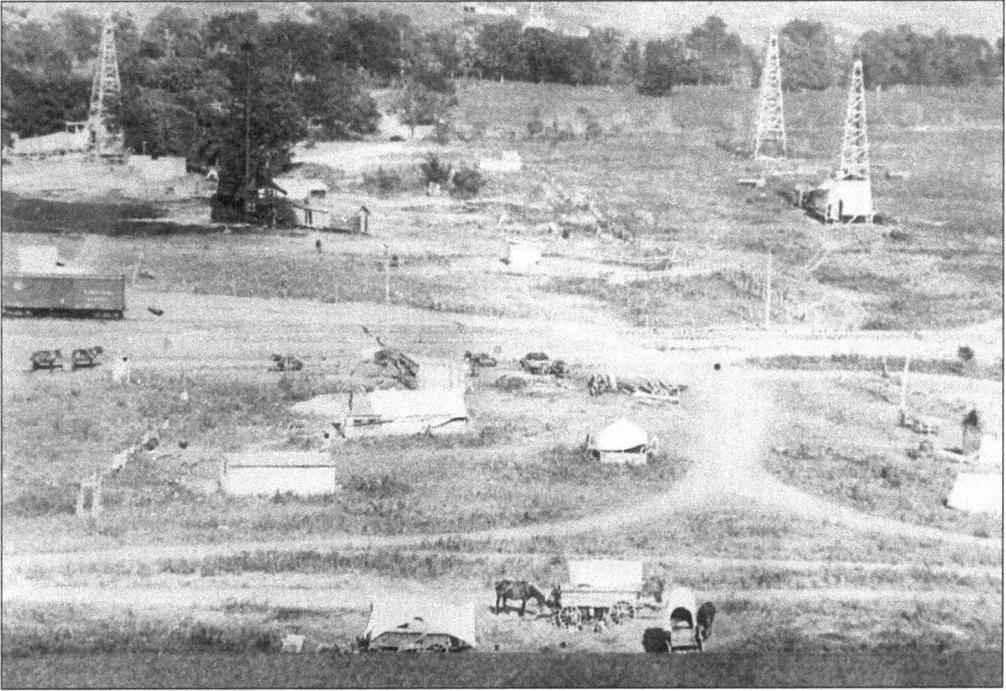

A new well site is being prepared at Glenn Pool by teams and scrapers, while rig timbers are being unloaded. One can see a shotgun house, with wash hanging on the clothes line, near the well site. The covered wagons in the foreground were used to transport perishable supplies. (Courtesy Western History Collections, University of Oklahoma Library.)

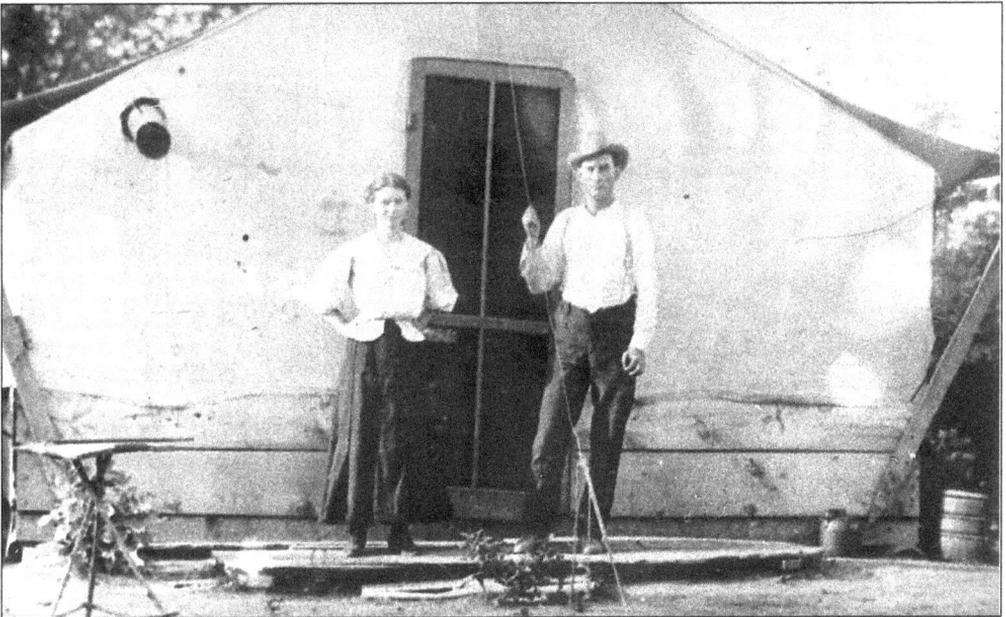

Mr. and Mrs. E. Self of Glenpool, who were among the first settlers of the Glenn Pool area, are standing in front of a tent which was typical of the oil fields. The tent community was known as Rag Town. (Courtesy Oklahoma Heritage Association.)

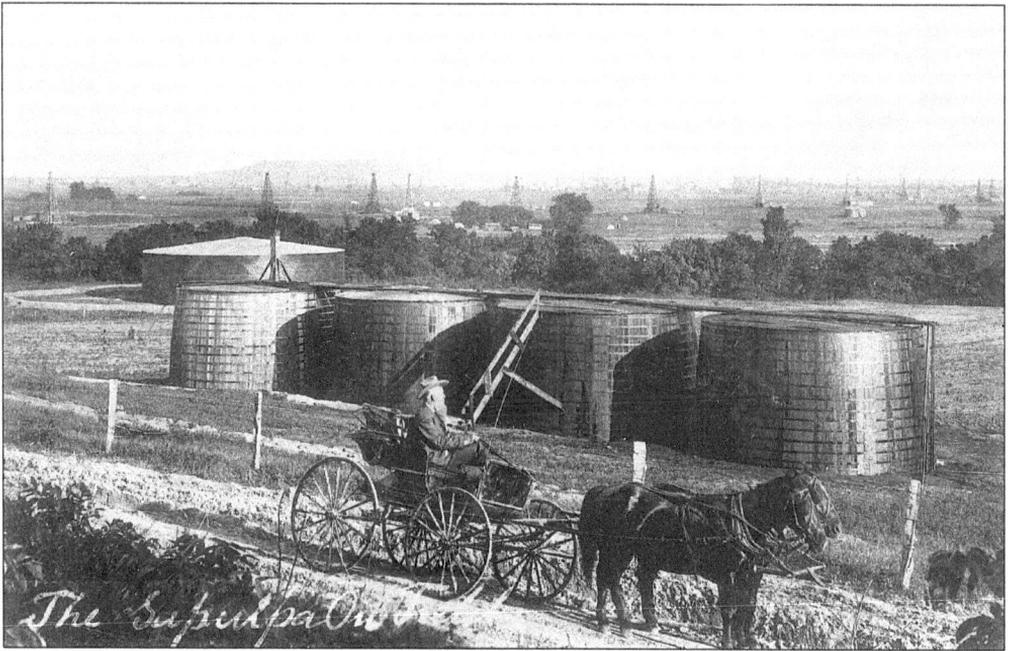

For several years the Glenn Pool Oil Field was also referred to by oil men as the Sapulpa Oil Field. The field was famous for its low number of dry holes. Production was so great that output quickly overwhelmed pipeline outlets and much of the crude was diverted into storage tanks for future shipment. Many, like those shown in this photograph, had covered tops to prevent evaporation. (Courtesy Oklahoma Historical Society.)

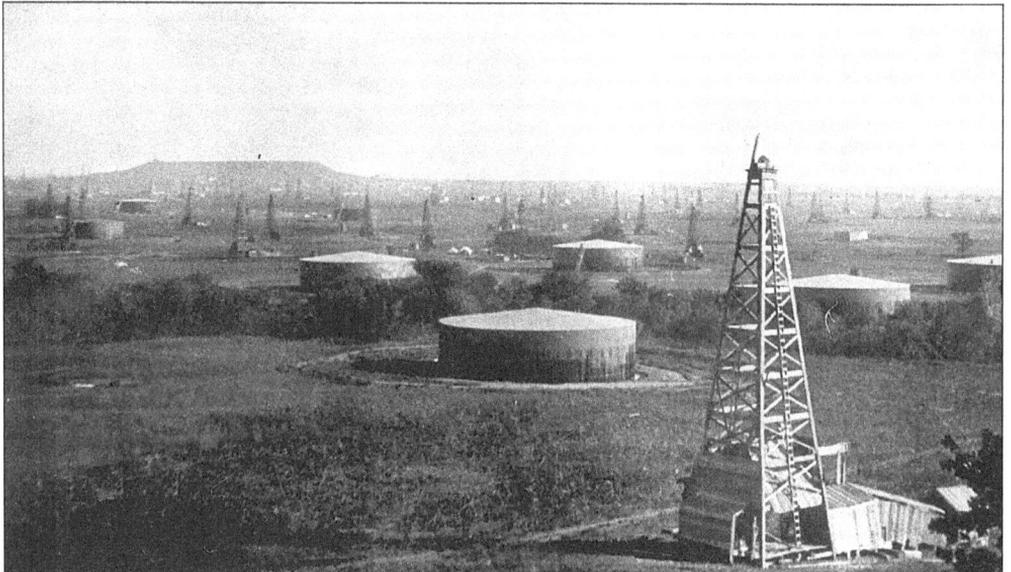

Just to the south of Tulsa was the Glenn Pool Oil Field. The production from the field was so great that its wells moved Oklahoma into first place among America's oil-producing states. Here, numerous 55,000-barrel oil storage tanks dot the landscape. Each tank is surrounded by a dike to prevent burning oil from spreading should the tanks catch fire. (Courtesy University of Tulsa, McFarlin Library.)

42

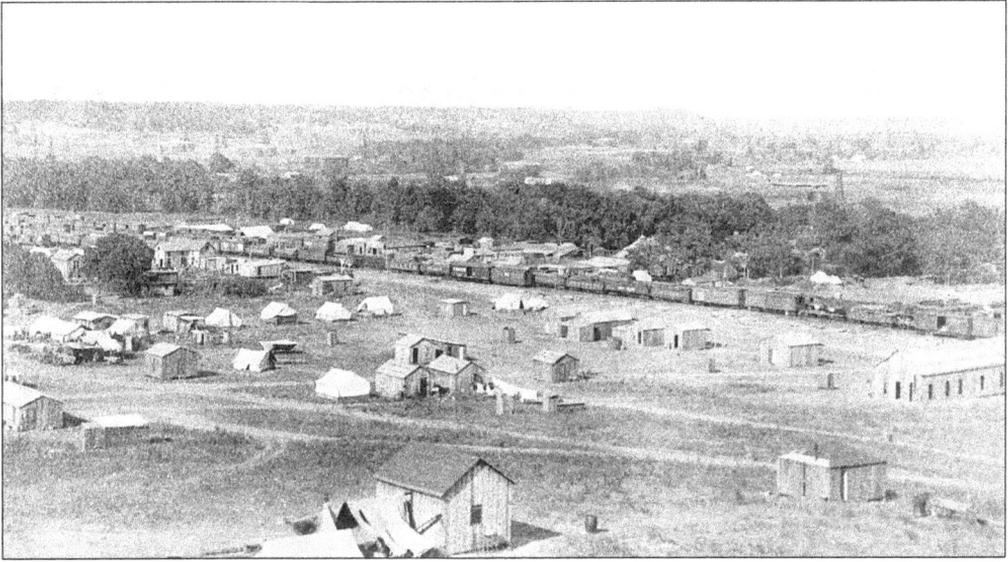

The St. Louis and San Francisco Railroad depot in Kiefer offered an outlet for Glenn Pool's crude oil prior to the completion of pipelines into the region. (Courtesy Sapulpa Historical Museum.)

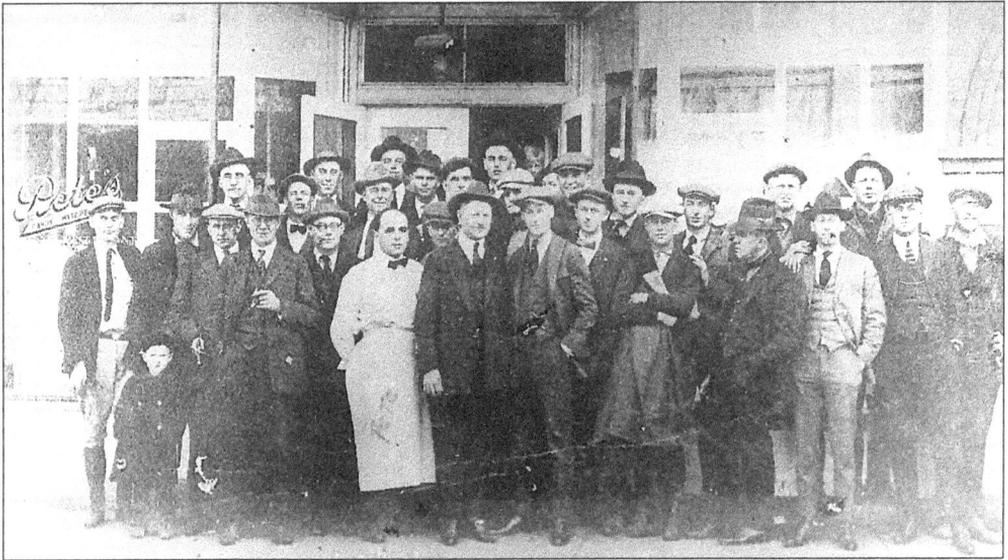

The first meeting of the Midcontinent Oil Scouts and Land Men was held in Sapulpa in November 1922. The Oklahoma oil fields were part of the huge Mid-Continent Oil Region, which stretched from central Texas across Oklahoma to eastern Kansas. (Courtesy Sapulpa Historical Museum.)

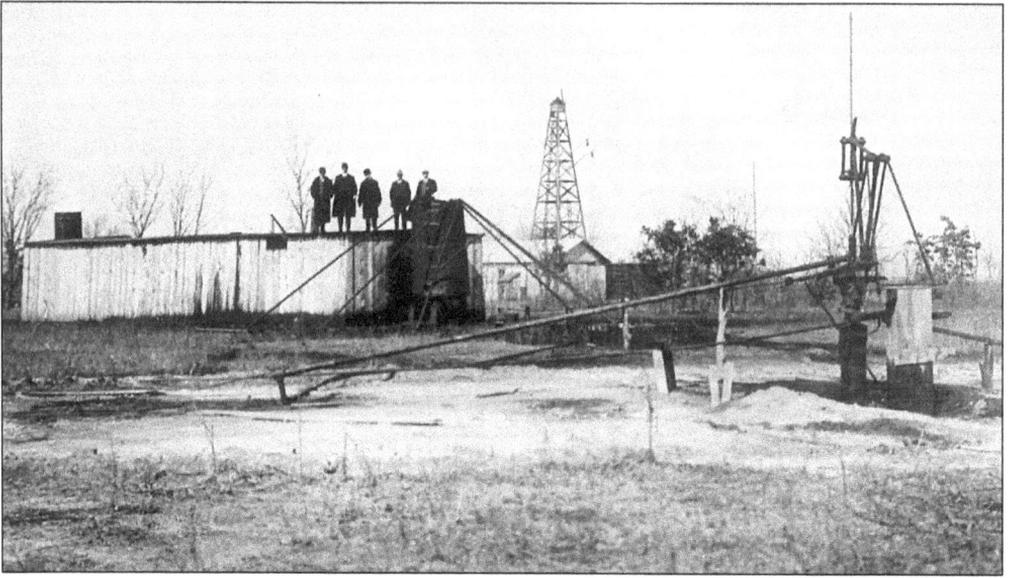

In north Tulsa, the Bird Creek Oil Field was opened in 1906 and within months claimed 1,000 producing wells. The well on the right was powered by a series of rods and pulleys that ran throughout the field from the powerhouse on which the men are standing. If you look carefully, you can see the power rod running from the house to the well. (Courtesy Beryl D. Ford.)

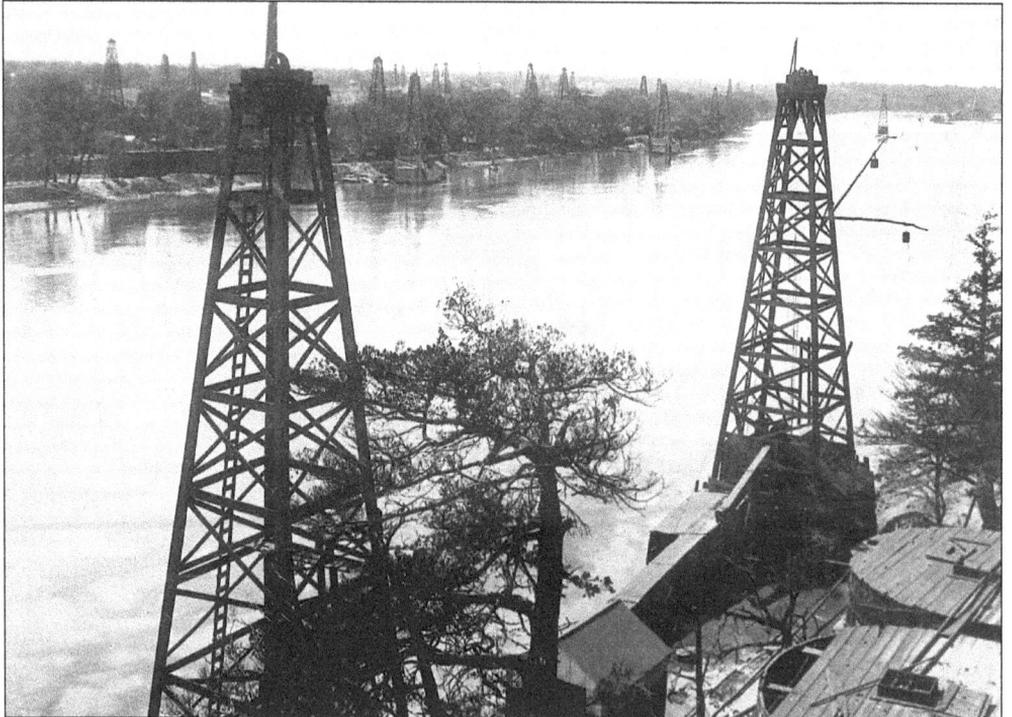

In 1912, the prolific Cushing Field was located just west of Tulsa. It quickly became the tenth largest field in America prior to 1950. By 1919, Cushing was producing 17 percent of all the oil marketed in the United States. (Courtesy Beryl D. Ford.)

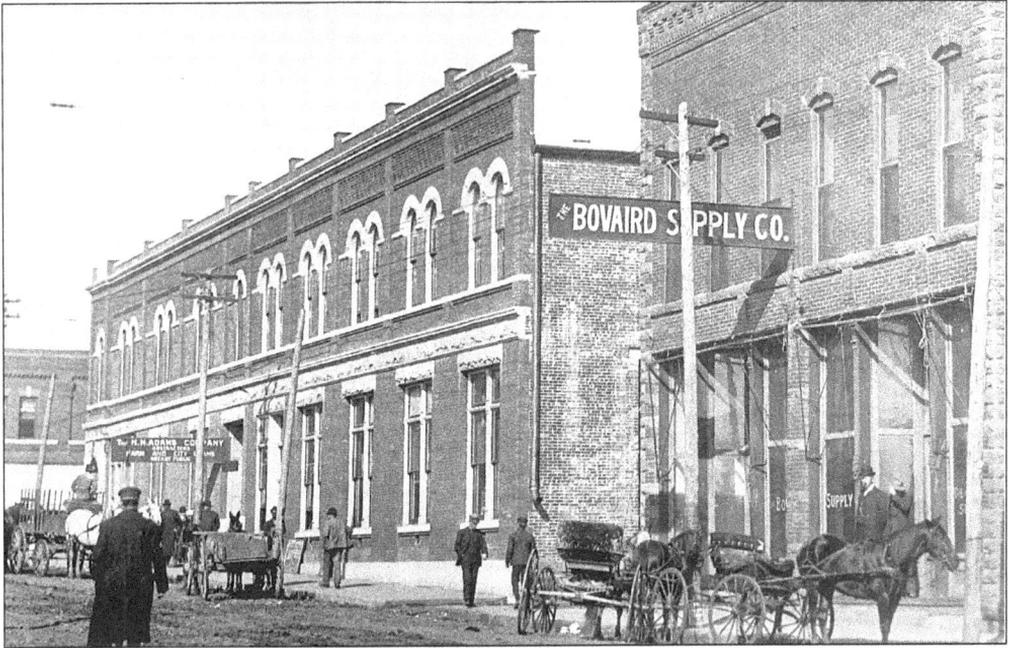

Bovaird Supply Company on Hobson Avenue in Sapulpa was a major supplier of oil field equipment in the early development of the Mid-Continent Region. The firm's Sapulpa store was established in 1907 and was the first such store outside of Kansas. It quickly expanded to also include a warehouse and repair shop for equipment. (Courtesy Oklahoma Historical Society.)

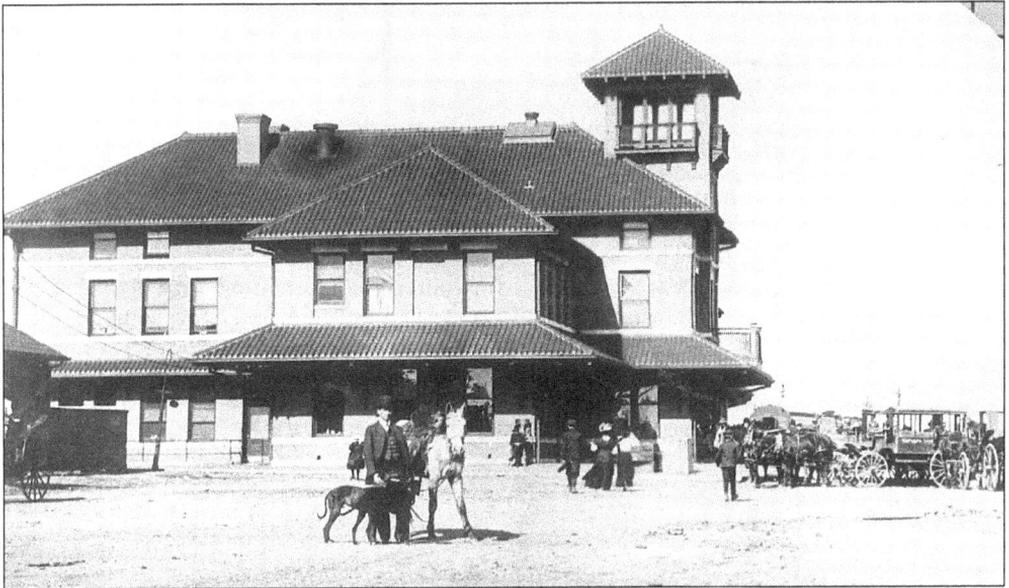

At the height of the oil boom, 30 trains a day ran between Tulsa and Sapulpa. To handle the tremendous increase in traffic the St. Louis and San Francisco Railroad constructed a modern new depot and yard facilities at Sapulpa. This was the terminus of four passenger and freight divisions of the Frisco. The railyards contained 40 miles of track and had a payroll of nearly $125,000 a month. (Courtesy Oklahoma Historical Society.)

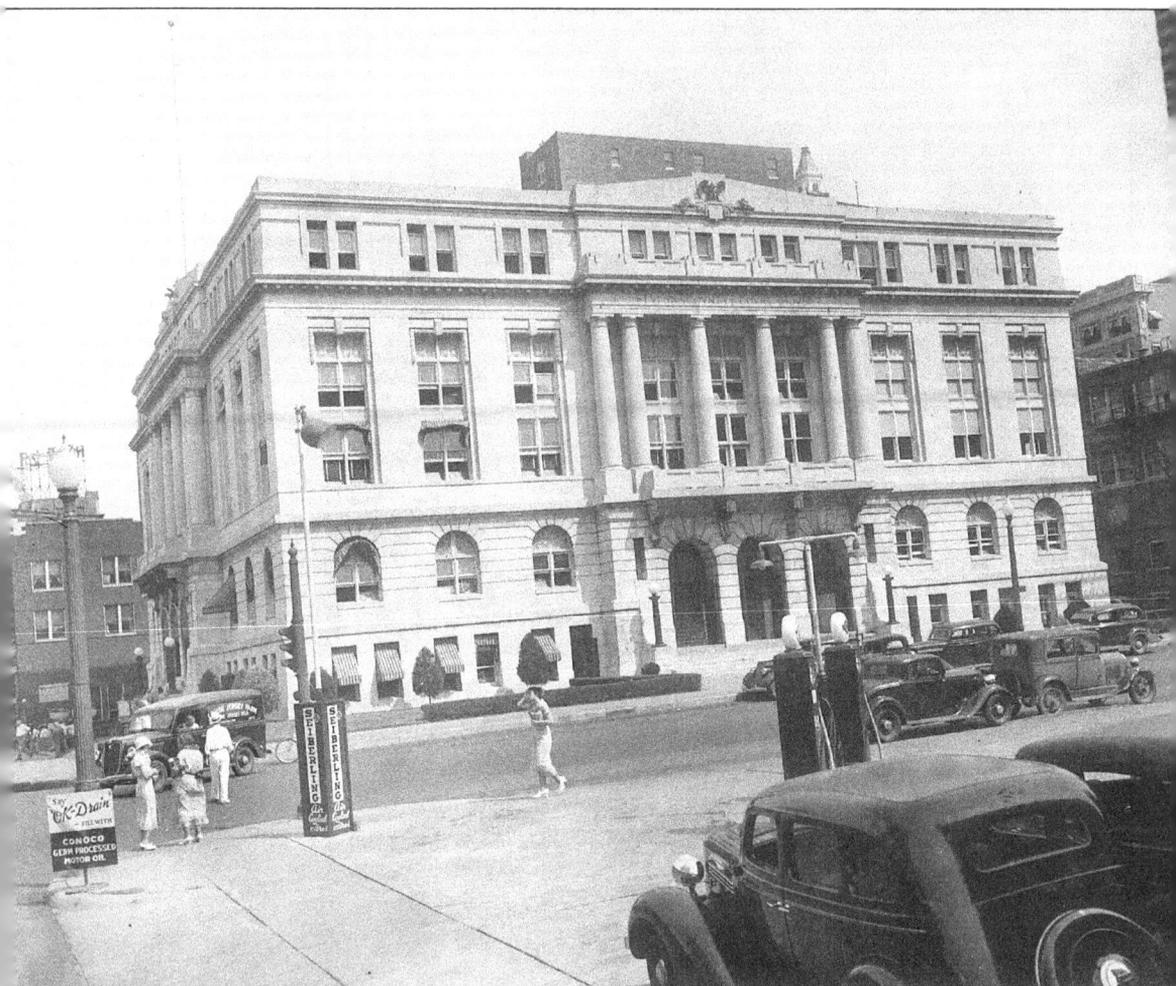

Tulsa's rapid growth was not all glitter and gold. The city also suffered pain and turbulence. Located at the corner of Sixth Street and Boulder Avenue, the Tulsa County Courthouse was built between 1910 and 1911. The jail on the roof of the courthouse was the location in which a 19-year-old black man, Dick Rowland, was held after a confrontation with a 17-year-old white woman, Sarah Page. Following the publication of an inflammatory editorial in the *Tulsa Tribune*, a riot broke out on May 31, 1921. To protect Rowland, the elevator was disconnected and the steel door barring the narrow stairs to the jail was padlocked. Assault charges were never filed against Rowland. (Courtesy *The Daily Oklahoman*.)

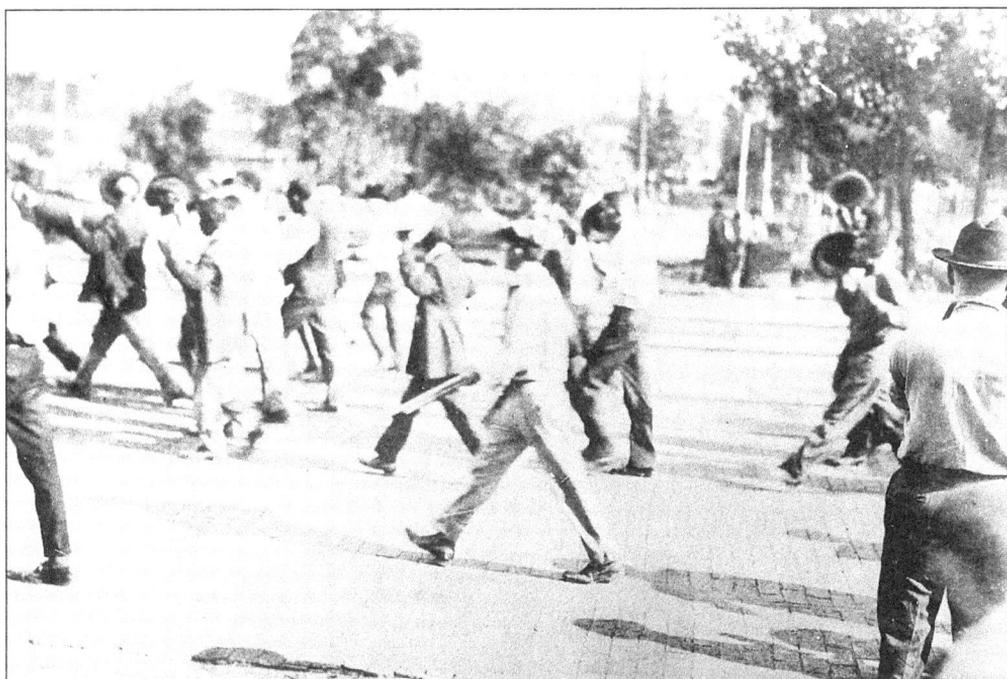

Hundreds of special deputies were commissioned by Tulsa officials during the 1921 race riot, which lasted from approximately 10 p.m. May 31, 1921, to June 2, when order was restored. One of the special deputies, the man in the center of the photograph armed with a shotgun, escorts black men to a holding area in the Tulsa Convention Center. (Courtesy Brenda Martin.)

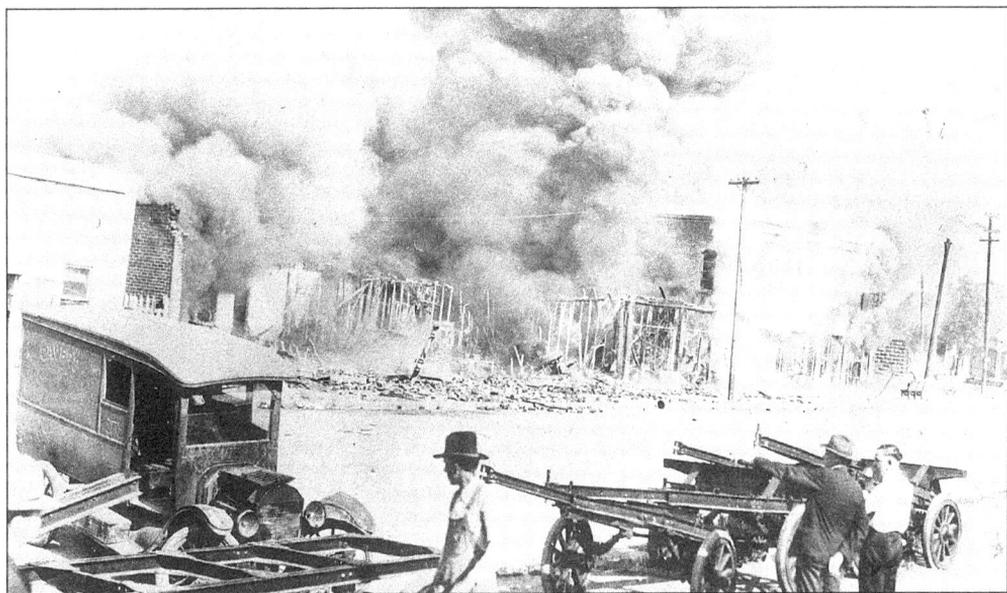

Thirty-five blocks of black-owned businesses and homes in the Greenwood District were destroyed by fire during the 1921 race riot. It was not until the Oklahoma National Guard restored order that the Tulsa Fire Department, accompanied by guardsmen for protection, was able to enter the region and extinguish the flames. (Courtesy Brenda Martin.)

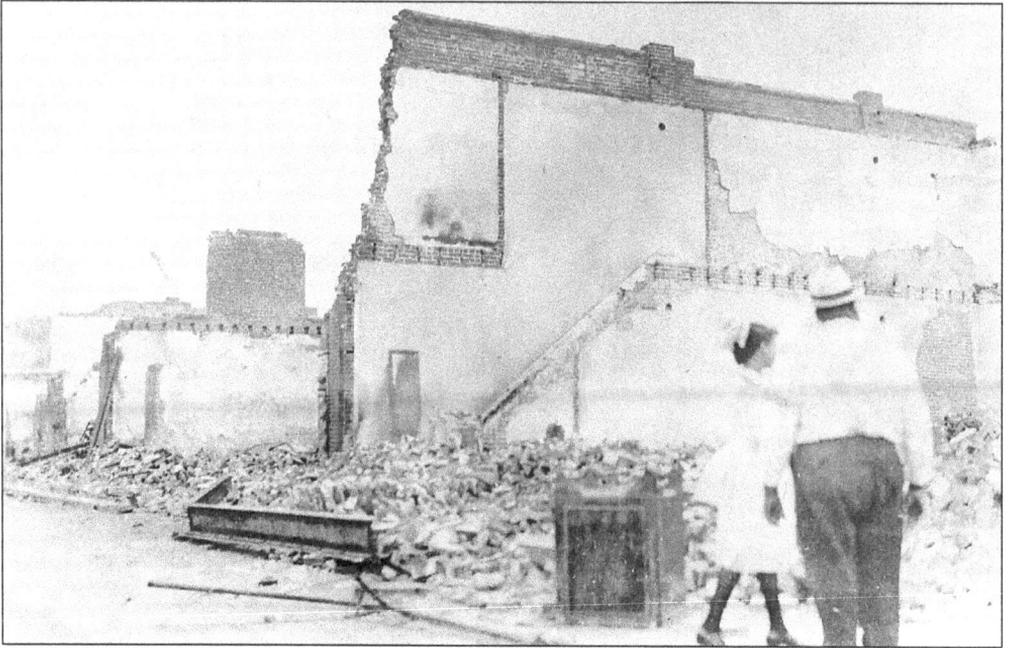

Two spectators, one a nurse, view what is left of the black hospital, located in Tulsa's Greenwood District. The hospital was one of the many buildings destroyed in the area during the 1921 race riot. (Courtesy Brenda Martin.)

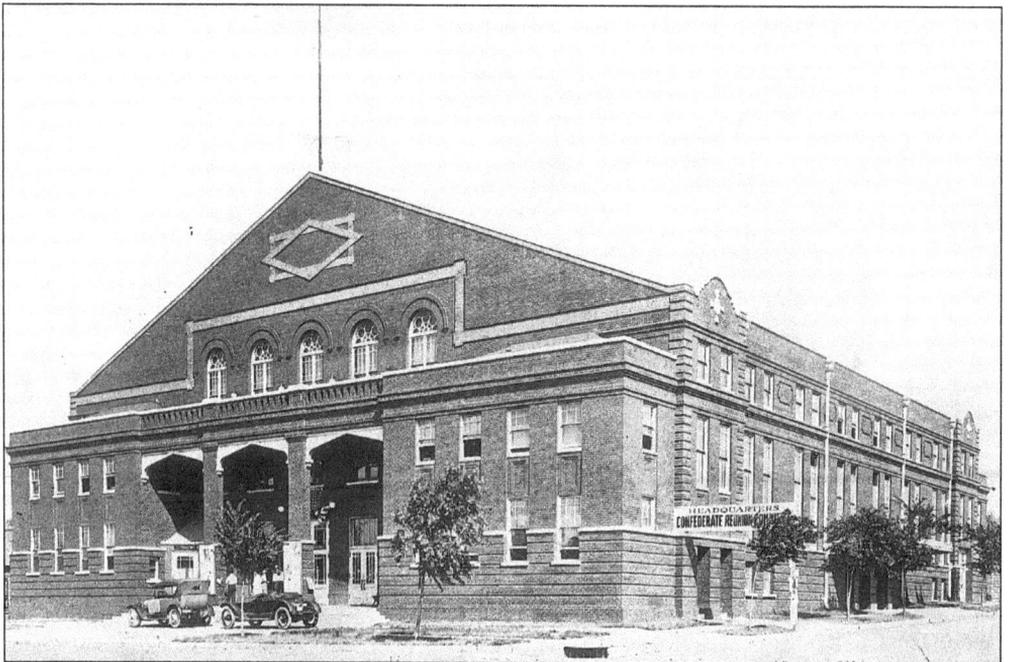

During the Tulsa race riot of 1921, several thousand black Tulsans sought refuge in the Tulsa Convention Hall, located at the intersection of Boulder and Brady Avenues. However, in this photograph taken in September 1919, it served as the headquarters for a Sons of Confederate Veterans reunion. (Courtesy *The Daily Oklahoman*.)

One of the nation's worst race riots is memorialized on this granite stone near the Greenwood Cultural Center. The 1921 riot destroyed more than 35 blocks of black-owned businesses and homes in Tulsa's black community. (Courtesy Oklahoma Department of Tourism and Recreation; photograph by Fred Marvel.)

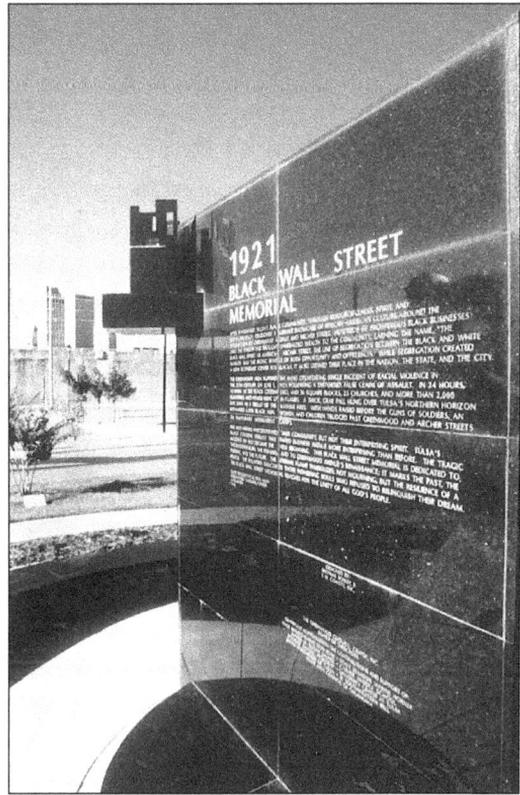

YOUR SUPPORT APPRECIATED

8 ⊙⬡⬡⊙ 3

J. C. (Jack) WALTON

DEMOCRATIC CANDIDATE FOR

GOVERNOR

SUBJECT TO PRIMARIES AUG. 1, 1922

Oklahoma Governor Jack C. Walton declared martial law over parts of Tulsa County on August 13, 1923, to counter acts of violence by the Ku Klux Klan. In his proclamation Walton declared that "a general state of lawlessness" had existed for more than a year and accused Tulsa civil authorities of being in secret sympathy with the Klan. (Courtesy Oklahoma Heritage Association.)

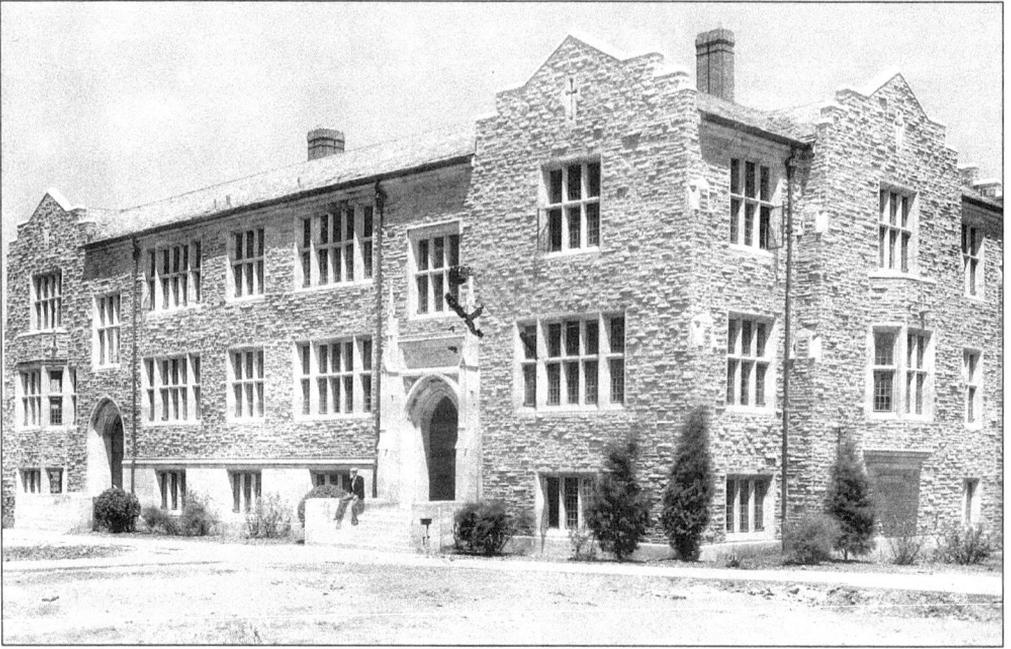

Here is the Petroleum Engineering Building on the campus of the University of Tulsa. Opened in 1928, the university's School of Petroleum Engineering draws students from major oil-producing regions worldwide. (Courtesy *The Daily Oklahoman*.)

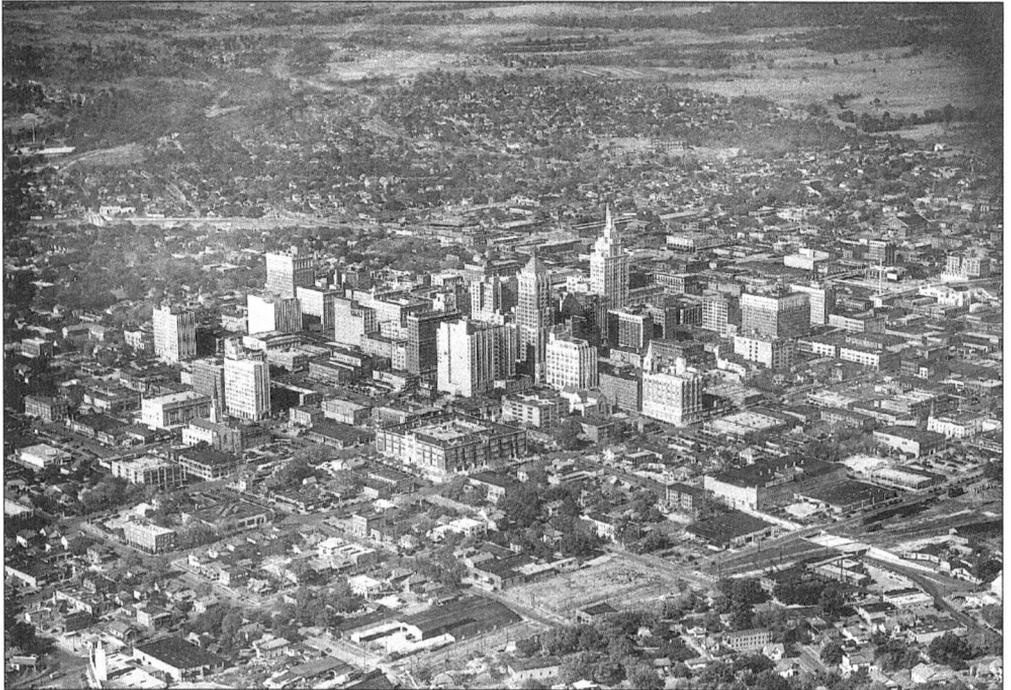

This aerial view of downtown Tulsa dates to 1937. By then, Tulsa had matured into a modern cosmopolitan city; however, note the surrounding farmland that was still undeveloped. Tulsa often bills itself as the "Biggest Little City in America." (Courtesy *The Daily Oklahoman*.)

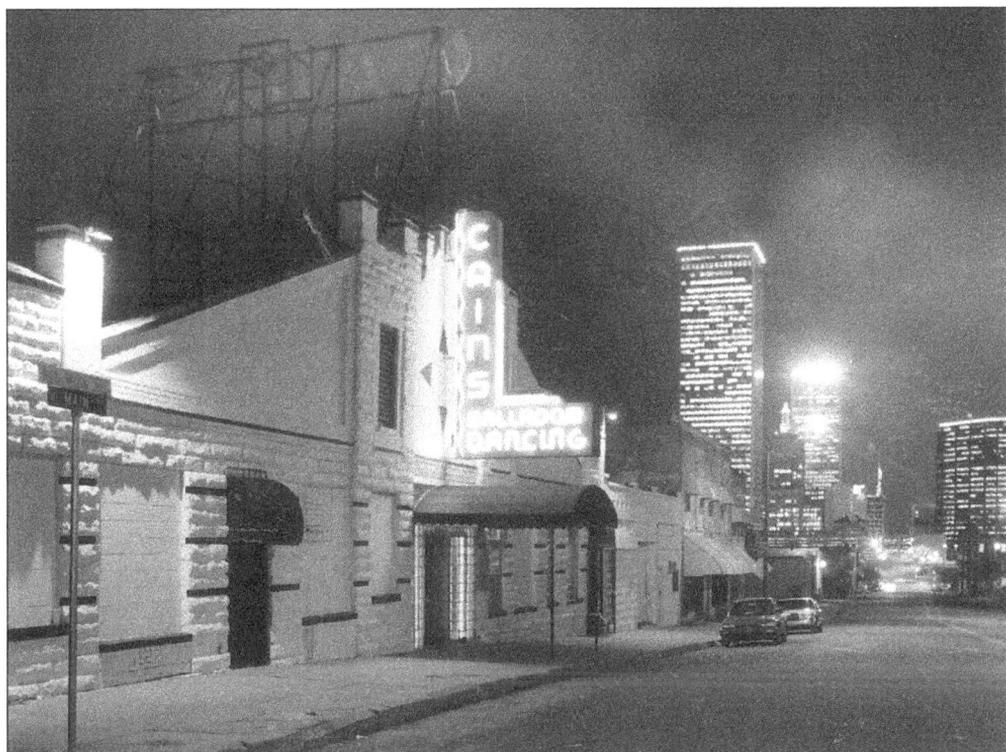

The historic Cain's Ballroom at 423 Main Street in Tulsa was the birthplace of Western Swing Music, and also where Bob Wills made "Take Me Back to Tulsa" the community's theme song. (Courtesy Bob McCormack, Inc.)

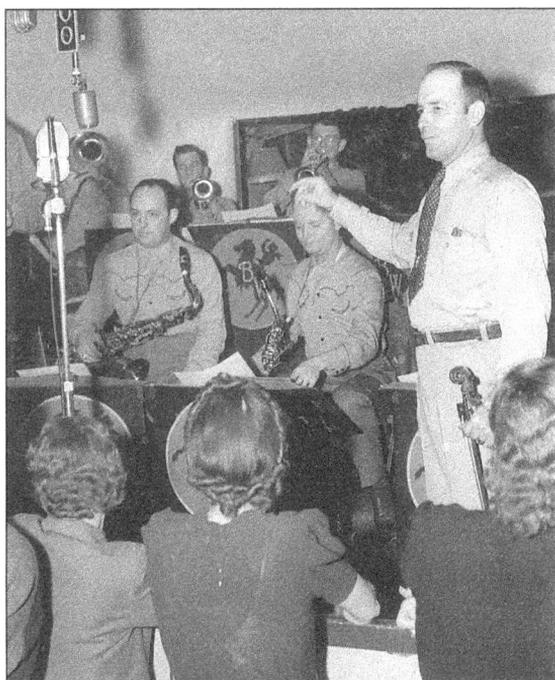

"Sag-bellied, cigar-chewing, tight-trousered" Bob Wills fiddled away with his Texas Playboys on the stage of Cain's Ballroom in Tulsa, which proclaimed that it was the "Home of Bob Wills." Starting in 1934, Tulsa radio station KVOO broadcast the Wills brand of Western Swing live from Cain's Ballroom to a far-flung audience. (Courtesy Bob McCormack, Inc.)

Johnny Lee Wills, on the left, took over the music at Cain's Ballroom when Bob Wills accepted an offer to star in Hollywood movies. He continued the popular Western Swing sound much to the delight of Tulsans. (Courtesy Bob McCormack, Inc.)

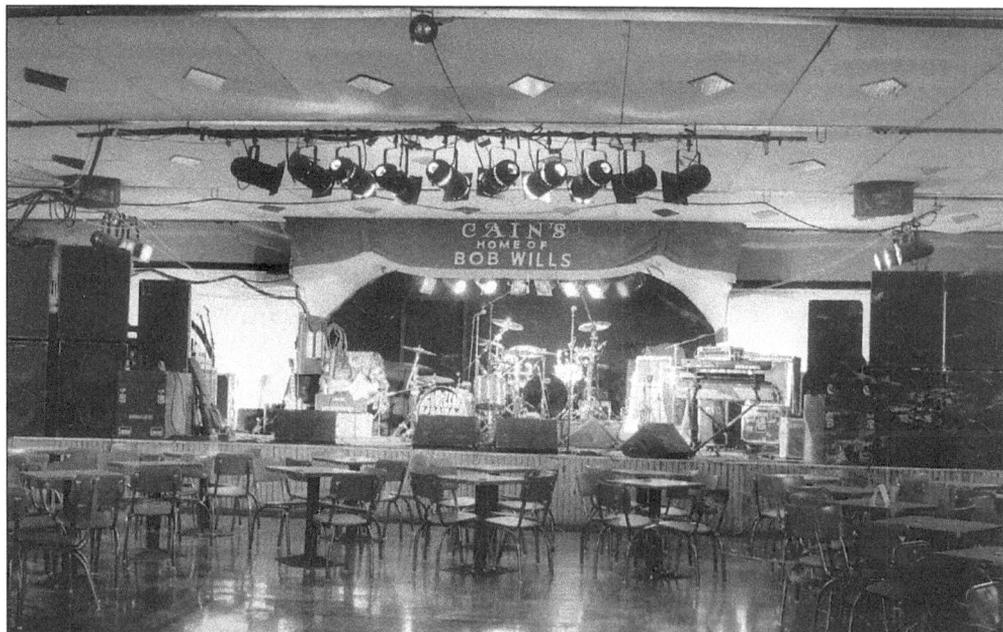

The dance floor of Cain's Ballroom in Tulsa, the "Home of Bob Wills," was suspended on truck springs so that it would move to the beat of the music as customers danced. (Courtesy Bob McCormack, Inc.)

Three

OIL CAPITAL OF THE WORLD

It was petroleum that transformed Tulsey Town from a rural frontier community into a modern urban environment. Early settlers had long been aware of natural oil seeps south and west of Tulsa near Red Fork, Sapulpa, and Glenn Pool. The first well in the area blew in as a gusher on June 24, 1901. It was drilled in Red Fork and was named the Sue A. Bland No. 1.

To the south of Tulsa, Robert Galbreath discovered the Glenn Pool Oil Field on November 22, 1905. By 1907, the discovery at Glenn Pool had moved Oklahoma into the lead among oil-producing states.

Within 100 miles of the once sleepy Creek village were hundreds of oil fields, and Tulsa quickly became the refining, transport, and financial center for the development of this huge source of crude oil.

By the 1930s there were 187 oil and natural gas equipment manufacturers and supply houses in Tulsa, along with 50 drilling contractors, 40 major oil companies, and more than 400 independent oil companies.

However, as Tulsa entered the last quarter of the 19th century, the importance of the oil company lessened. In response, civic leaders began to develop a diversified economy that propelled the city into the 21st century.

53

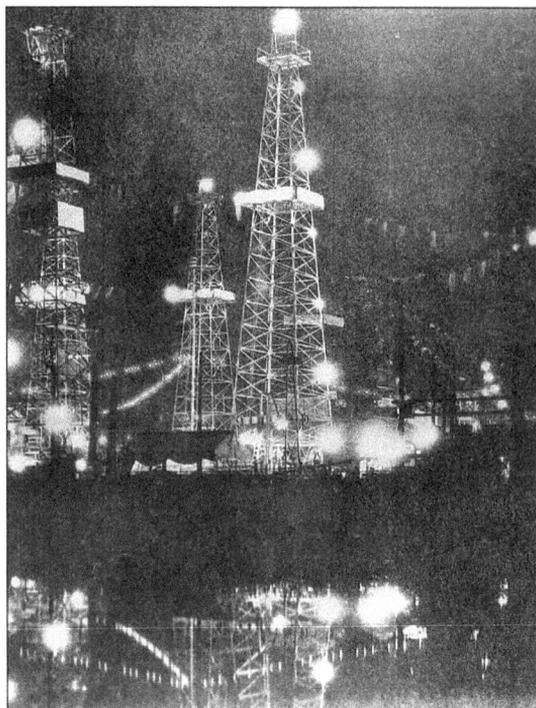

The discovery of oil transformed Tulsey Town from a rural frontier community into a modern, bustling urban environment. (Courtesy PennWell Publishing Company.)

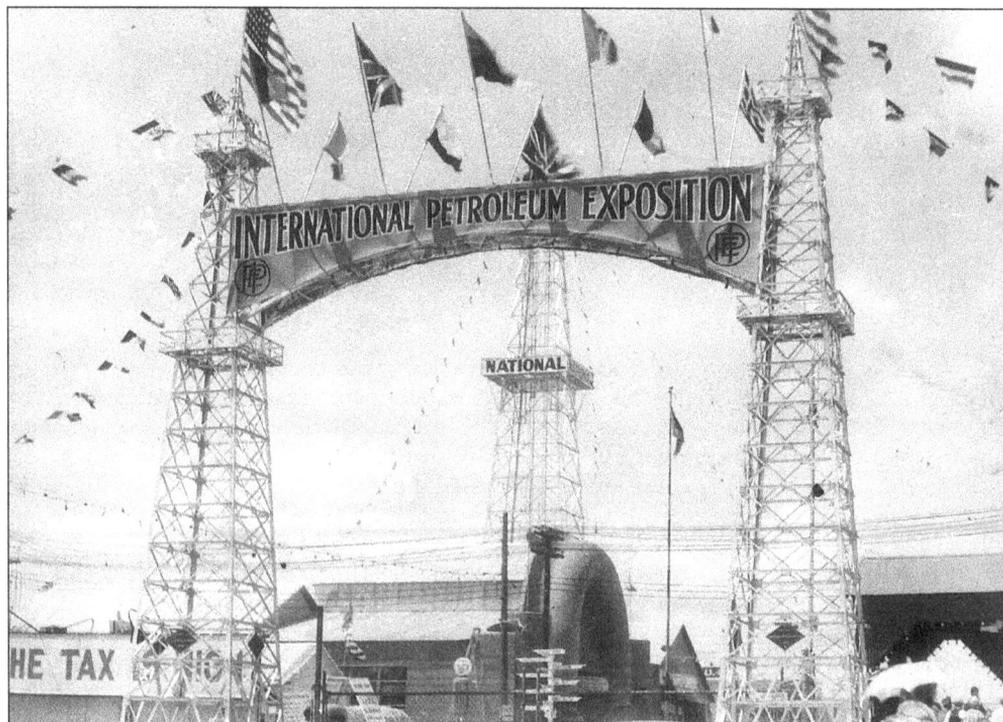

By 1923, when the initial International Petroleum Exposition was held in Tulsa, the community was calling itself the "Oil Capital of the World," and rightly so, for Oklahoma had out-produced all other states in the first three years of the Roaring Twenties. (Courtesy Beryl D. Ford.)

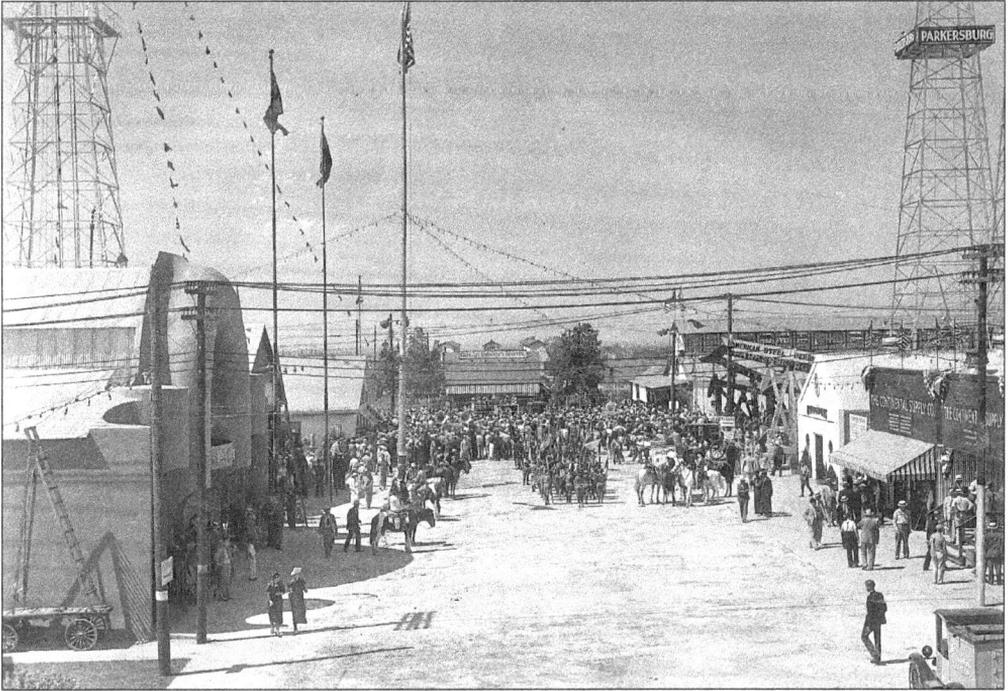

Opening day ceremonies of the 1934 International Petroleum Exposition in Tulsa were held in front of the IPE's First Aid Emergency Hospital. At the conclusion of the ceremony a group of massed Boy Scouts, visible in the center of the photograph, presented the flags of all the nations represented at the gathering. (Courtesy Beryl D. Ford.)

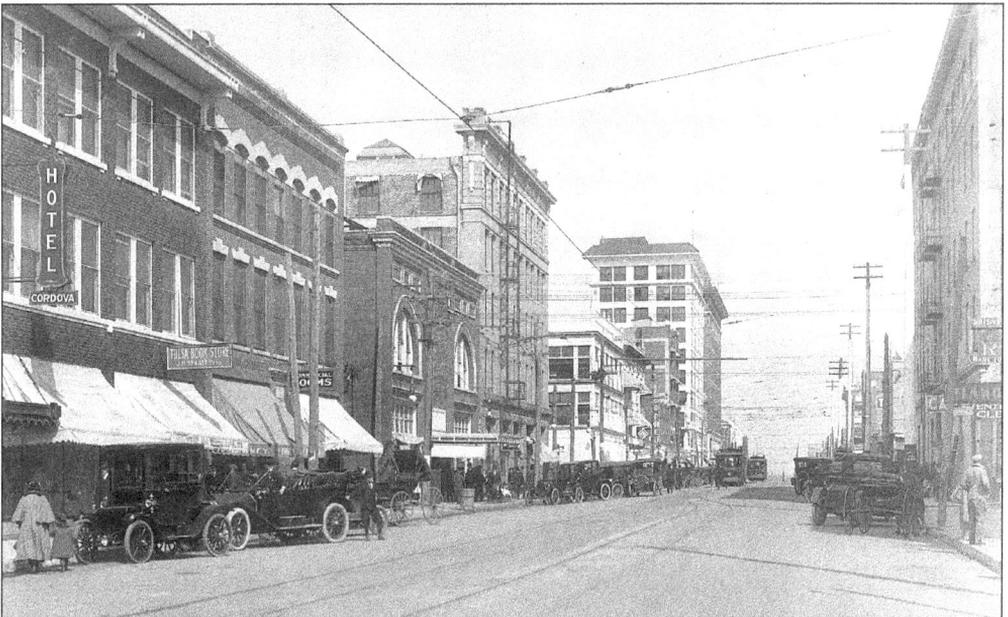

Looking east on Third Street from Boulder Avenue during the second decade of the 20th century, one notices the mix of automobiles, horse-drawn buggies, and street cars. The automobile on the extreme left is an early-day electric-powered model. (Courtesy *The Daily Oklahoman*.)

James A. Chapman, facing the camera, was one of the founders of the McMan Oil Company. Here he visits with an unidentified man. At that time, McMan Oil Company was the largest independent oil company in the United States. (Courtesy Oklahoma Heritage Association.)

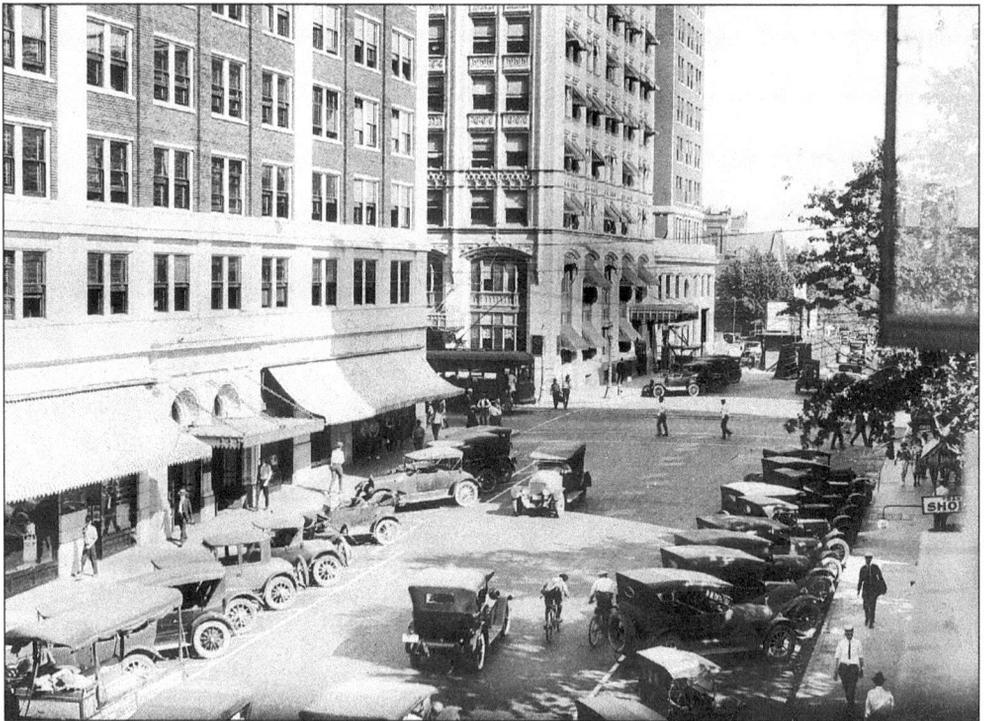

Boston Avenue in downtown Tulsa during the 1920s was one of the busiest streets in the United States. Note the horse-drawn delivery wagon operated by the American Railway Company in the lower left, and the electric-powered interurban in the center of the photograph. (Courtesy *The Daily Oklahoman.*)

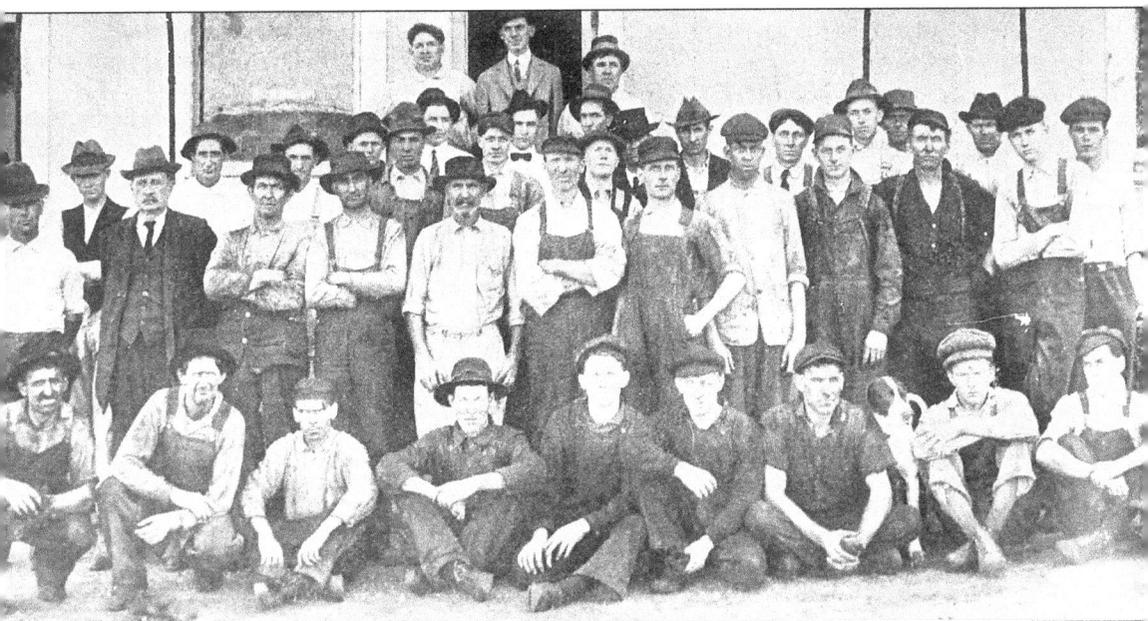

The workers at the Prairie Oil and Gas Company's Tulsa warehouse, from left to right, are as follows: (front row) H.N. Shoemaker, boiler-maker's helper; W.L. Roach, blacksmith's helper; Clarence Rhodes, hammer driver; M. Felding, boiler-maker's helper; C.F. Cox, boiler-maker's helper, John Dunlap, boiler-maker's helper; R.S. Peters, boiler-maker; "Old Bird," mascot; Irving Hughlett, machinist apprentice; and James Williford, machinist apprentice. The second row, from left to right, includes: F.L. Whitaker, yard foreman; John Flanagan, night watchman; W.H. Norwood, machinist helper; Fred Smalley, teamsters' helper; W.A. Burton, yardman; C.H. Chance, machinist helper; A. Hawkinson, machinist; G.E. Davis, floorman; J.E. Musgraves, machinist; E.M. McCann, blacksmith; and Joe Root, machinist apprentice. The third row, from left to right, includes: Fred Miller, yardman; W.E. Pearce, assistant foreman; J.O. Howard, yardman; Ed Marler, teamster; C.M. Worley, yardman; C.S. Oliver, teamster; M.C. Williford, machinist helper; F.L. Benson, machinist; George Chandler, floorman; Ray Hetzer, floorman; E.E. Clulow, floorman; Harald Hough, yardman; C.J. Buller, carpenter; J.H. Reed, machinist helper; and Tom Cline, pattern-makers' apprentice. The fourth row, from left to right, includes: J.E. Winger, operator; L.D. Armstrong, clerk; and Robert Jacobs, carpenter. Lastly, the back row includes, from left to right: M.J. Flanagan, foreman, boiler department; F.S. Gray, general foreman; and T.J. Flanagan, foreman of the matching and blacksmith shops. (Courtesy *Oil and Gas Journal*.)

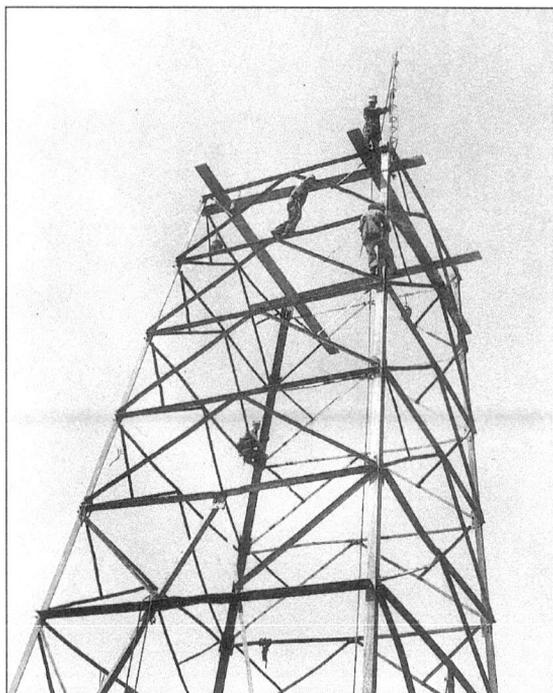

The more modern steel rigs were constructed of pre-cut pieces. Many rig builders considered safety belts to be unnecessary and clumsy. None of the men on this job are wearing any. The buckets hanging from the braces are full of bolts used to fasten the pieces together. The man on the top right is using a crude crane to pull additional pieces to the workers from the ground. (Courtesy Cities Service Oil Company.)

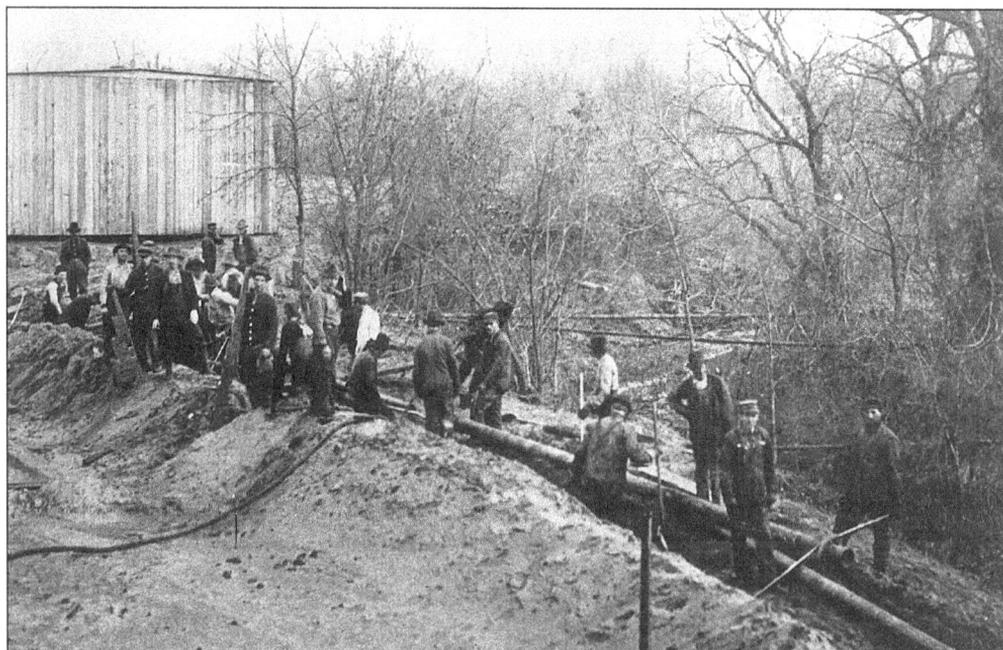

A pipeline gang working in the oil fields around Tulsa is connecting the ends of a screw-type pipeline. To connect the pipe sections, the crew uses the long tongs, which can be seen on the right, to screw the pipe together, while a "collar pecker" beats on the pipe with a hammer to make sure of a snug fit. The connection of West Tulsa to the surrounding oil fields and of Tulsa to outlets on the Gulf Coast and Great Lakes made the community a major oil refining center. (Courtesy University of Tulsa, McFarlin Library.)

J. Paul Getty, often called the "richest man in the world," got his start in the oil business in Tulsa. His father, George Getty, was an early-day Oklahoma oil man, and in 1914 he formed a partnership with his son. Based out of a $6-per-week room in Tulsa's Cordova Hotel, and with another $6 a week budgeted for food, the younger Getty scouted the surrounding areas for oil leases. Once J. Paul secured the lease his father would furnish the money for its development in exchange for a 70 percent share in the well. (Courtesy Oklahoma Heritage Association.)

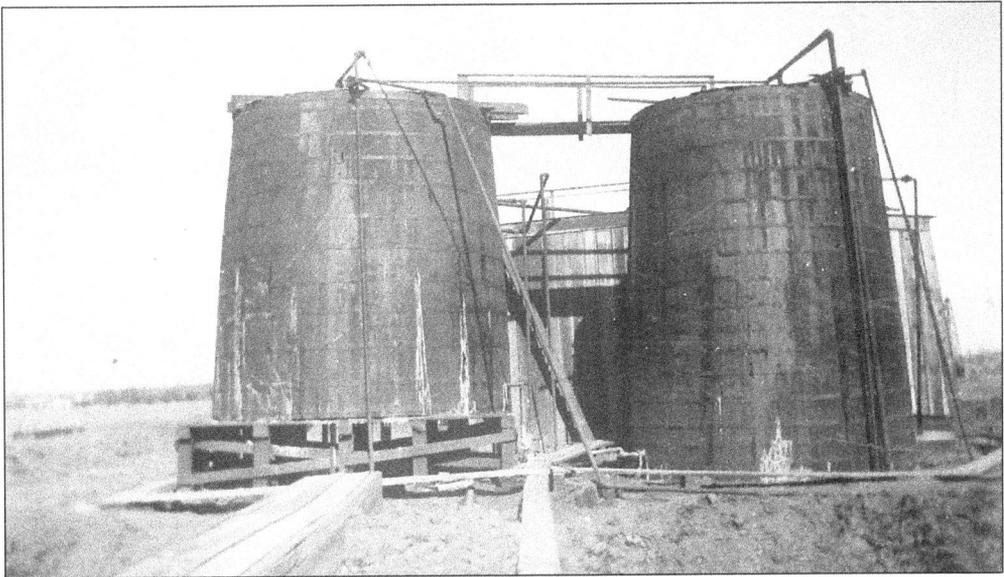

Wooden storage tanks such as these leaked badly and were notorious for catching on fire and burning quickly. They were doubly dangerous because rats would build nests beneath them, and when the tanks caught on fire, the burning oil would overflow, setting the rats on fire. The frightened rats would then run from beneath the burning tanks and seek shelter under other nearby tanks, thus spreading the flames. (Courtesy Getty Refining and Marketing Company.)

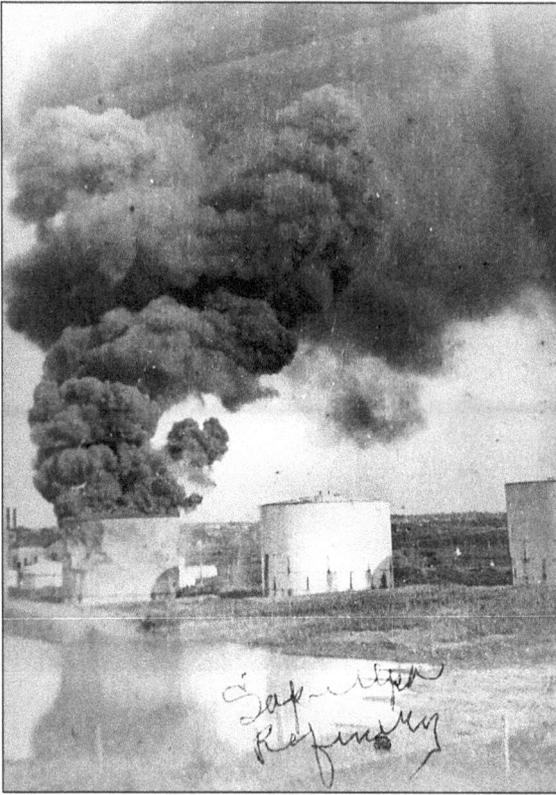

Oil storage tank fires were a common occurrence in the boom days. This one is taking place at the Sapulpa Refining Company tank farm. (Courtesy Sapulpa Historical Museum.)

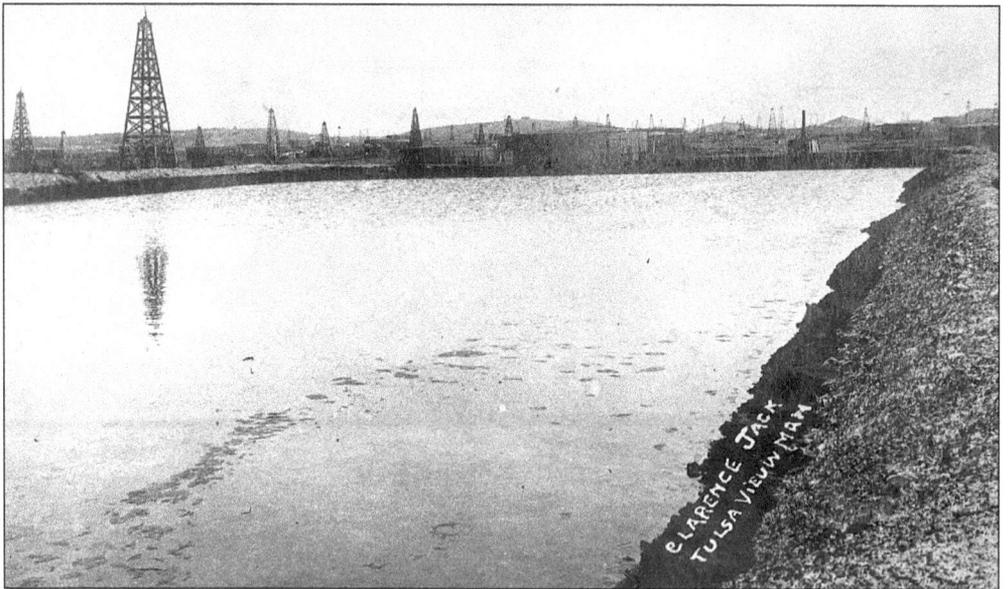

Earthen storage pits such as this one were a cheap and quick way to store excess crude. Much of the oil was lost through seepage or evaporation. Oil man Charles Colcord recalled that the huge lakes attracted thousands of wild ducks that died after landing in the oil. (Courtesy University of Tulsa, McFarlin Library.)

The Philtower building is another landmark in Tulsa built by oil money. It was constructed by oil man Waite Phillips, brother of Frank and L.E. Phillips, who founded the Phillips Petroleum Company. Waite was an outstanding independent oil man and philanthropist. (Courtesy Beryl D. Ford.)

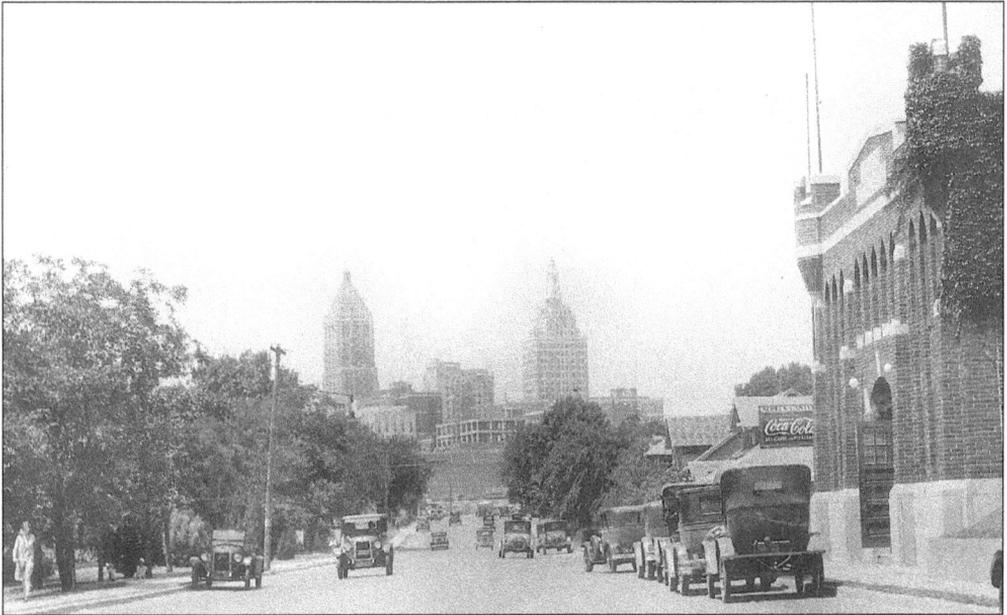

This photograph looks west from Tulsa's Central Park along Sixth Street during the Roaring Twenties. In the center background is the Cosden Building, on the right is the Exchange National Bank Building, and on the left is the Philtower. Known as the "Prince of Petroleum" for his flamboyant lifestyle, Josh Cosden made and lost two $50 million fortunes and died broke. (Courtesy *The Daily Oklahoman*.)

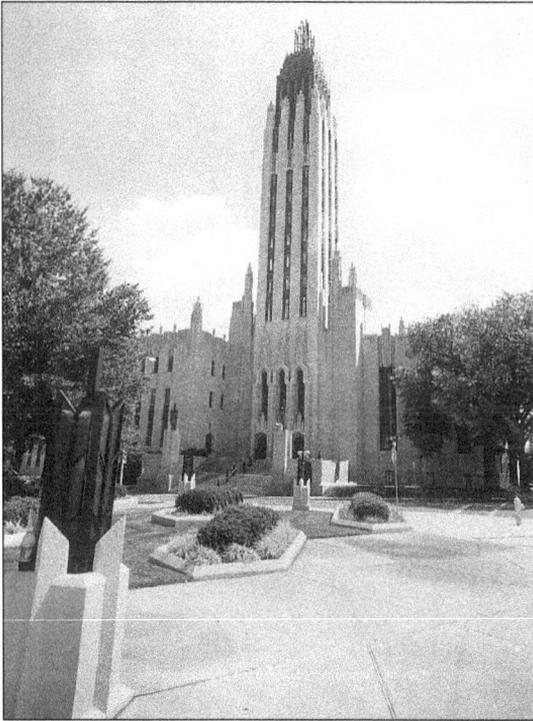

Office buildings and impressive homes were not the only things being built in Tulsa with oil money during the booming 1920s and 1930s. Churches also flourished. Tulsa's Boston Avenue Methodist Church was completed in 1930. The $1.4 million building housed the only skyscraper-designed church in the world. (Courtesy Judy Dawson.)

This stained-glass window in the Trinity Episcopal Church in downtown Tulsa is known as "Hell's Window." From high in the clerestory, the face of Jesus looks down upon Hell in which can be seen the faces of Adolph Hitler, Benito Mussolini, Herman Goring, Joseph Goebbels, and other Nazi leaders of World War II. (Courtesy *The Daily Oklahoman*.)

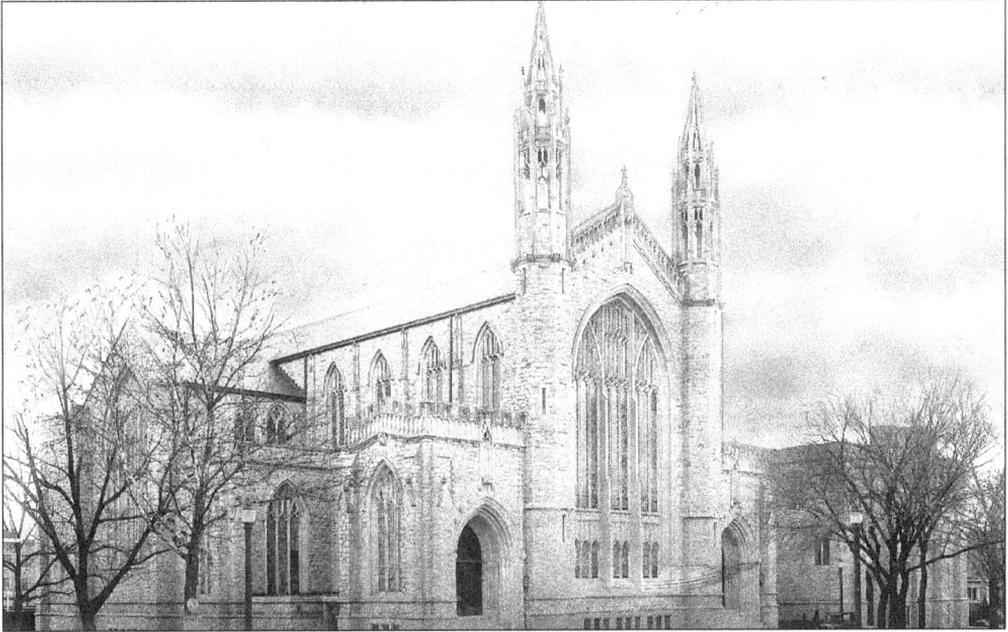

One of the oldest congregations in Tulsa, the First Methodist Episcopal Church has a colorful history. On Christmas Eve of 1887, a group of drunken cowboys gathered on the balcony of the original structure and threw whiskey bottles at the Christmas tree, and in 1888, a drunken Native American accidentally discharged his rifle inside the church. After that, the Reverend George W. Mowbray's wife stood at the door and collected rifles and pistols as the congregation entered. (Courtesy *The Daily Oklahoman*.)

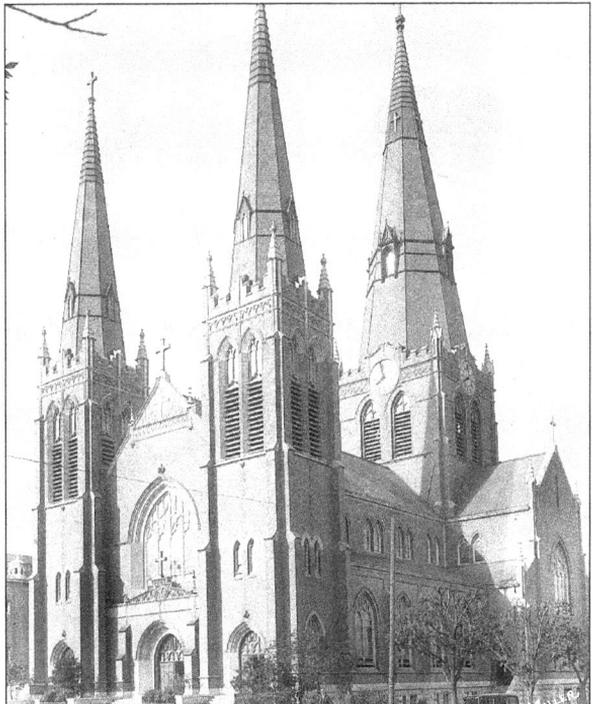

The Tulsa churches, built during the oil boom, were meant to inspire awe with their numerous spires and delicate art decor. Located at 802 South Boulder, the Holy Family Cathedral, as seen in this 1938 photograph, has long been the center of Catholic worship in Tulsa. (Courtesy *The Daily Oklahoman*.)

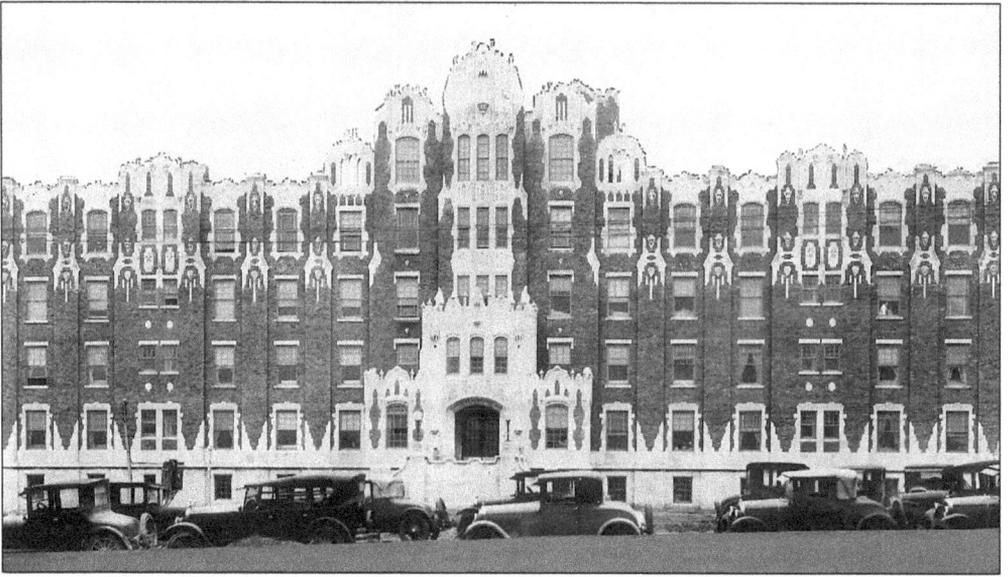

This photograph is of Tulsa's Morningside Hospital at 1653 East Twelfth Street as it appeared in December of 1930. The hospital contained a fully accredited, three-year training school for nurses, and housed 225 patient beds. (Courtesy *The Daily Oklahoman*.)

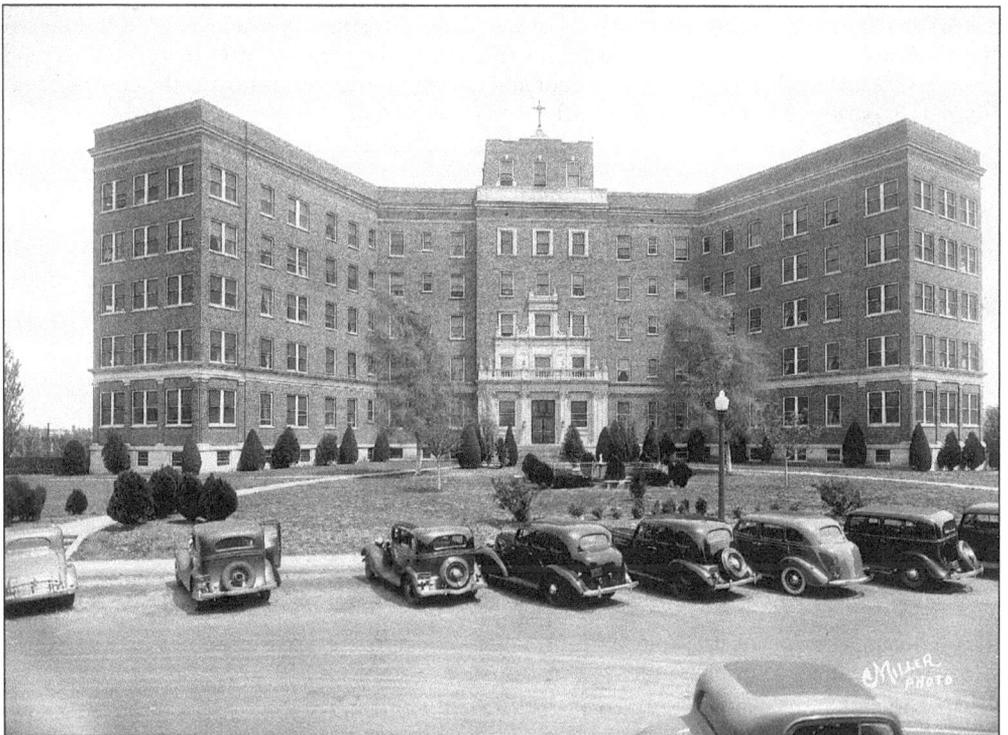

Owned and operated by the Sisters of the Sorrowful Mother, this is a 1938 view of Tulsa's St. John's Hospital, located at 1923 South Utica Avenue. Today, the hospital is known as St. John Medical Center and is one of the state's best-known and well-equipped health care facilities. (Courtesy *The Daily Oklahoman*.)

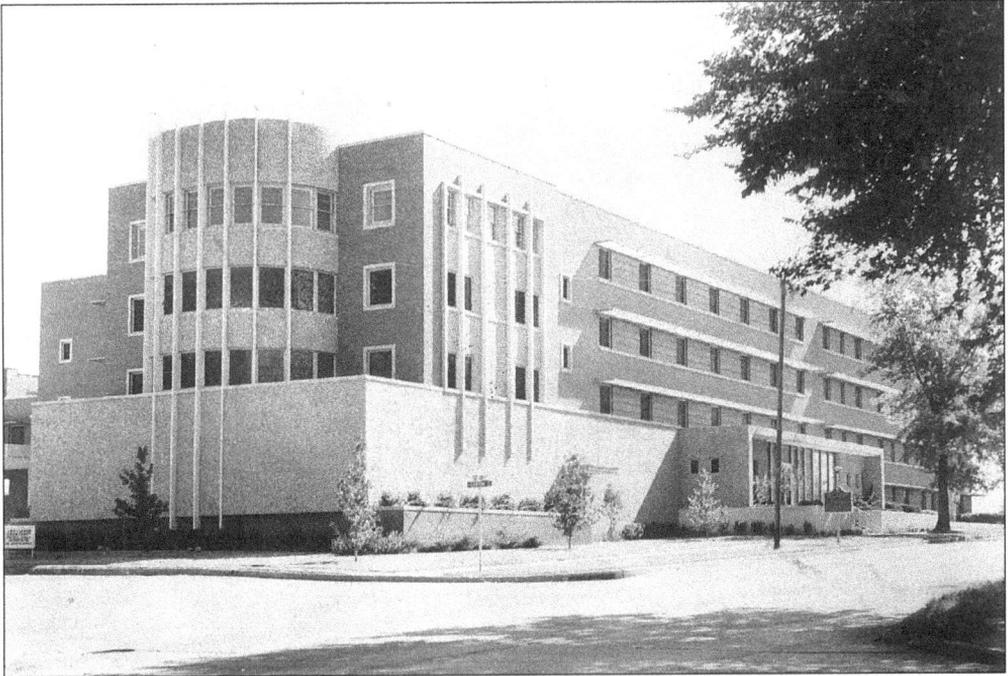

Tulsa's Columbia Regional Medical Center, formerly known as the Oklahoma Osteopathic Hospital, is located at 744 West Ninth Street. TRMC is the primary teaching facility for the Oklahoma State University College of Osteopathic Medicine and Surgery. (Courtesy *The Daily Oklahoman.*)

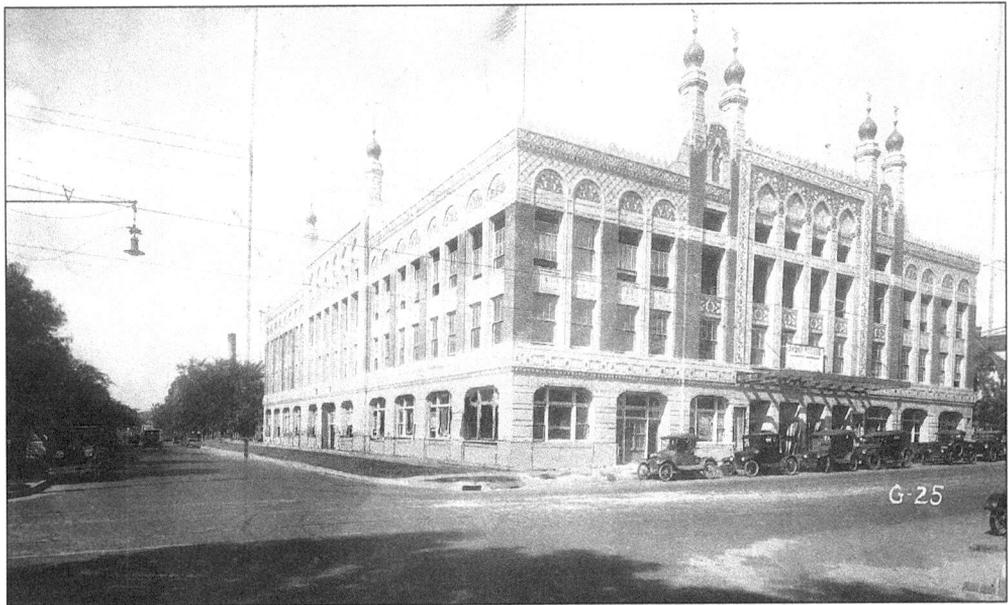

Membership in the Ancient Arabic Order of Nobles of the Mystic Shrine's Akdar Mosque in Tulsa is limited to 32nd Degree Masons and Knights Templars. It is one of the community's most active service organizations, and is well-known for its annual circus that supports physically-challenged children. (Courtesy *The Daily Oklahoman.*)

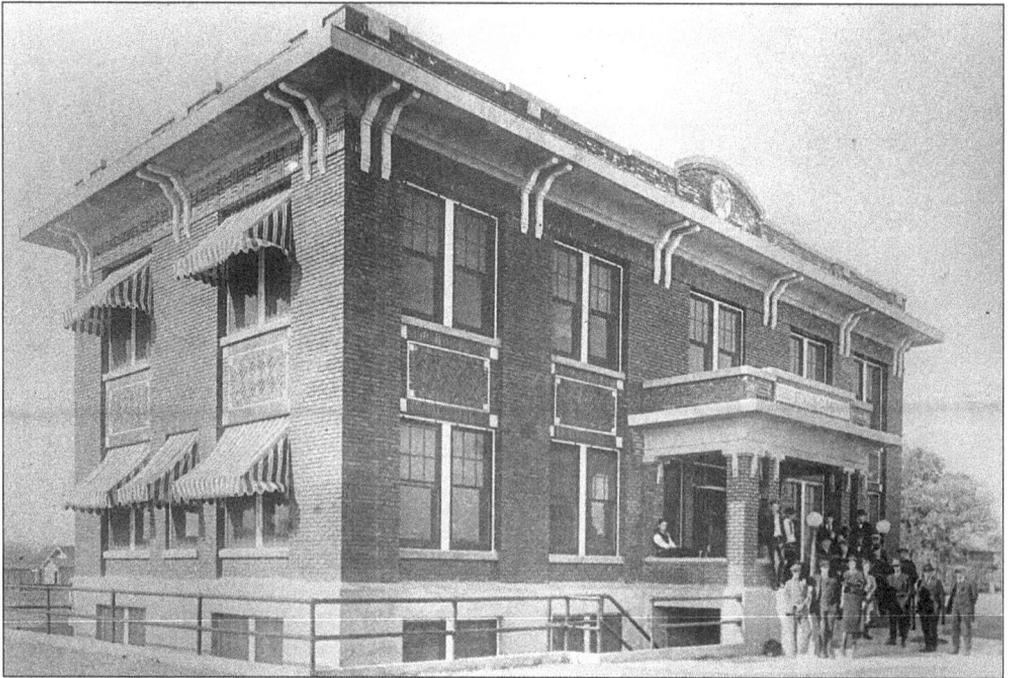

The Texas Company (Texaco) refinery headquarters was built in west Tulsa in 1921. Opened in 1910, the Texaco Refinery was capable of handling 50,000 barrels of crude daily before it was closed in the 1980s. The refinery was a community within itself, and featured housing for workers, a fire department, and recreational facilities. (Courtesy American Petroleum Institute.)

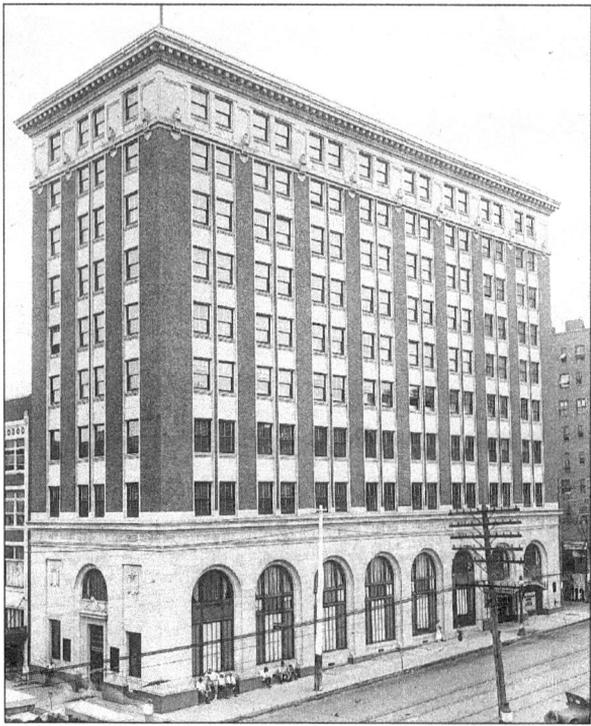

For some reason, the telephone pole in front of Tulsa's First National Bank building was painted white in this 1920s photograph. (Courtesy *The Daily Oklahoman*.)

The new 29-story Exchange National Bank and Exchange Trust Company Building was still under construction in March 1928. The bank was known as the oil man's bank because it financed most of the nearby drilling operations. (Courtesy *The Daily Oklahoman*.)

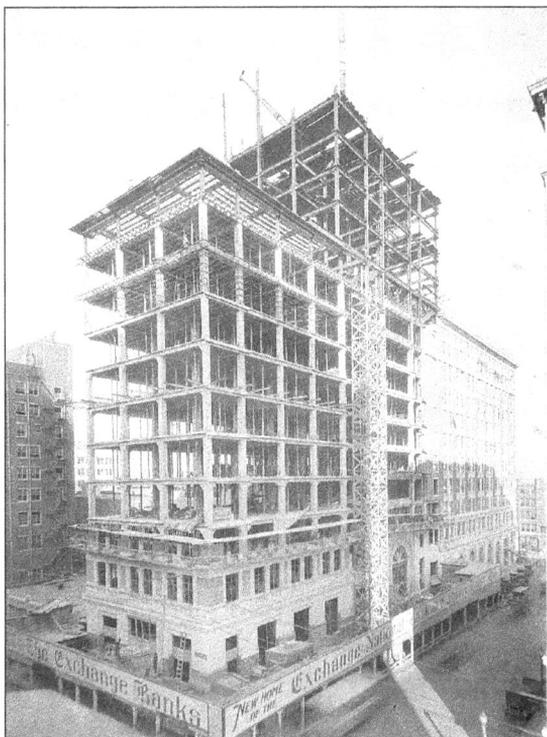

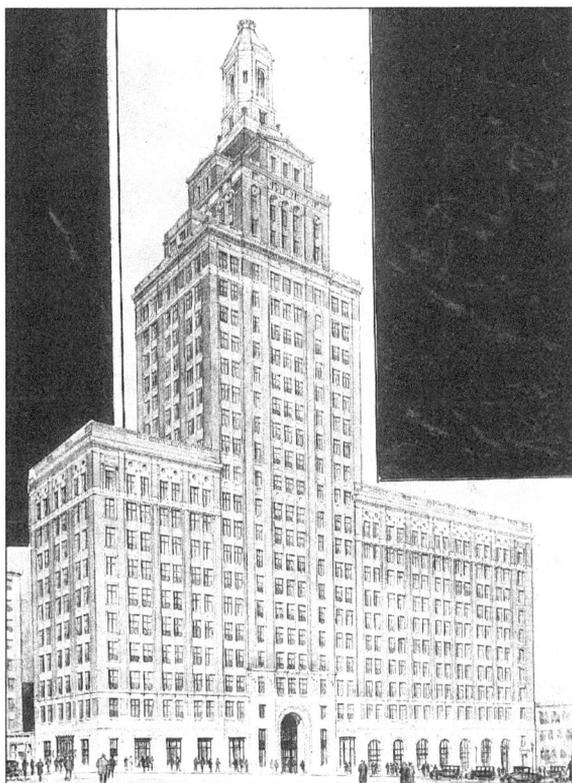

By the time the new home of the Exchange National Bank was completed in 1929, it boasted assets of $50 million. Unfortunately, the bank closed during the Great Depression. (Courtesy *The Daily Oklahoman*.)

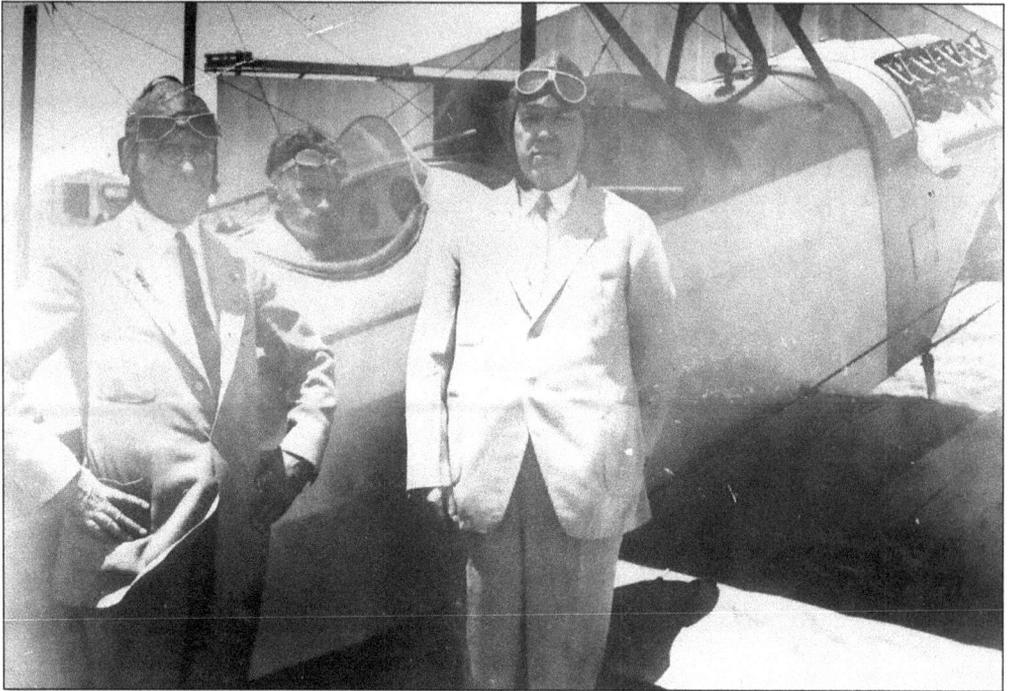

William K. Skelly, shown on the left, was one of the world's petroleum innovators. His Tulsa-based Skelly Oil Company often led the way in oil field technology. He was also one of the first oil men to adapt air travel to his business. Shown here preparing to climb into the front seat of his World War I-era biplane, Skelly was often flown to the latest oil strike. To Skelly's left is Omer K. Benedict. Between the two men is Skelly's pilot. (Courtesy *The Daily Oklahoman*.)

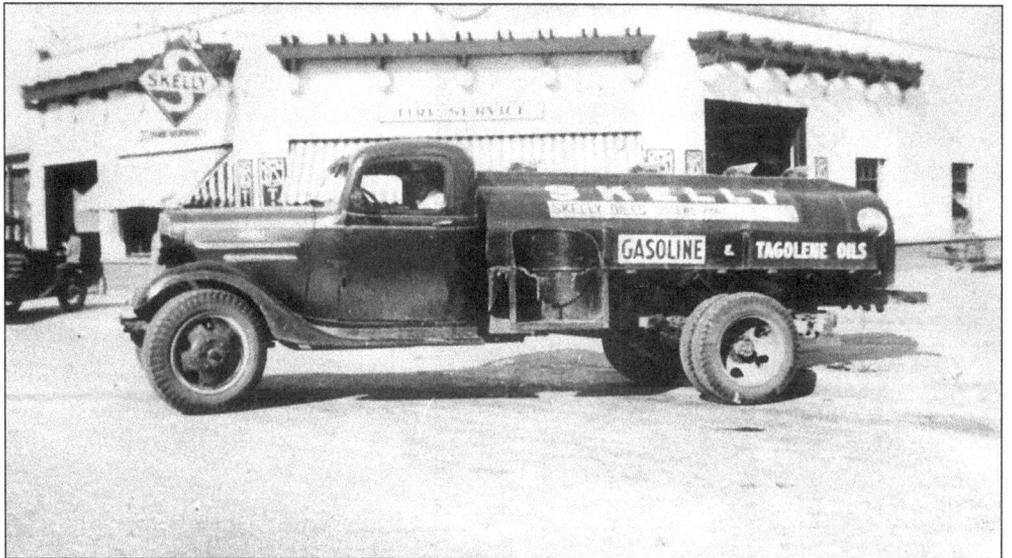

Founded by William K. Skelly on October 2, 1919, and originally headquartered at Fourth Street and Boulder Avenue in downtown Tulsa, Skelly Oil Company produced and distributed its own line of products through a fleet of company trucks. (Courtesy Getty Refining and Marketing Company.)

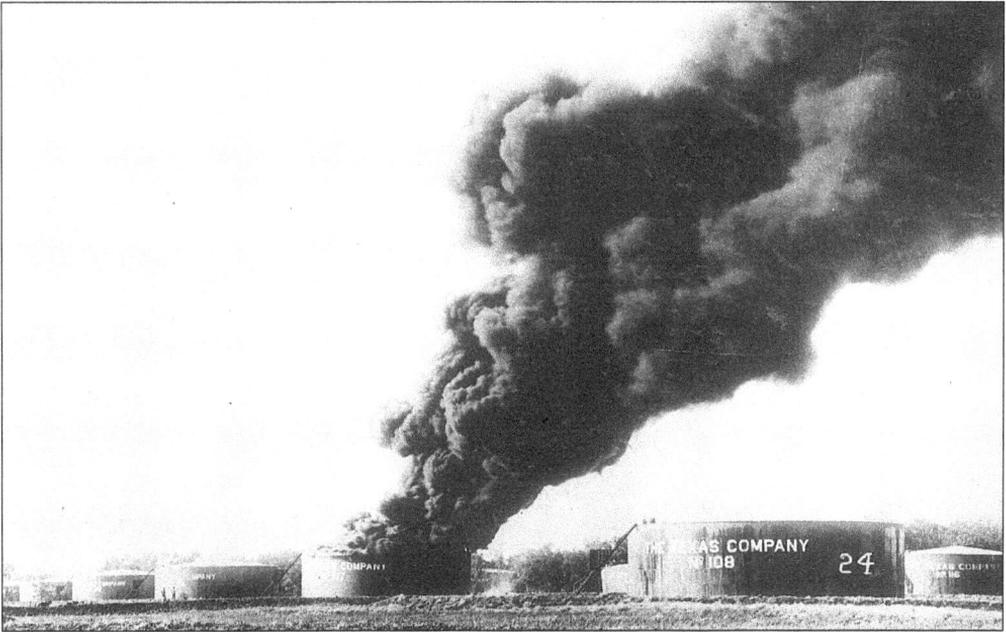

The air over Tulsa was often filled with black smoke from fires raging in the refineries across the Arkansas River in West Tulsa. Here, the Texas Company's Tank No. 107 is on fire. Notice that each of the tanks was surrounded by an earthen dike to contain the oil should it boil over the top of the tank. Refinery workers often extinguished tank fires by using Civil War cannons, firing solid shot to pierce the tanks below the flames. As the non-burning oil ran out it was contained by the dike, and when the tank was emptied, the fire burned itself out. (Courtesy Western History Collections, University of Oklahoma Library.)

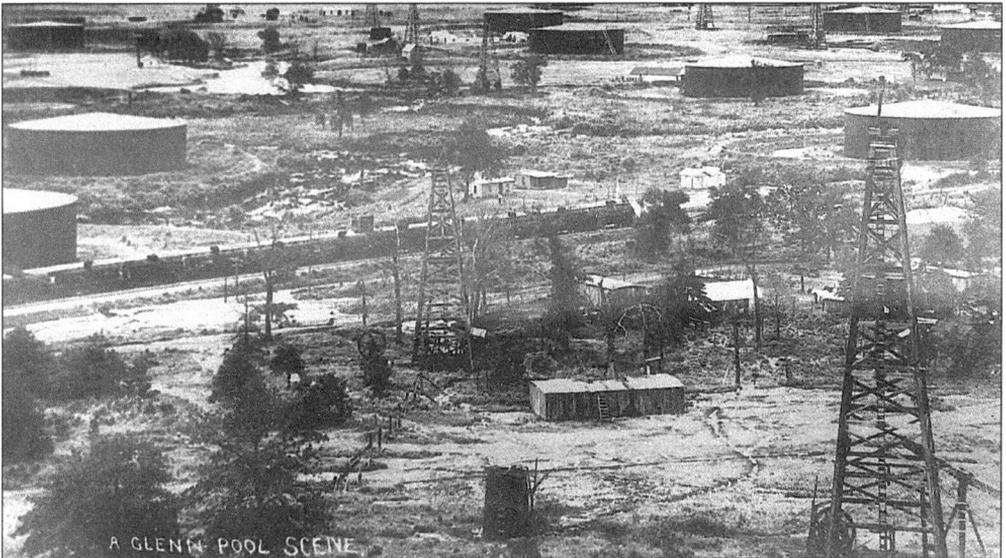

Production was so great at Glenn Pool, south of Tulsa, that oil men were forced to dam gullies to contain the surplus oil. Note the lake of oil in the upper left of this photograph and the pool of oil surrounding the 55,000-barrel oil storage tank in the upper center. (Courtesy Burk Burnett, Texas Public Library.)

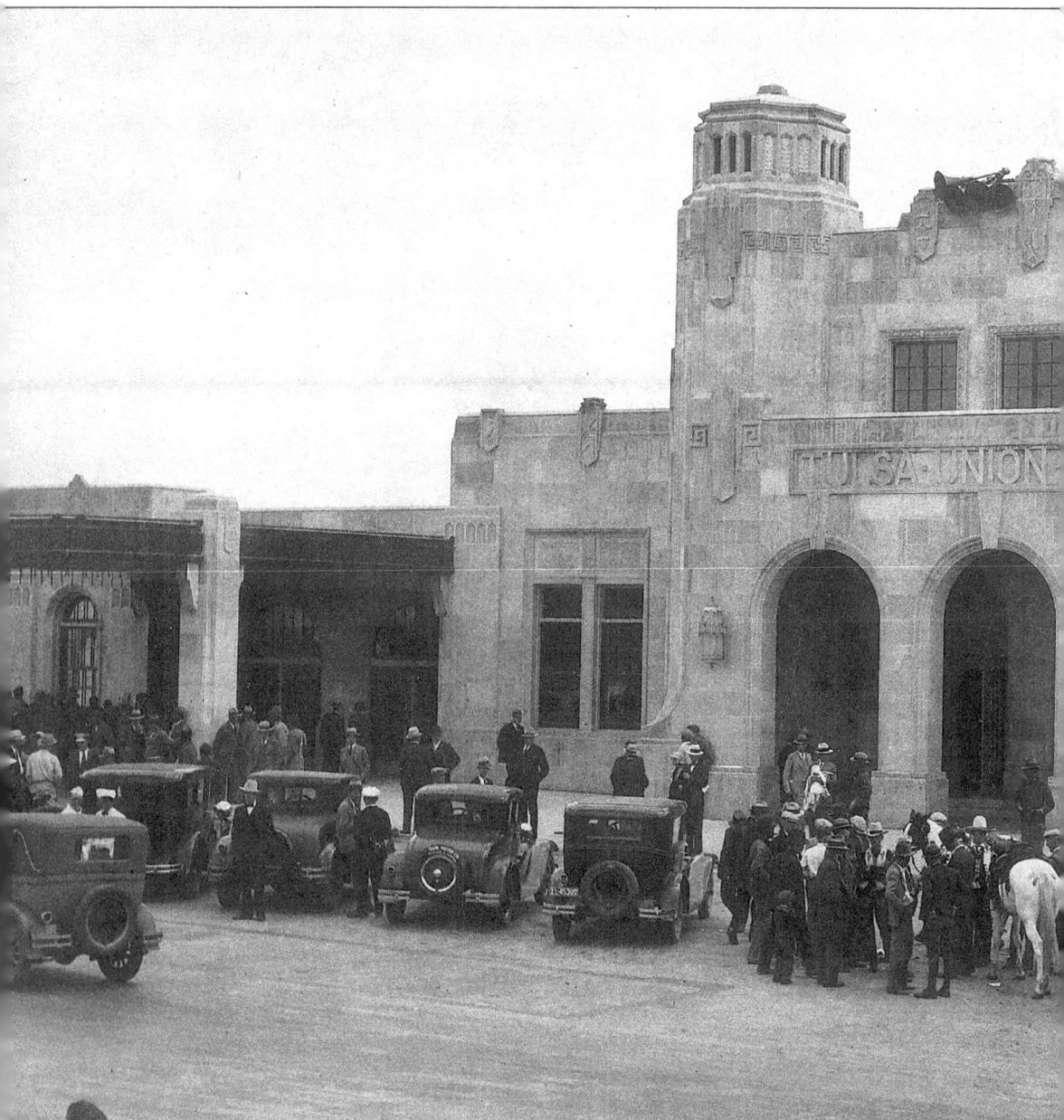

When Tulsa's Union Depot was completed at the intersection of Third Street and Boulder Avenue in 1931, it was the first union depot in Oklahoma. Because the railroad tracks had been elevated to the level of the levees along the Arkansas River, nearby streets were raised

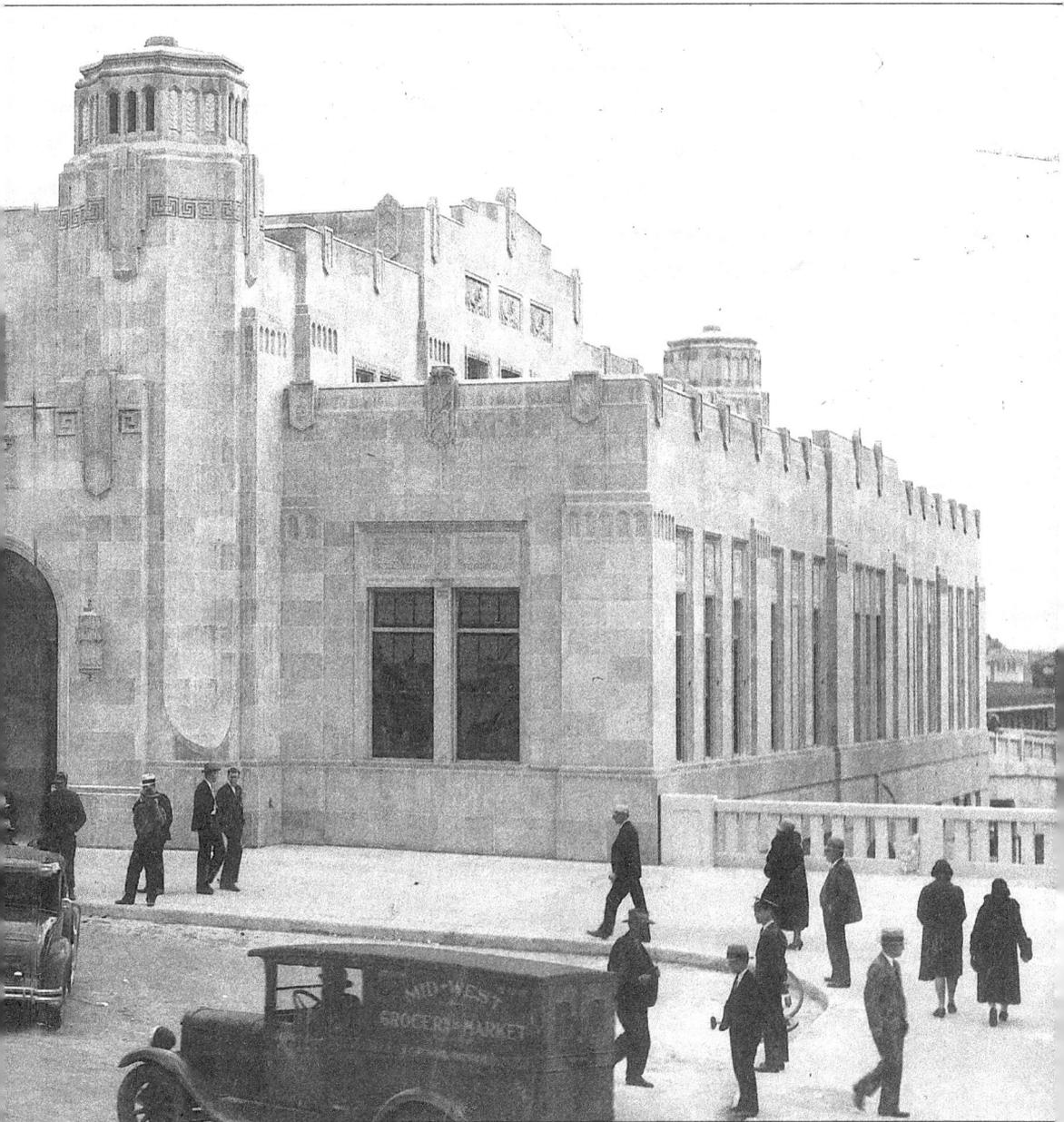

even higher to cross the tracks. Thus, the entrance to the depot was 30 feet above the railroad tracks. (Courtesy *The Daily Oklahoman*.)

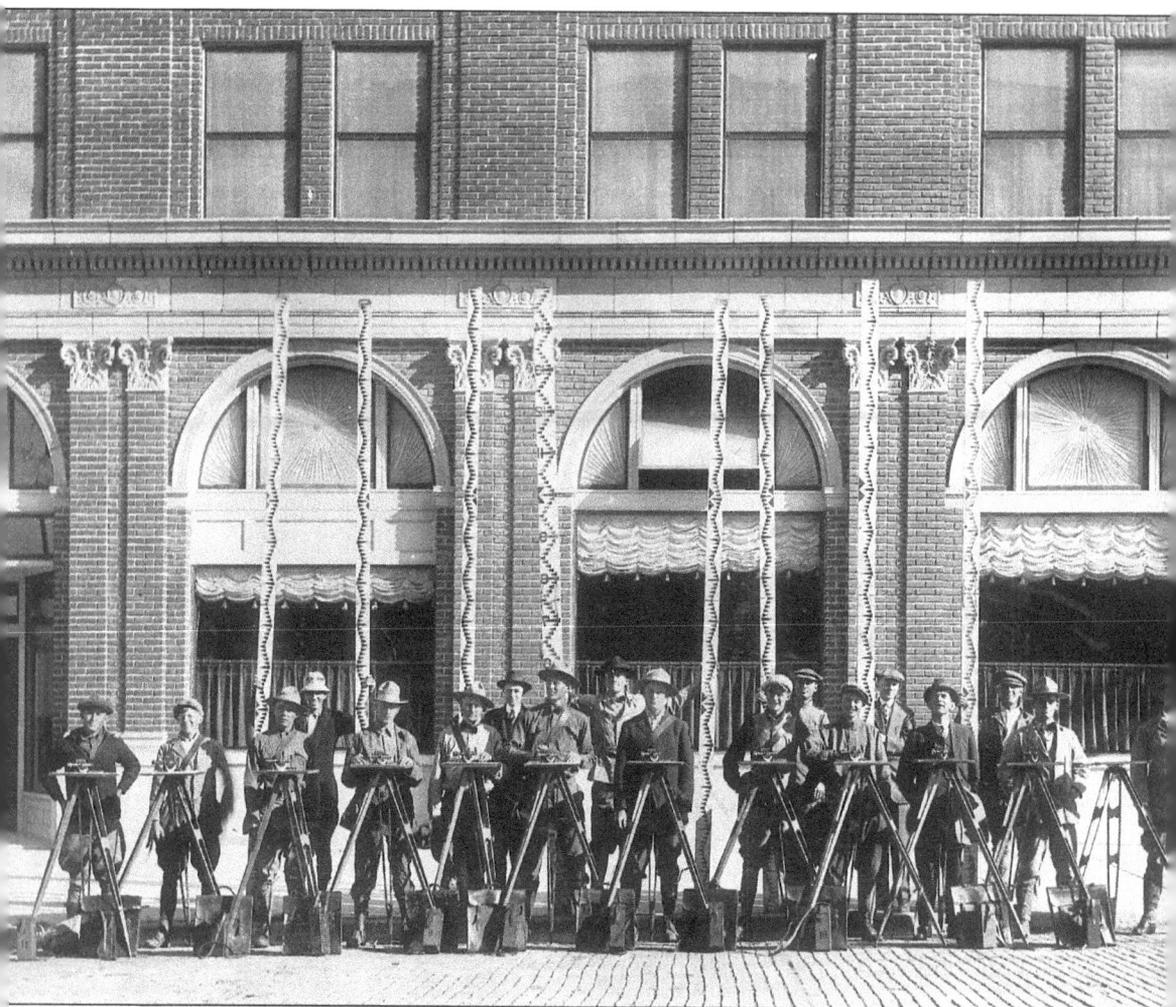

Cities Service Oil Company is credited with initiating the first wide-scale geological survey by an oil company in the search for oil and gas. It started in 1913 with the hiring of Cities Service's first geologist, and extended over the intervening years to World War I, when conditions disrupted the program. Personnel-wise it started with Charles Gould, expanded to include Everett Carpenter, and by 1916 included the group pictured here. At its height, the geological staff included 250 men. Cities Service is also credited with hiring one of the first female geologists. The group of Cities Service geologists shown in this Bartlesville picture taken in 1916 includes many who later became leaders in the oil-finding business. (Courtesy Cities Service Company.)

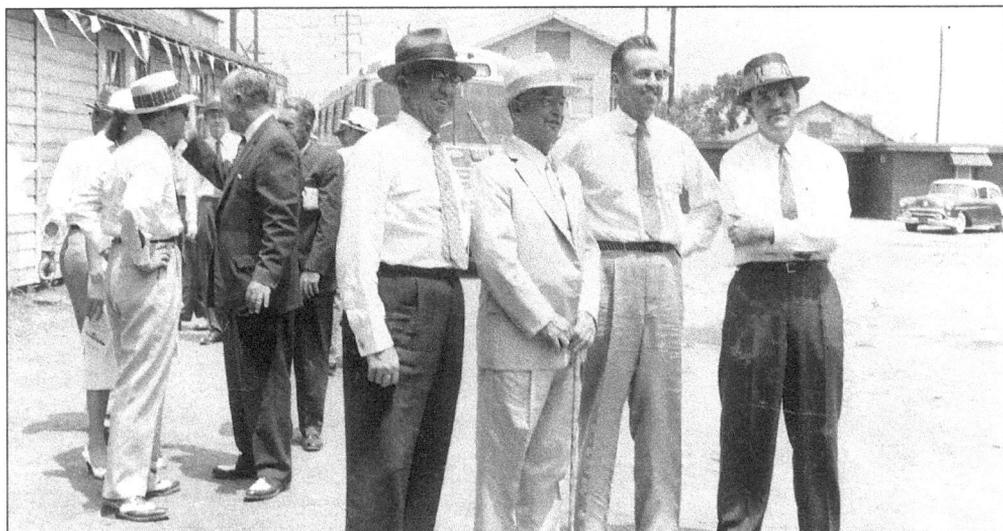

The Tulsa-based Reading and Bates Offshore Drilling Company is known worldwide for its offshore drilling innovations. Founded by J.W. Bates Sr. and George M. Reading in 1949, the company has drilled in the Gulf of Mexico, the North Sea, the Mediterranean Sea, and the South China Sea. Pictured, from left to right, are as follows: J.W. Bates Sr., George M. Reading, J.W. Bates Jr., and C.E. Thornton. The men are witnessing the christening of the *J.W. Bates*, a Levinston-type drilling tender, with a length of 260 feet and a beam of 54 feet, in 1956. (Courtesy Reading and Bates Offshore Drilling Company.)

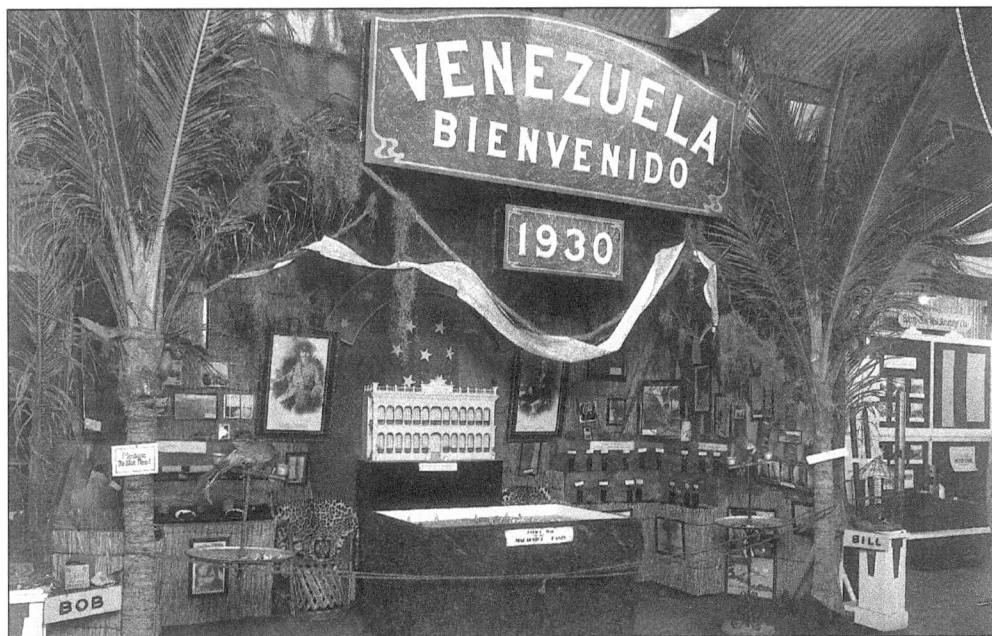

The Venezuelan exhibit at the 1930 IPE in Tulsa was one of many. The International Petroleum Exposition was billed as the largest gathering of international oil men in the world and offered oil-related businesses the opportunity to tout their products to a worldwide audience. Notice the two parrots, Bob on the left and Bill on the right. The parrots were the hit of the exhibit. (Courtesy Beryl D. Ford.)

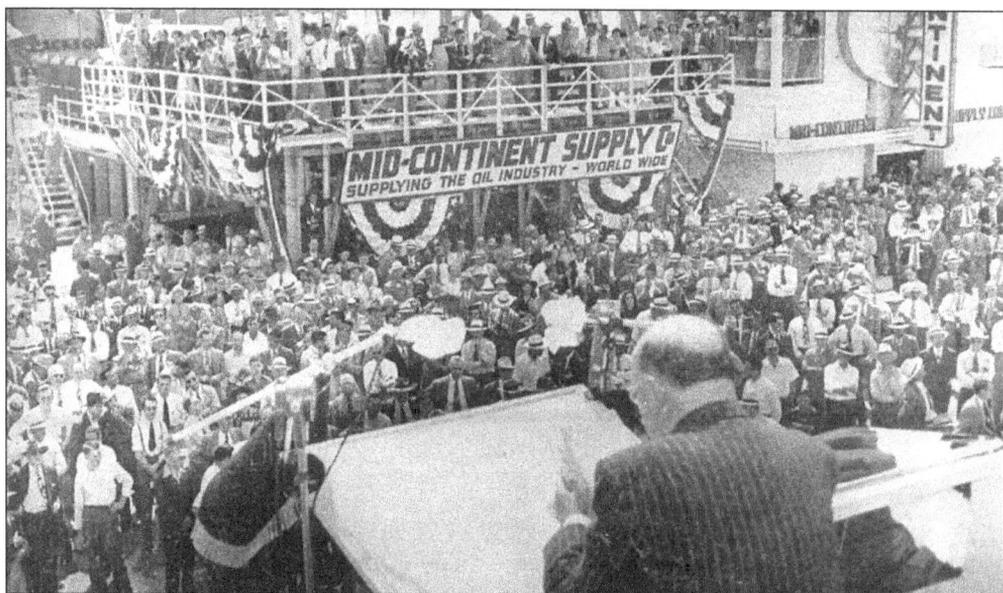

William G. Skelly is shown addressing the crowd in attendance at the 1948 International Petroleum Exposition from the speaker's platform atop the NOMADS Building. Skelly, the founder of the Tulsa-based Skelly Oil Company, was instrumental in the founding of the IPE and served as president of the organization from 1925 until 1957. (Courtesy *Oil and Gas Journal.*)

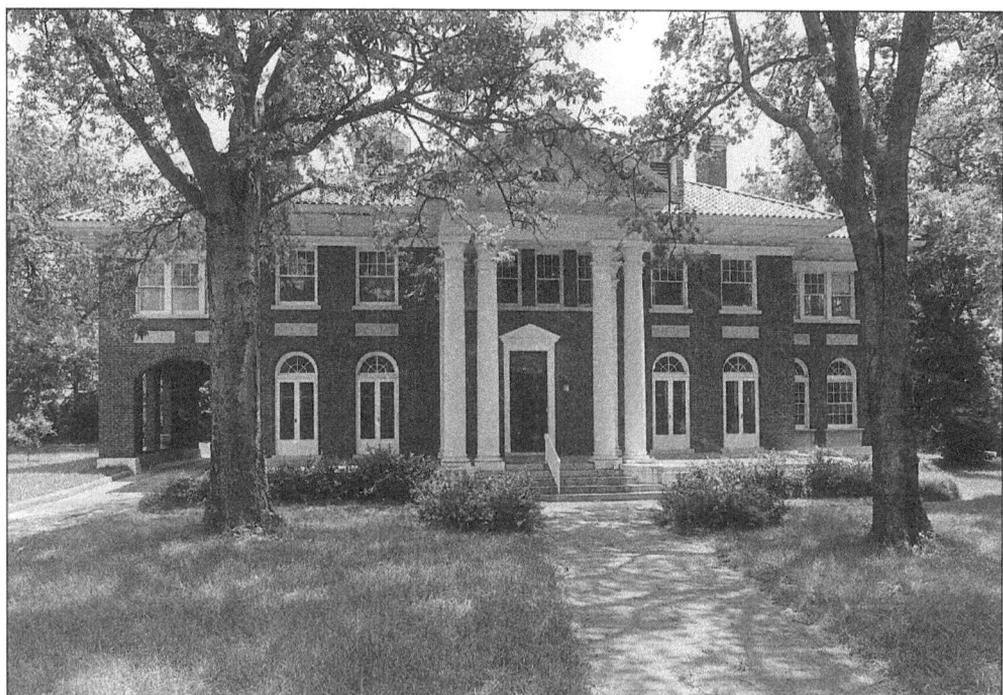

The home of William G. Skelly, the founder of Skelly Oil Company, which merged with Texaco, is located on Twenty-first Street in south Tulsa. It is but one of numerous oil mansions that were built in the city. (Courtesy *The Daily Oklahoman.*)

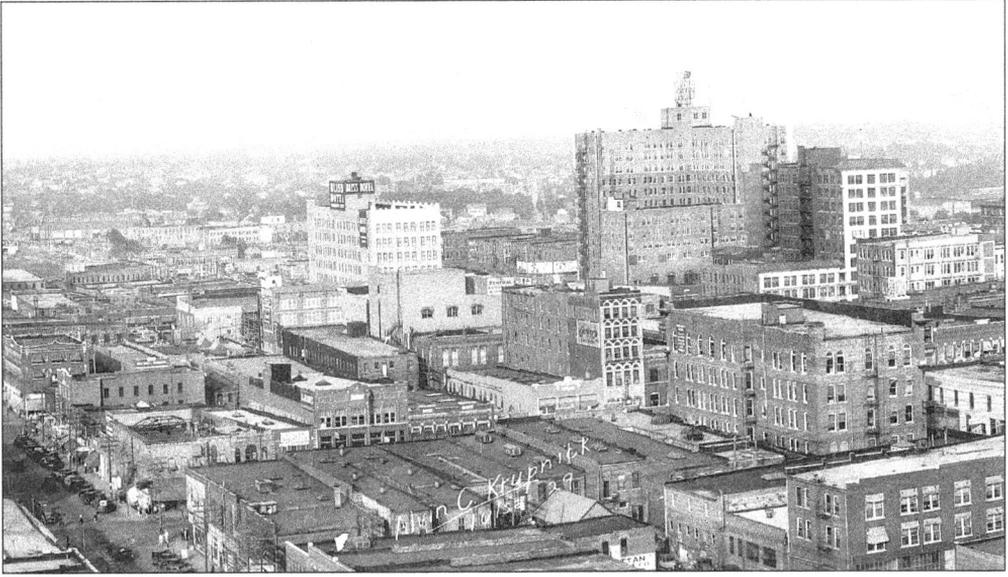

Because it served as a jumping-off place for the numerous nearby oil fields, Tulsa boasted a large number of hotels. The Bliss Hotel, on the right, and the Hotel Tulsa, on the left, were two of the more popular in 1929. By the end of the Roaring Twenties many of the city's early cut stone buildings had been replaced by brick facade. However, this trend is not reflected in the lower left corner of this picture, as the early-day cut stone structures still remain. (Courtesy *The Daily Oklahoman*.)

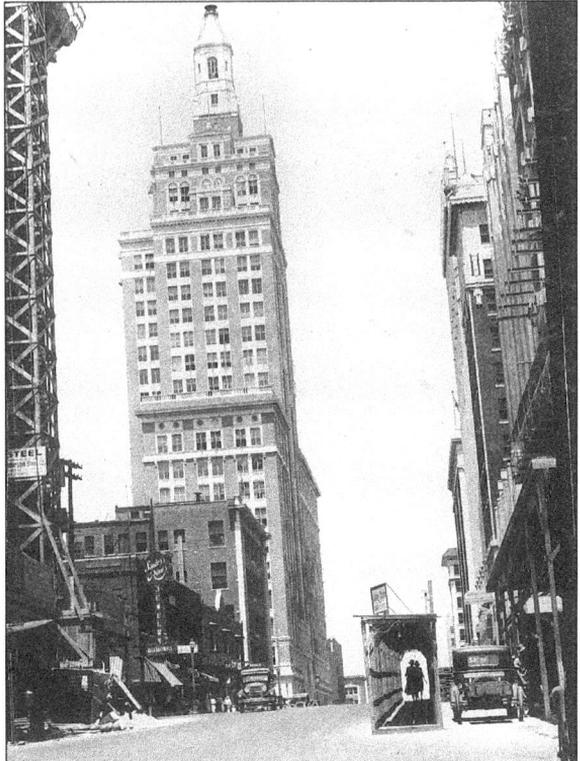

The Exchange National Bank failed during the Great Depression despite the efforts of several Tulsa oil men, including James Chapman, who offered $5 million to keep the bank open. Even so, it was reopened in 1933 as the National Bank of Tulsa, and eventually became the Bank of Oklahoma. (Courtesy Oklahoma Heritage Association.)

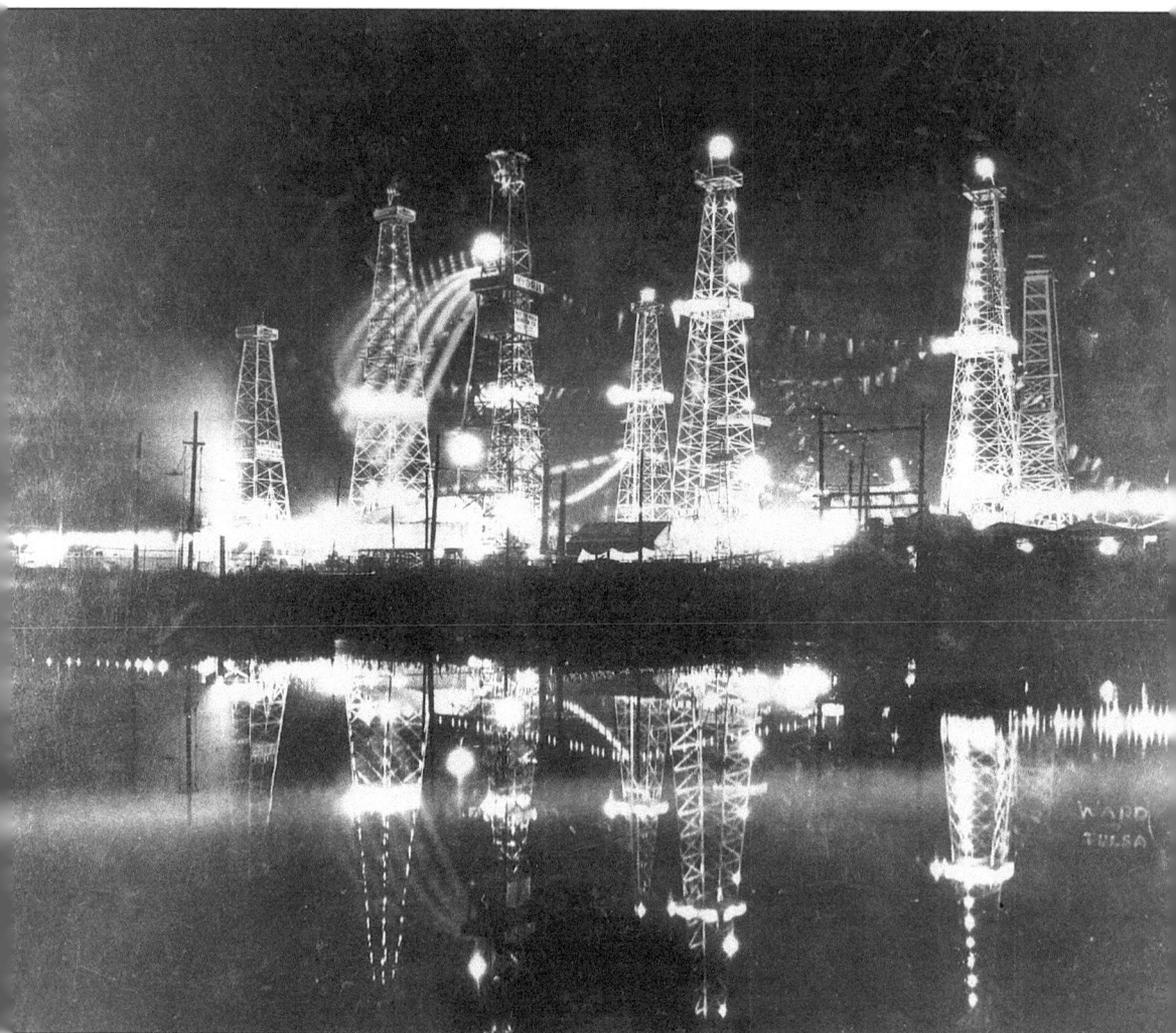

A huge American flag is suspended between two oil well derricks in this night view of the 1949 International Petroleum Exposition. Although known as the "Oil Capital of the World," oil-well drilling was prohibited within Tulsa's city limits. However, during one of the IPE sessions, one of the drilling rigs struck a shallow pool of oil while putting on a demonstration. (Courtesy Oklahoma Historical Society.)

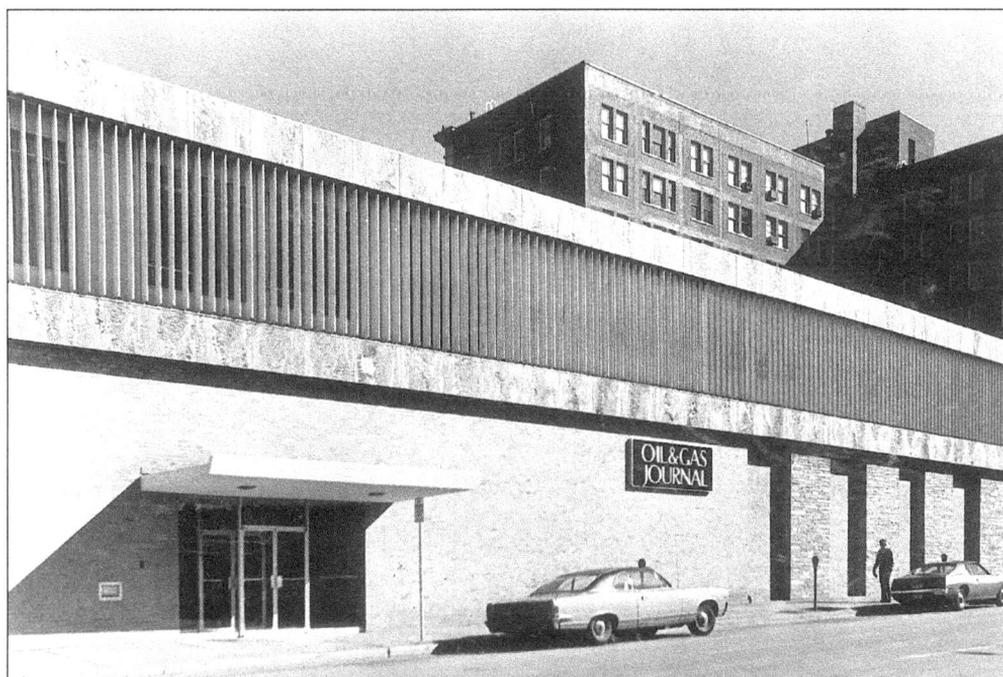

The headquarters of the *Oil and Gas Journal* at 211 South Cheyenne Avenue in Tulsa is pictured here in April of 1975. The relocation of the journal from Beaumont, Texas, to Tulsa in 1910 was a major factor in Tulsa becoming known as the "Oil Capital of the World." The magazine's parent organization, Petroleum Publishing Company, is known worldwide for its technical publications and other industry-related magazines, books, encyclopedias, and directories. (Courtesy Petroleum Publishing Company.)

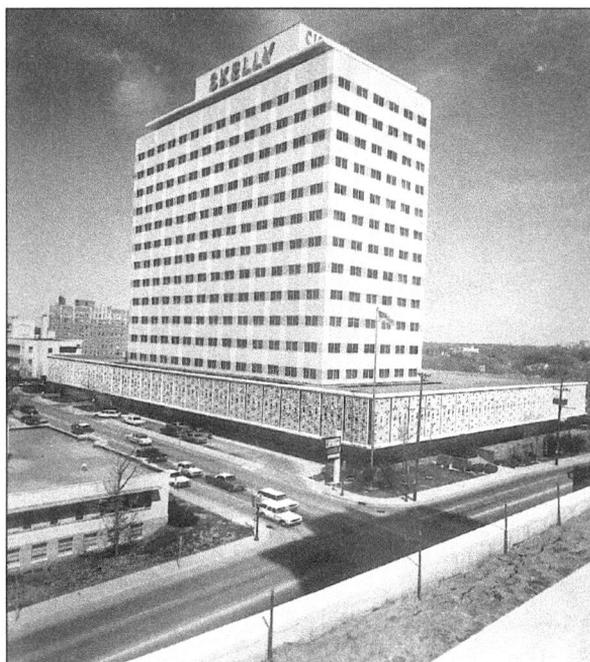

This is the international headquarters of Skelly Oil Company in downtown Tulsa. Skelly Oil Company eventually became a part of Getty Refining and Marketing Company. (Courtesy Oklahoma Heritage Association.)

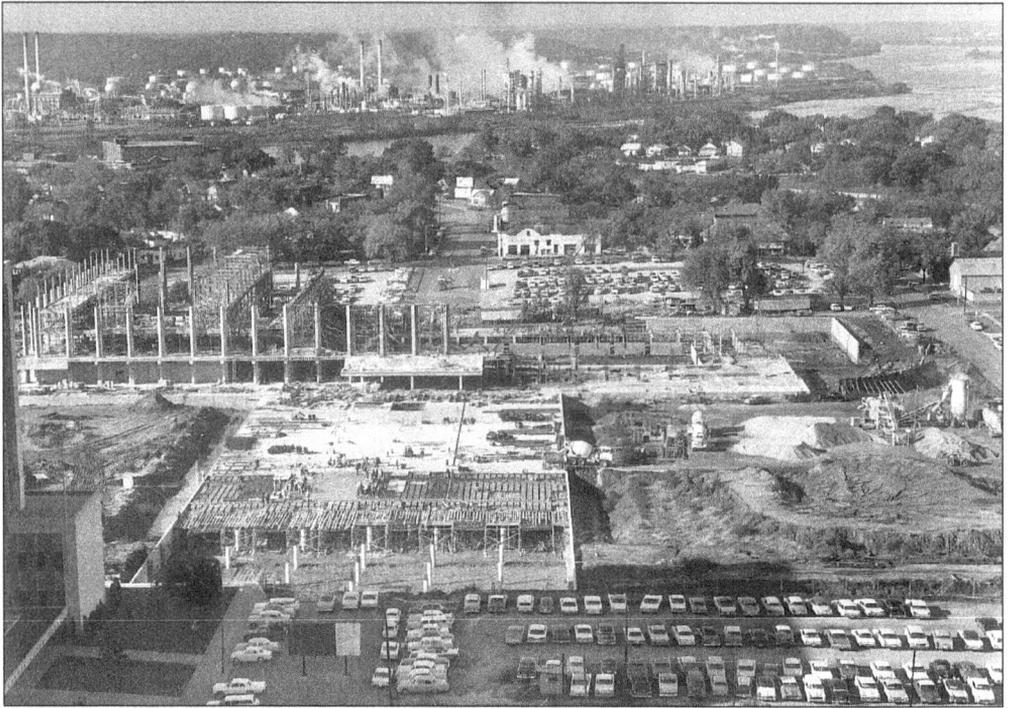

Tulsa's Civic Center's construction is well under way in the center of this photograph. This picture was taken from an upper floor of the Mayo Hotel, looking west across the Arkansas River toward West Tulsa. Although internationally known as the Oil Capital of the World, Tulsa civic leaders, as early as the 1890s, banned refineries from inside the city limits. As a result, West Tulsa developed into one of the state's major refining centers. (Courtesy *The Daily Oklahoman*.)

Known worldwide for its petroleum-related curriculum, the University of Tulsa boasted a working indoor drilling rig on which to train students. (Courtesy Guy Logsdon.)

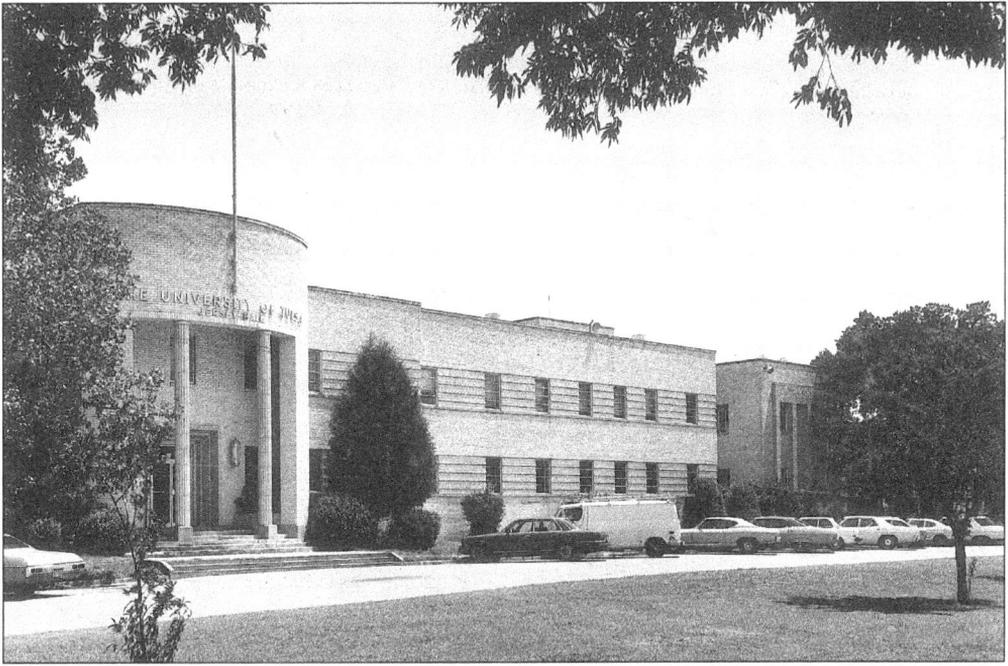

The Petroleum Engineering Building at the University of Tulsa, shown here in the 1970s, has become the home of one of the most prominent petroleum schools in the world. Opened in 1928, the School of Petroleum Engineering continues to draw students from major oil producing regions worldwide. The building was donated to the university by the Humble Oil and Refining Company. (Courtesy University of Tulsa, McFarlin Library.)

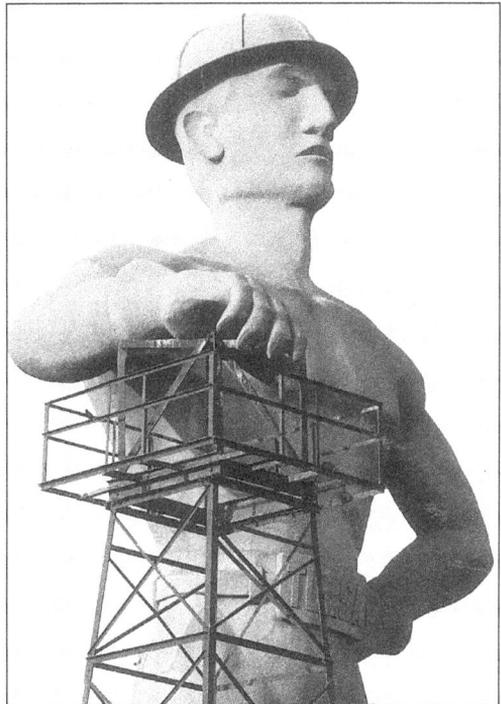

It is not difficult to locate the entrance to Tulsa's Expo Square . . . just look for the Golden Driller. The Golden Driller received a fresh coat of paint in 1999 by radio station KRMG's Rick Couri as a fund-raising stunt for Operation Aware, a drug education program used in the Tulsa Schools. (Courtesy Oklahoma Department of Recreation and Tourism; photograph by Fred Marvel.)

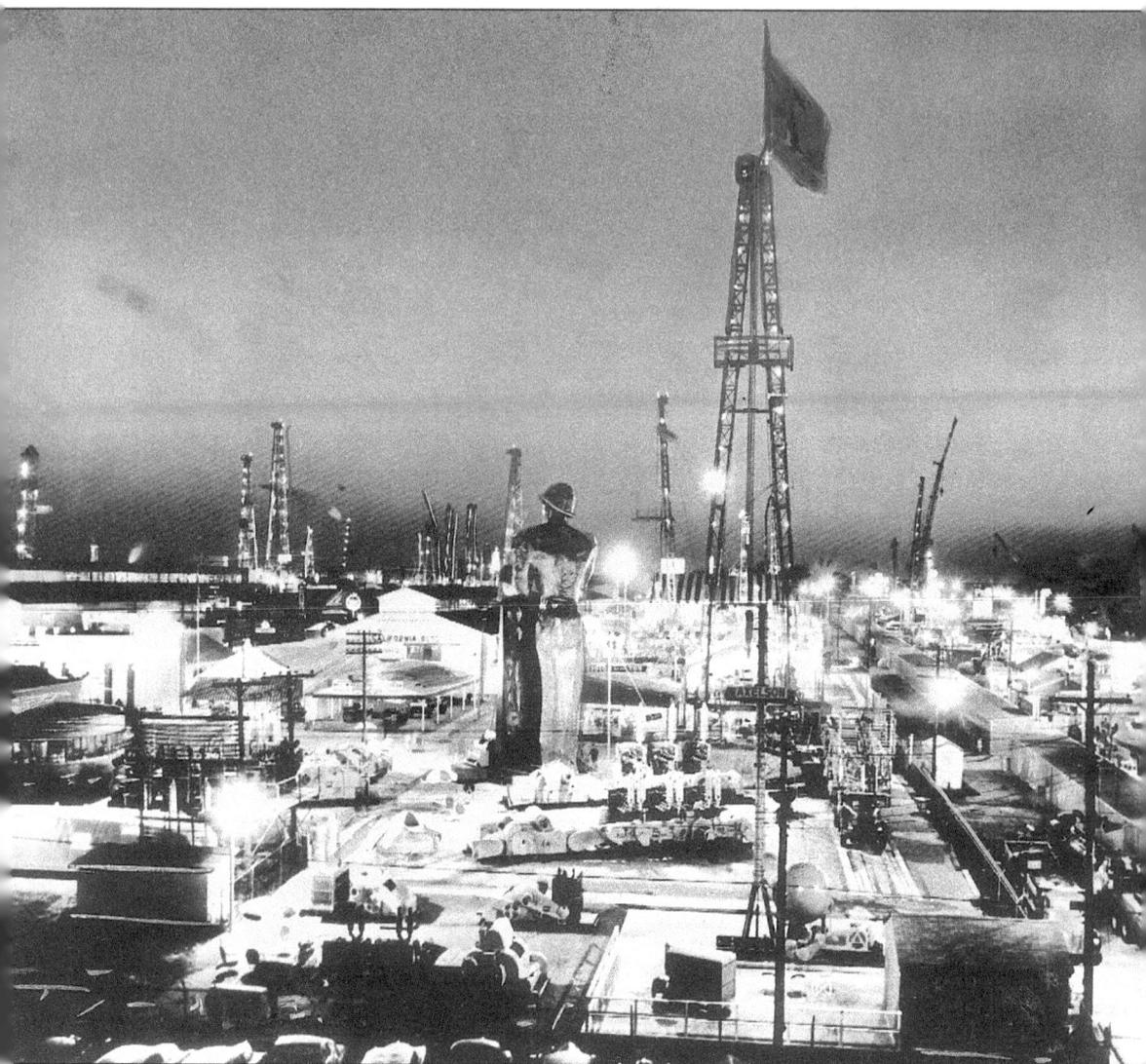

A night scene at the 1953 International Petroleum Exposition is captured here. Standing in the center of the 28-acre grounds is the 65-foot tall Golden Driller, long the symbol of the IPE. Rebuilt in 1966, the Golden Driller is now 76 feet tall, weighs 43,500 pounds, contains more than 2.5 miles of rods and mesh, and is one of the world's largest, free-standing statues. (Courtesy *The Daily Oklahoman*.)

Four

THE MAGIC EMPIRE

By the onset of the second millennium, Tulsa had grown into the state's second largest metropolitan area. In addition to being a modern urban community, supported by a diversified economy, it is also a world-class cultural center.

As a major aviation, technological, and manufacturing center, Tulsa is the home to Tulsa International Airport, American Airlines' maintenance facility, and the Spartan School of Aeronautics. It is also the site of the Oklahoma State University College of Osteopathic Medicine, the University of Oklahoma College of Medicine, and the headquarters for Blue Cross-Blue Shield. The Tulsa Ford Motor Company Glass plant, John Zinc Company, MCI-WorldCom, and Whirlpool all are representative of Tulsa's modern diversified economic basis.

Higher education started in Tulsa in 1907 when Henry Kendall College moved to the community from Muskogee. It became the University of Tulsa in 1920. Eventually, Oklahoma State University-Tulsa, Oral Roberts University, Tulsa Community College, and Southern Nazarene University-Tulsa, as well as other institutions of higher education, were opened.

Tulsa prides itself on its cultural heritage, much of which is a legacy of its pioneer oil men. The Gilcrease Museum and Philbrook Museum of Art are world-renowned for their collections as are the Elsing Museum and the Fenster Museum of Jewish Art. Through the resourcefulness of its pioneer settlers and the foresight of its civic leaders, the Place of the Turtles has matured into one of the highest rated communities in America for its quality of life.

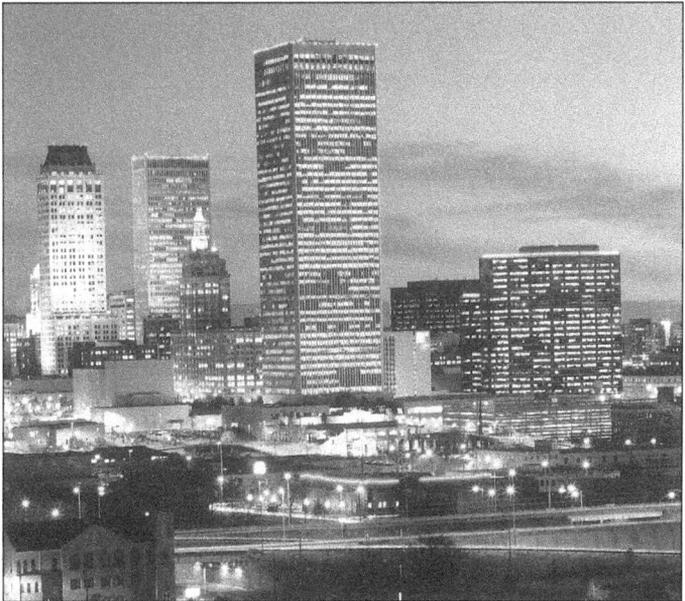

A drive up Reservoir Hill offers a spectacular view of Tulsa's skyline at the onset of the 21st century. (Courtesy Department of Tourism and Recreation; photograph by Fred Marvel.)

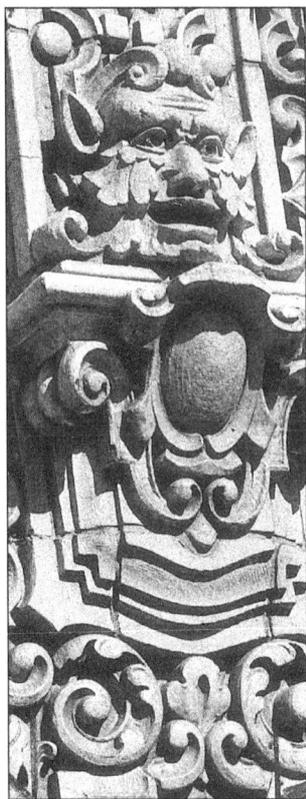

The Adams Hotel, at the intersection of Fourth Street and Cheyenne Avenue, is well-known for its intricate terra cotta design. This is a view of the Jester's face on the outside of the building. When the hotel opened, it advertised itself as the "Address of Distinction" and boasted 50 air conditioned rooms. (Courtesy *The Daily Oklahoman*.)

Long a prominent downtown Tulsa landmark, the historic Adams Hotel was renovated into the Adams Office Tower in the early 1980s. (Courtesy *The Daily Oklahoman*.)

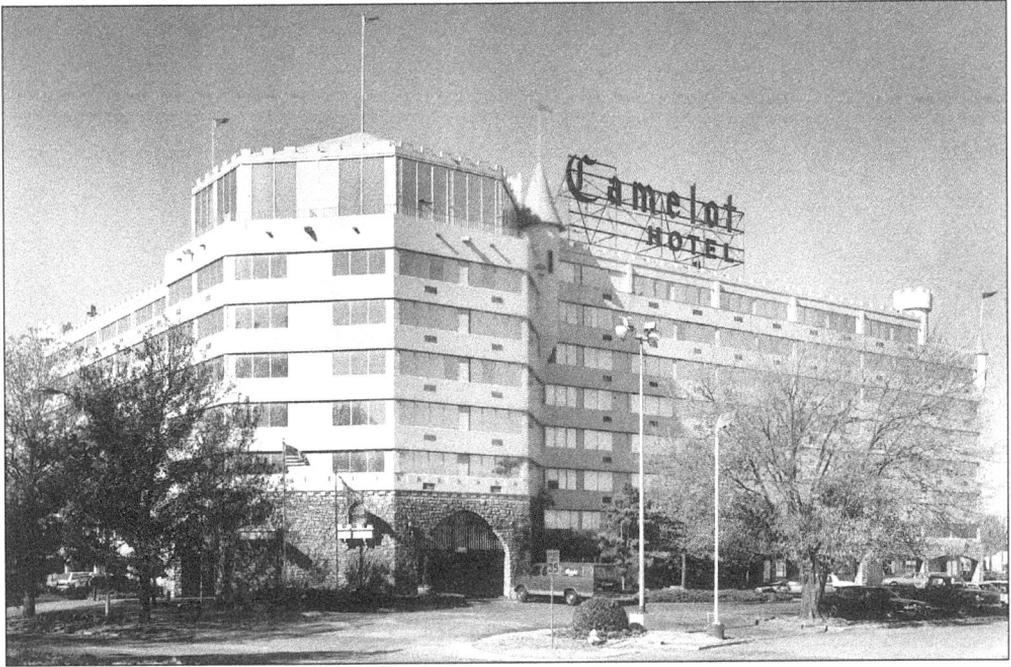

Built in 1966, Tulsa's Camelot Hotel on South Peoria was constructed to resemble King Arthur's medieval castle and has a large, shield-shaped swimming pool. (Courtesy *The Daily Oklahoman*.)

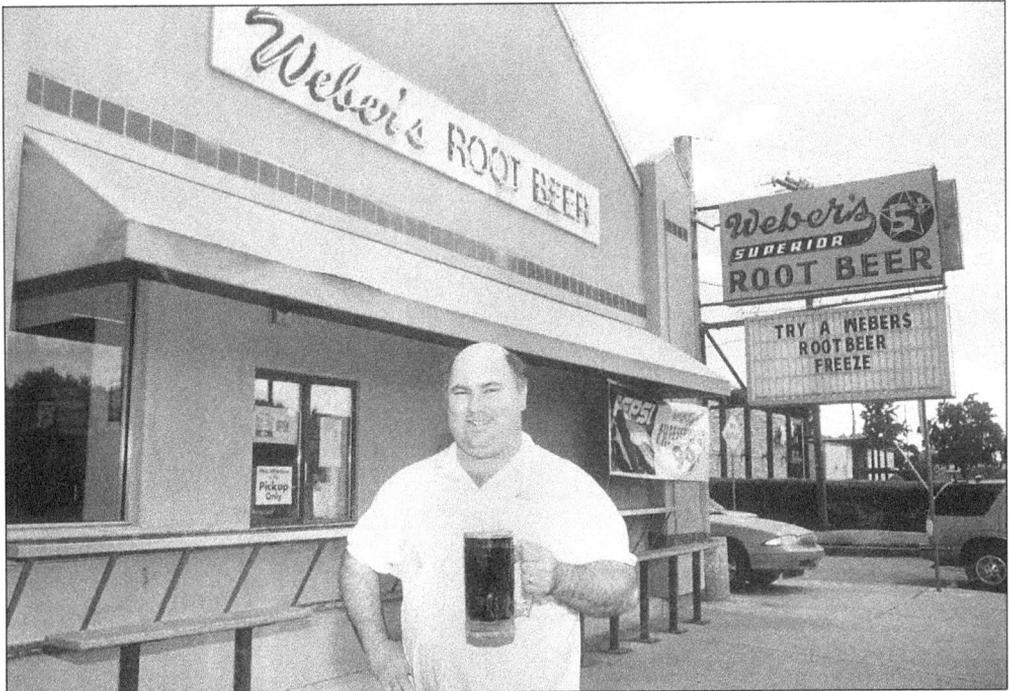

Weber's Root Beer, located at 3817 South Peoria, has been a Tulsa institution since 1933. Rick Bilby, pictured, is owner of Weber's Root Beer Stand, and still cooks hamburgers on the grill made by his grandfather, Oscar Weber Bilby, in 1891. (Courtesy Judy Dawson.)

Looking north on Boston Avenue, one can readily see the blending of Tulsa's newer, modern skyscrapers contrasted by earlier Art Deco-style buildings. (Courtesy Judy Dawson.)

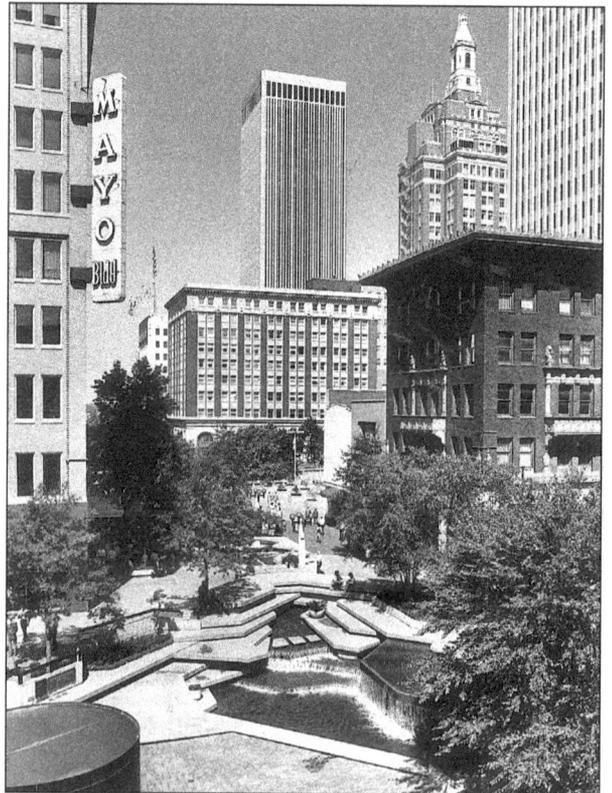

To make Tulsa more inviting, many areas of downtown Tulsa have been transformed into park areas filled with giant outdoor murals, sculptures, and fountains. (Courtesy Oklahoma Publishing Company.)

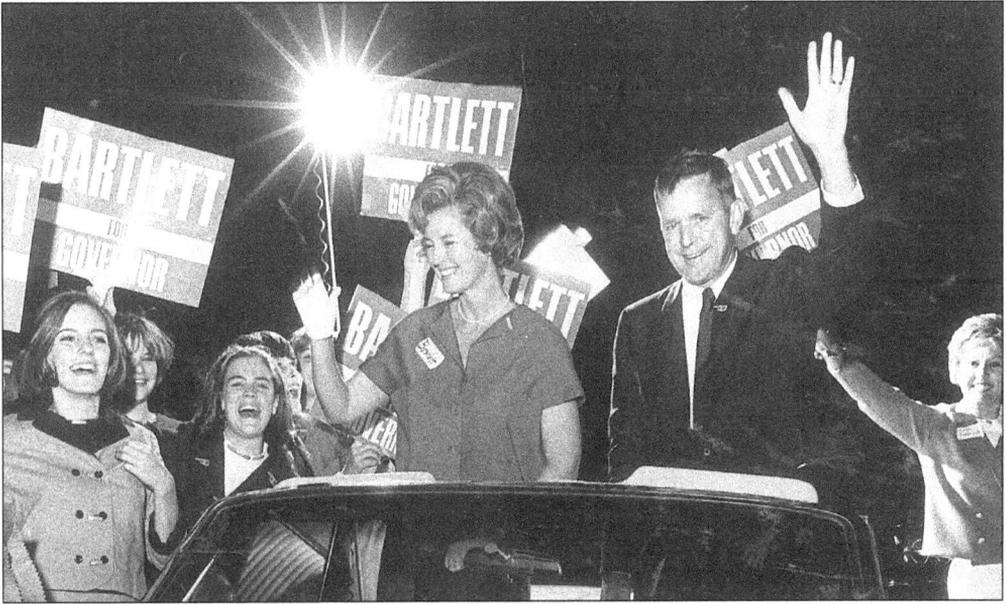

The first governor of the State of Oklahoma from Tulsa was Republican Dewey Bartlett. Here, Governor-elect Bartlett and his wife, Ann, are shown in a victory parade on November 9, 1966, the day after the general election. (Courtesy Oklahoma Publishing Company.)

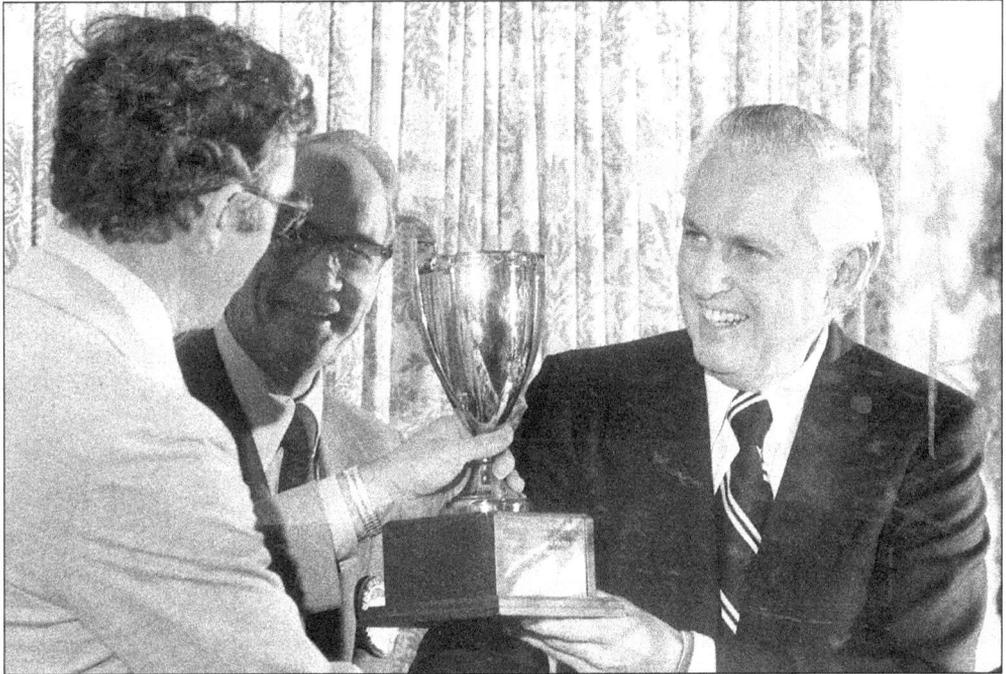

The 1970 Oklahoma gubernatorial election pitted Tulsa Democrat David Hall against the incumbent Republican Governor Dewey Bartlett, also of Tulsa. Hall, who won, is shown presenting a golf trophy to Gene Binning, an Oklahoma City Kiwanis Club director, left, and Ben Head, club president, center, in November of 1973. The Oklahoma City club defeated Tulsa Kiwanis members in the annual Turnpike Golf Tournament. (Courtesy *The Daily Oklahoman*.)

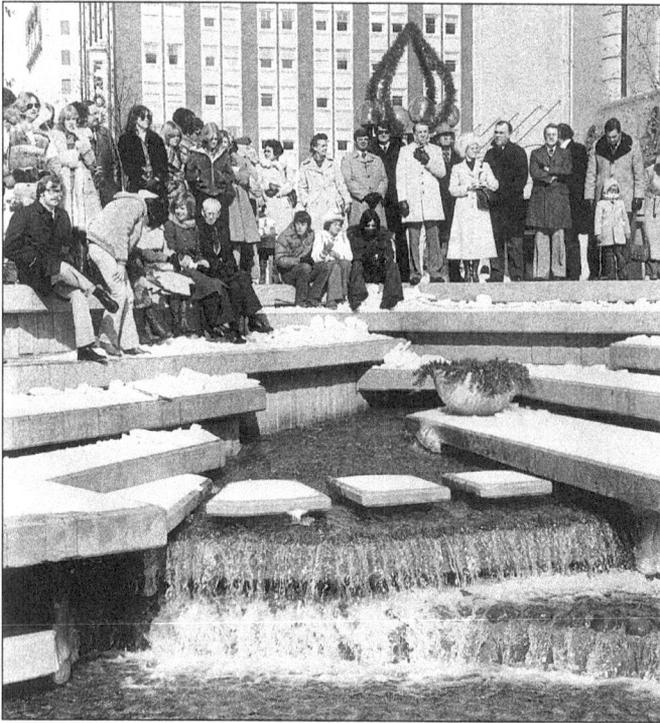

On January 4, 1979, George Nigh, who had been elected to succeed David Boren as governor, was sworn in on the Main Mall in Tulsa to complete the five days remaining in Boren's term after Boren was elected to the United States Senate. Thus, Nigh became the first governor of the state to be sworn into office in Tulsa. He was later sworn in at Oklahoma City for the full term. (Courtesy *The Daily Oklahoman*.)

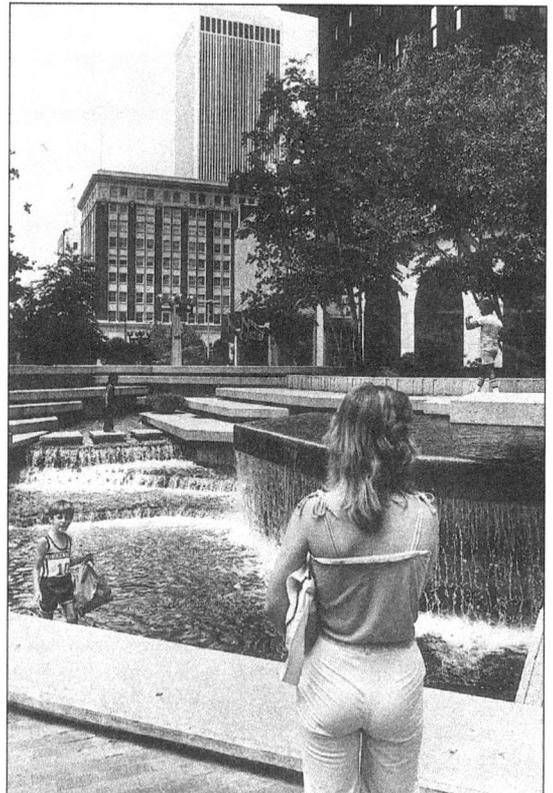

A major feature of downtown Tulsa is Bartlett Square, named after the first Tulsan to be elected governor of Oklahoma, Dewey Bartlett, who later became a United States senator. (Courtesy *The Daily Oklahoman*.)

When completed in 1973, the 42-story First National BanCorporation Tower, between Boston Avenue and Main Street in downtown Tulsa, was the state's tallest building. The $20 million tower was built to house 3,000 people. (Courtesy *The Daily Oklahoman*.)

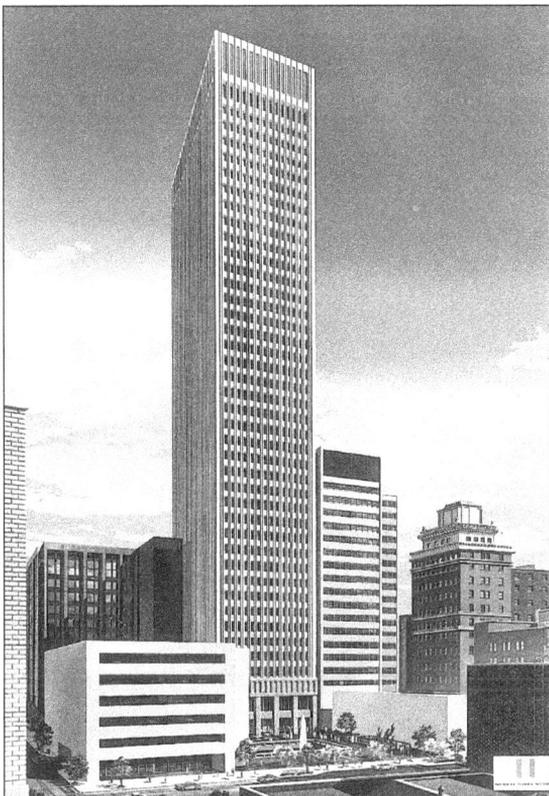

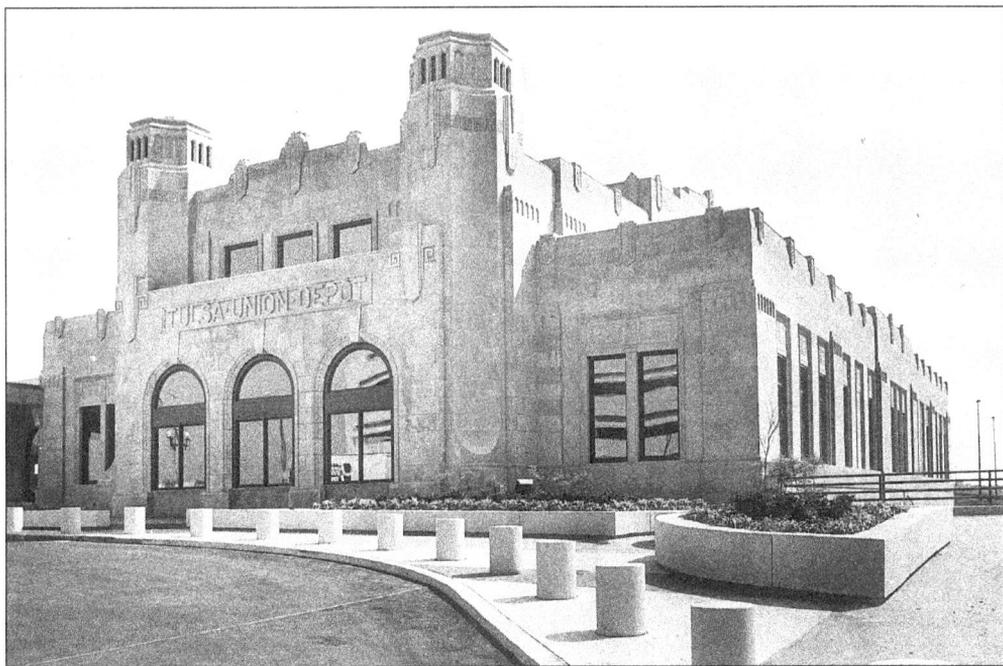

In the early 1980s, Tulsa's Union Railroad Depot was restored to its original grandeur. (Courtesy *The Daily Oklahoman*.)

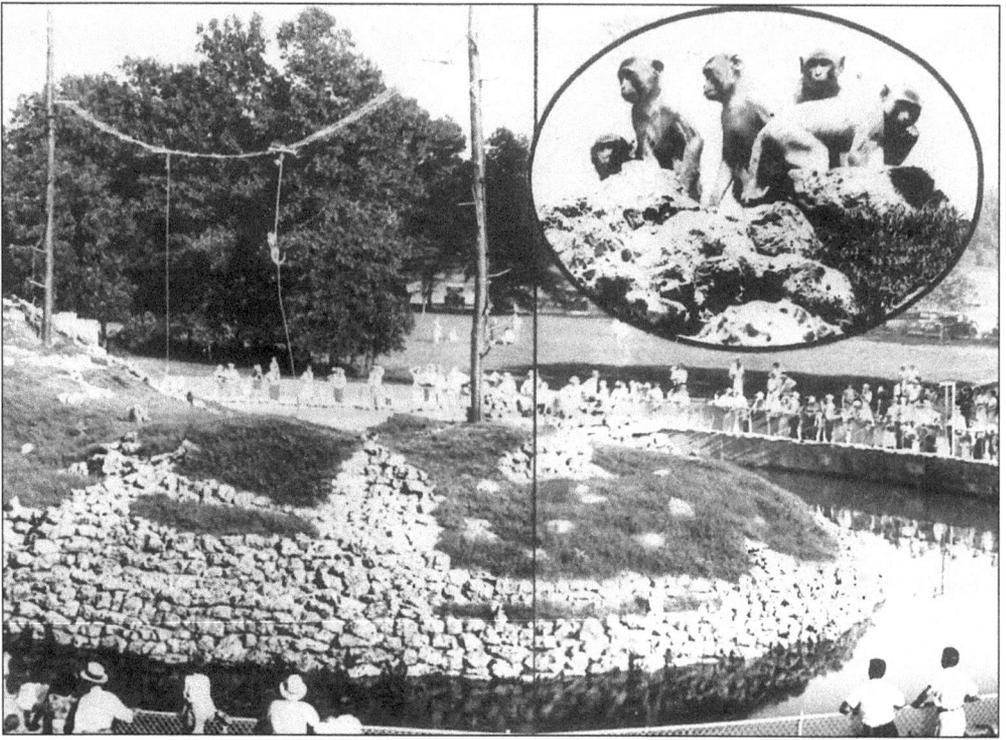

Tulsa's Mohawk Park and Zoo was established in 1924 after civic leaders underwrote its cost with notes secured by stud horses. One of the most popular exhibits at the park was monkey island. The 2,400-acre recreational facility, which included a number of fishing lakes, attracted tens of thousands annually during the pre-World War II era. (Courtesy *The Daily Oklahoman*.)

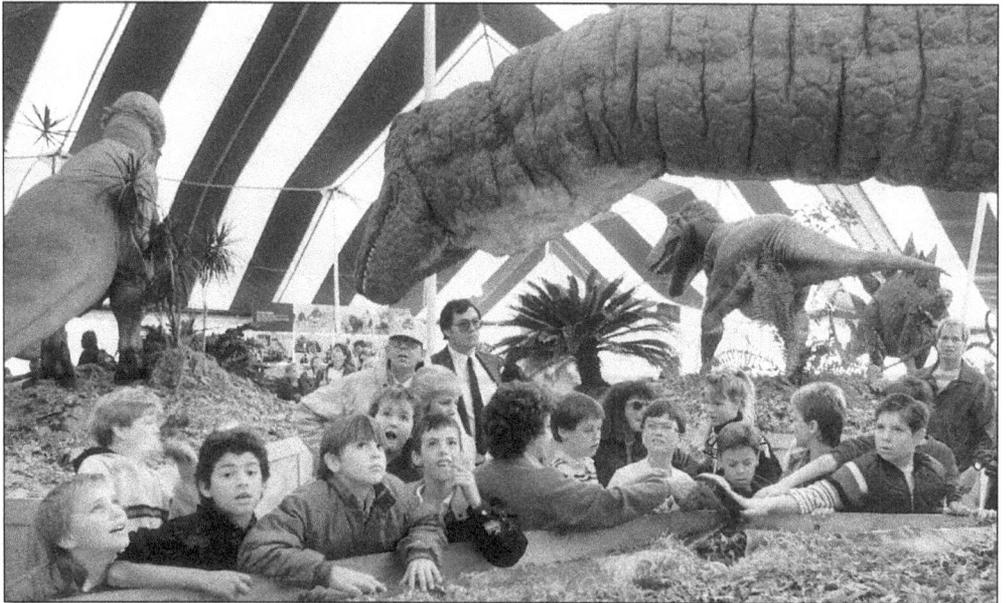

The dinosaur exhibit at the Tulsa Zoo was very popular during its 1988 showing. The large dinosaur in the center is a replica of a giant apatosaurus. (Courtesy *The Daily Oklahoman*.)

A definite eye-catcher on South Lewis Avenue is this Praying Hands sculpture at the entrance of Oral Roberts University. The sculpture is by Leonard McMurry. (Courtesy Judy Dawson.)

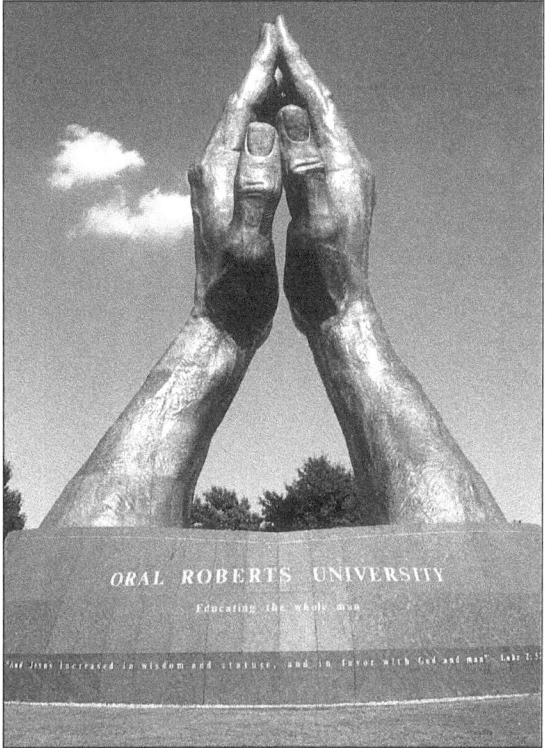

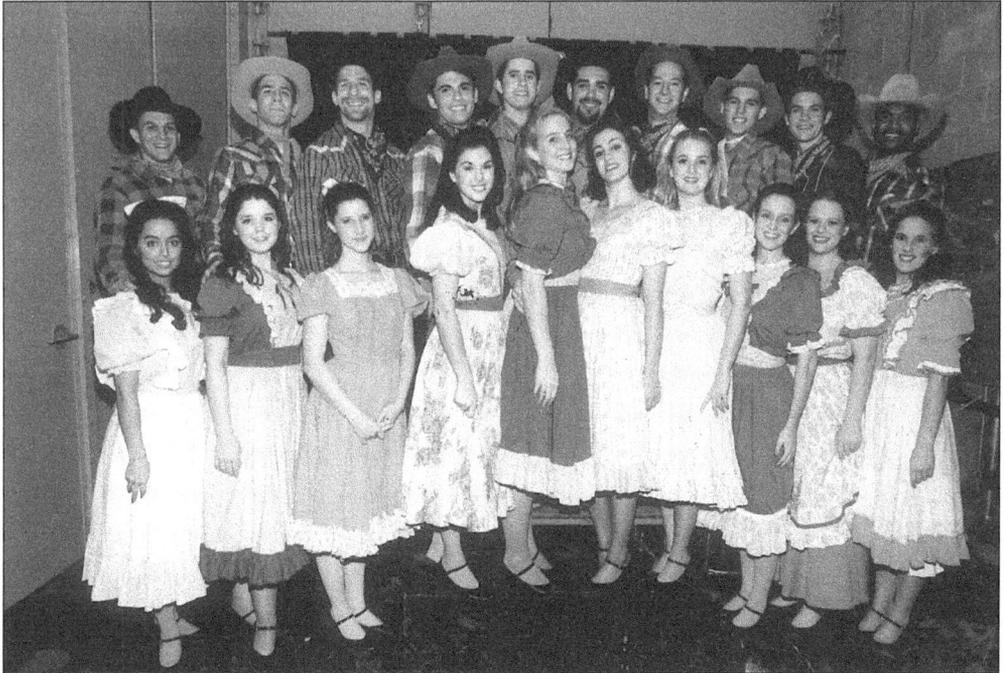

The University of Tulsa has a well-deserved reputation for its Fine Arts program. Here, the university's Musical Theater students appear in costume prior to their performance of the state song "Oklahoma!" (Courtesy Tom Gilbert.)

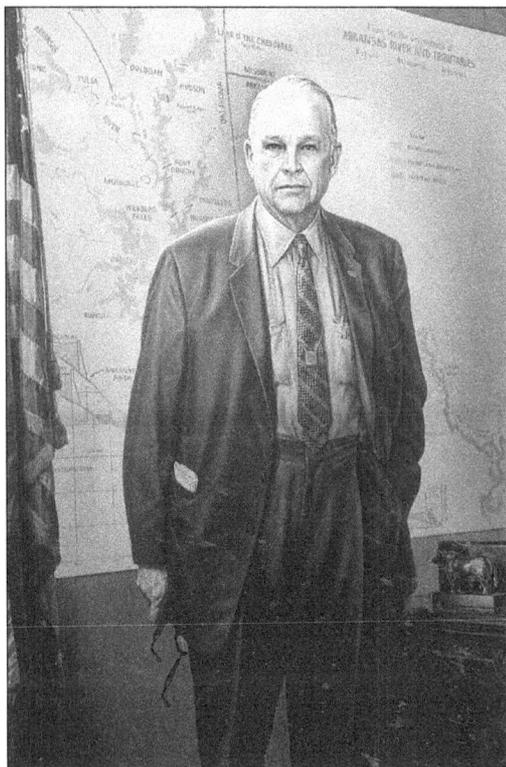

Behind this painting of Oklahoma's Democratic United States Senator Robert S. Kerr is a map of the McClellan-Kerr Arkansas River Navigation Project, which allows barges to travel between Tulsa and the Mississippi River. From the river, Tulsa businessmen can ship their products north to St. Louis and Kansas City, Missouri, or south to New Orleans, Louisiana. (Courtesy Oklahoma Department of Tourism and Recreation; photograph by Fred Marvel.)

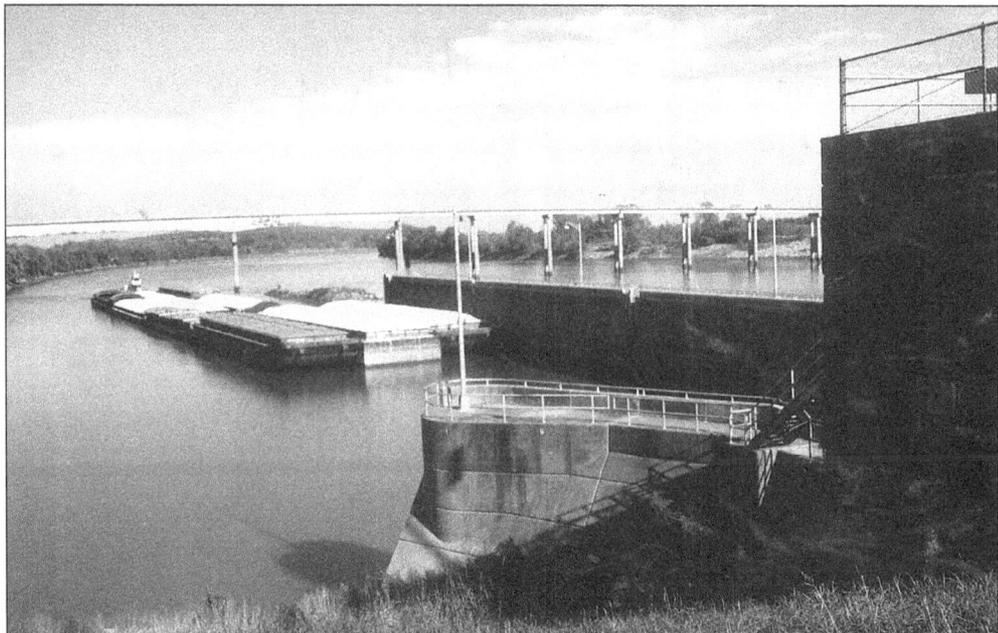

Pushing eight barges, this tug is approaching one of the locks on the McClellan-Kerr Arkansas River Navigation Project east of Tulsa. The 17 locks and dams on the system allow the barges to overcome the 420-foot rise in elevation between the junction of the Arkansas and Mississippi Rivers and Tulsa. (Courtesy Judy Dawson.)

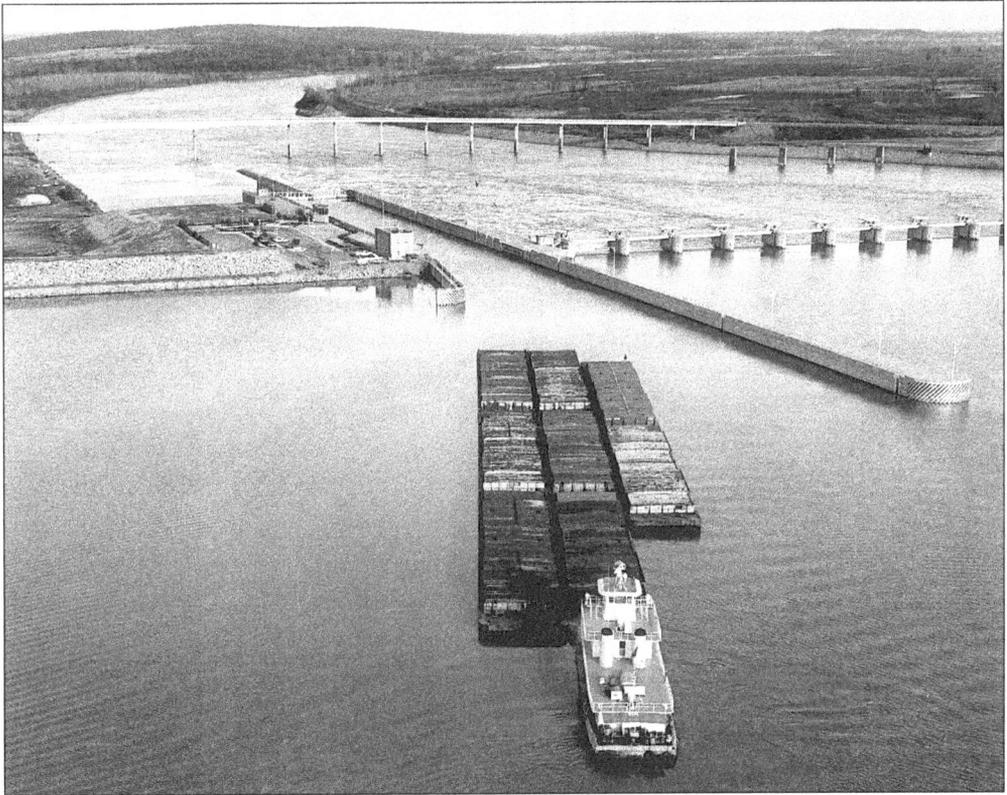

This is the Robert S. Kerr Lock and Dam on the Arkansas River. The McClellan-Kerr Arkansas River Navigation Project gave Tulsa-based industries an outlet to worldwide shipping by stabilizing the Arkansas River and opening it to barge traffic. When completed, it also gave Oklahoma more miles of shoreline than the Atlantic and Gulf coasts. (Courtesy *The Daily Oklahoman*.)

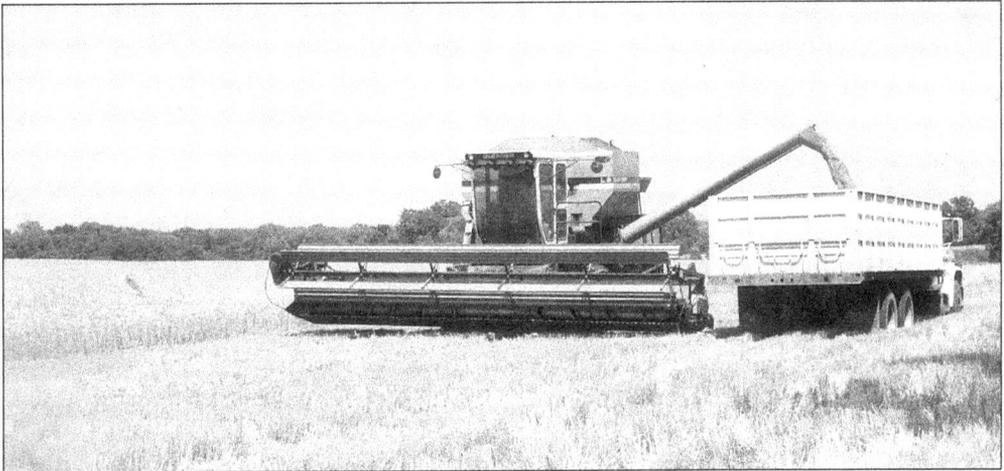

A modern combine cuts wheat on a farm near Tulsa. Agriculture remains an important facet in Tulsa's economy, especially after the completion of the McClellan-Kerr Arkansas River Navigation Project, which allows the bulk shipment of agricultural products worldwide. (Courtesy Clyda R. Franks.)

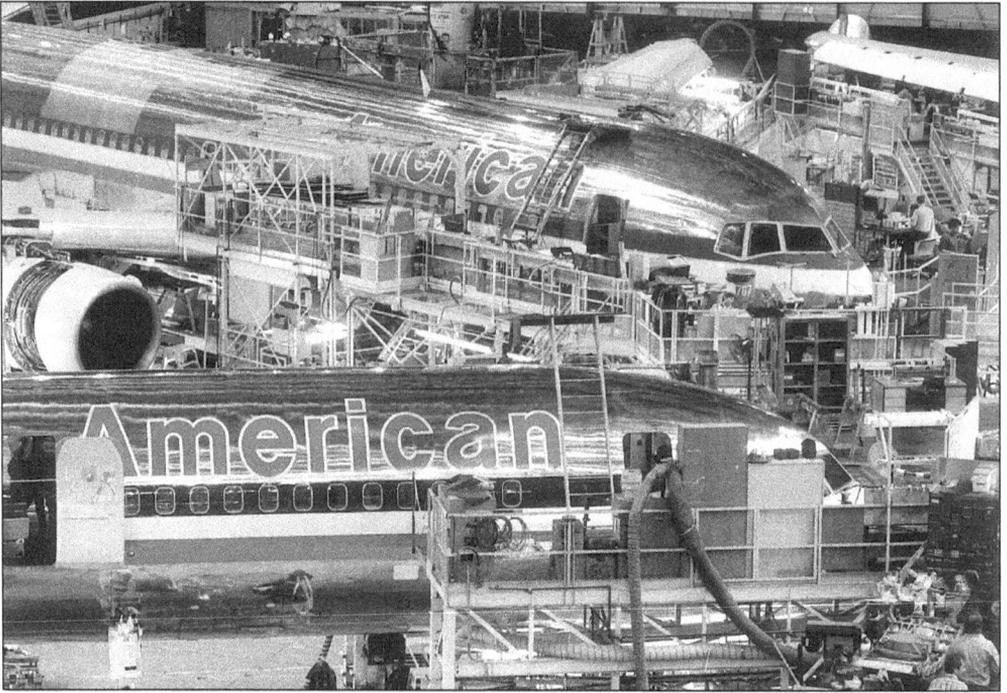

American Airline's Maintenance and Engineering Center at the Tulsa International Airport is a mainstay of the city's economy with a payroll that tops $400 million annually. Workers at the center update older aircraft, fit out new planes before they enter service, and provide scheduled maintenance for airframes and engines. (Courtesy *The Daily Oklahoman*.)

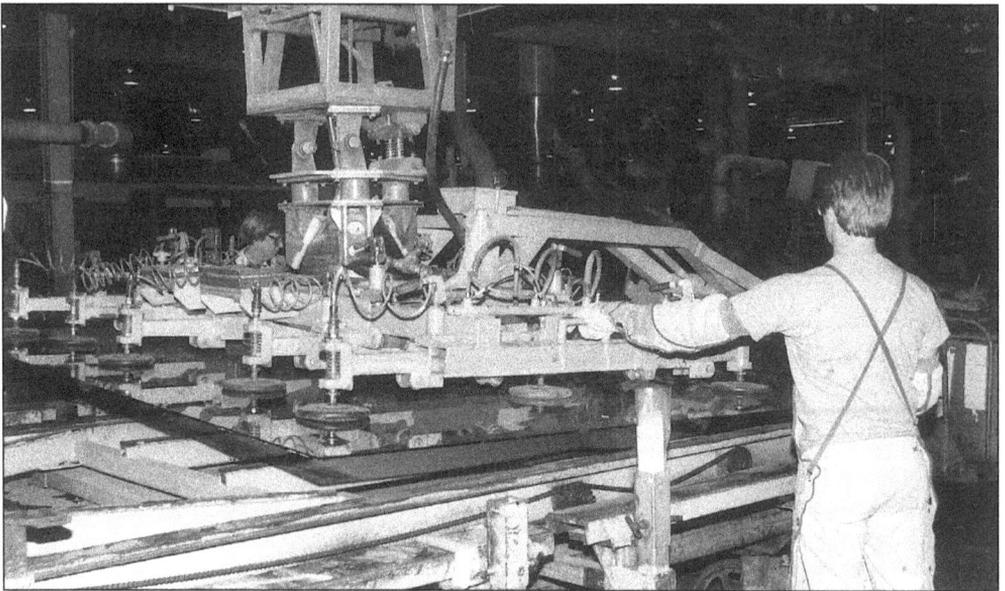

This is an inside view of the Ford Motor Company's glass plant in Tulsa. The plentiful supply of natural gas from nearby oil fields and sand along the Arkansas River has always attracted glass manufacturers to Tulsa. Ford's operation is the largest and produces glass for millions of Ford automobiles. (Courtesy *The Daily Oklahoman*.)

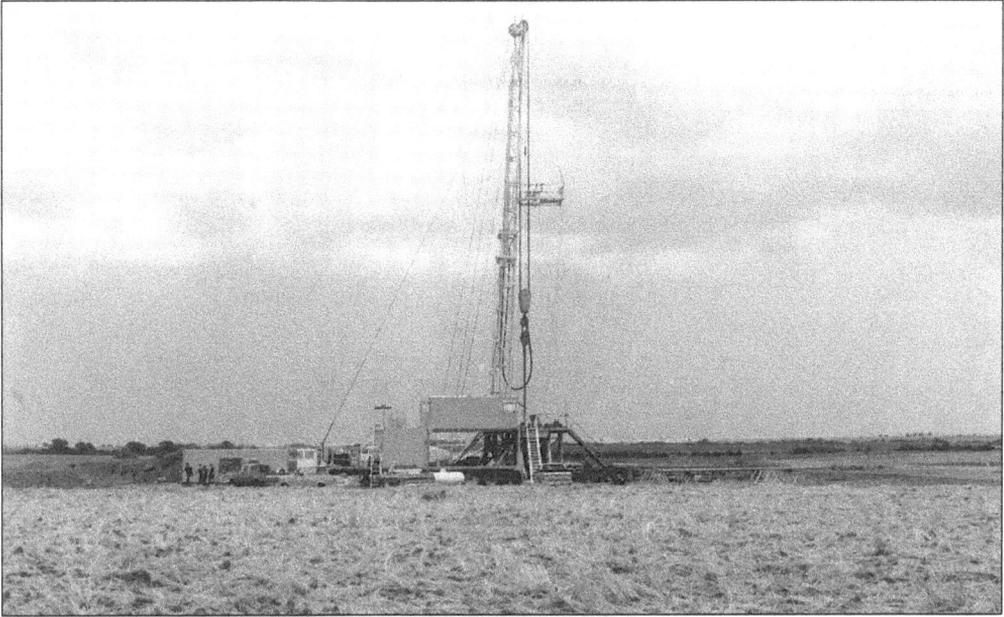

A modern drilling rig sinks a well near Tulsa. Although not as important as it was in the past, the energy industry is still a major factor in Tulsa's 21st century economy. Unlike the drilling rigs of the 1920s and 1930s, many of which were left standing after the wells were completed, modern rigs are portable. (Courtesy Clyda R. Franks.)

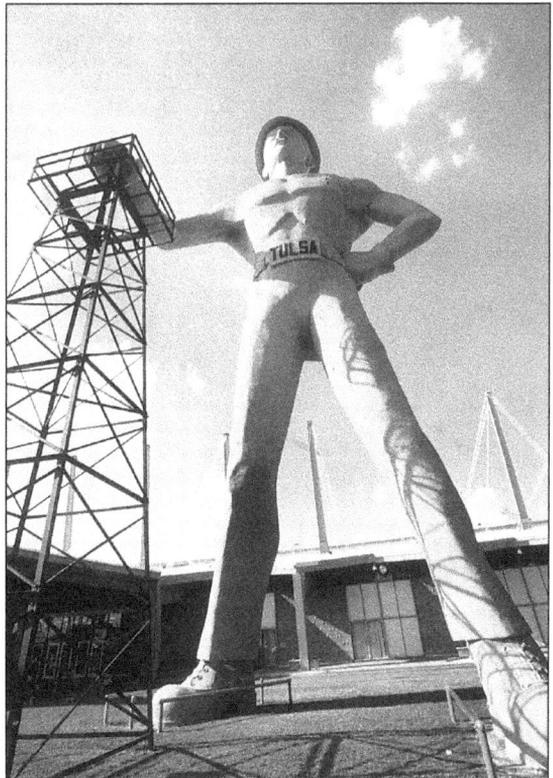

This is the most recent version of the Golden Driller. There were several prior to this, including an earlier version in which the Golden Driller climbed the side of an oil derrick. When it was agreed among area oil men to share the cost of the Golden Driller, it was decided that no company affiliation would be attached to the statue. One company, however, managed to include its logo on the driller's belt buckle. When discovered, the symbol was quickly removed. (Courtesy Judy Dawson.)

First organized in 1921, Tulsa's Little Theater was but one of the many cultural attractions available in Tulsa. *Destry Rides Again* was the theater's 1963 summer performance. (Courtesy *The Daily Oklahoman.*)

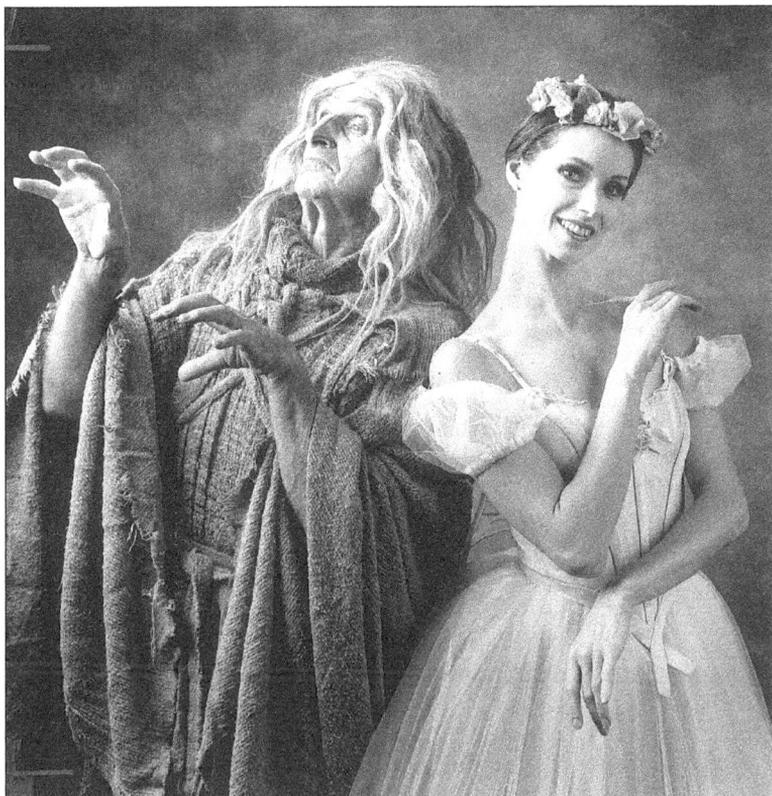

The Tulsa Ballet is one of the city's most successful cultural undertakings. Here, the ballet company presents *La Sylphide*, the story of a Scottish sprite who falls in love with a mortal. The 1988 production featured Frederic Franklin as Madge the witch and Kimberly Smiley as La Sylphide. (Courtesy *The Daily Oklahoman*.)

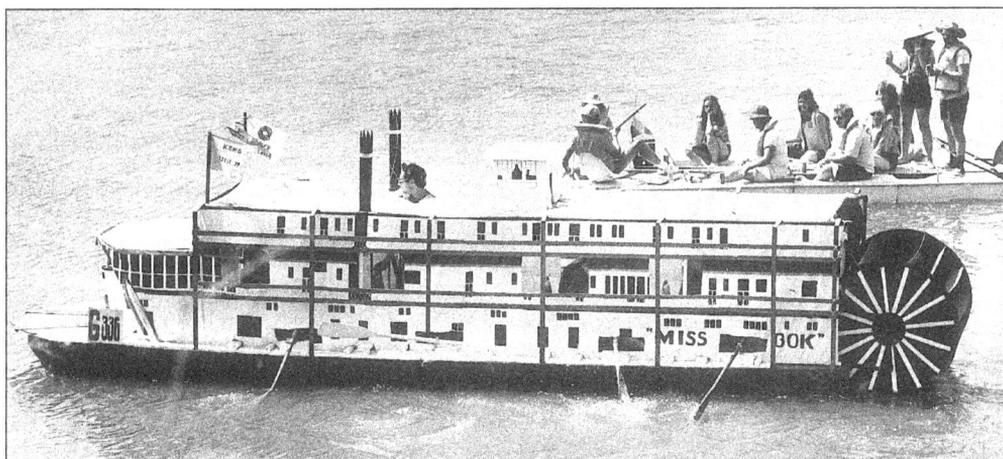

For years the annual Great River Raft Race down the Arkansas River drew thousands to the river as homemade rafts competed to be the first to finish the course, or to just lazily float downstream to the finish line. This was the *Miss BOK*, the Bank of Oklahoma's entry in the 1976 Great River Raft Race. (Courtesy *The Daily Oklahoman*.)

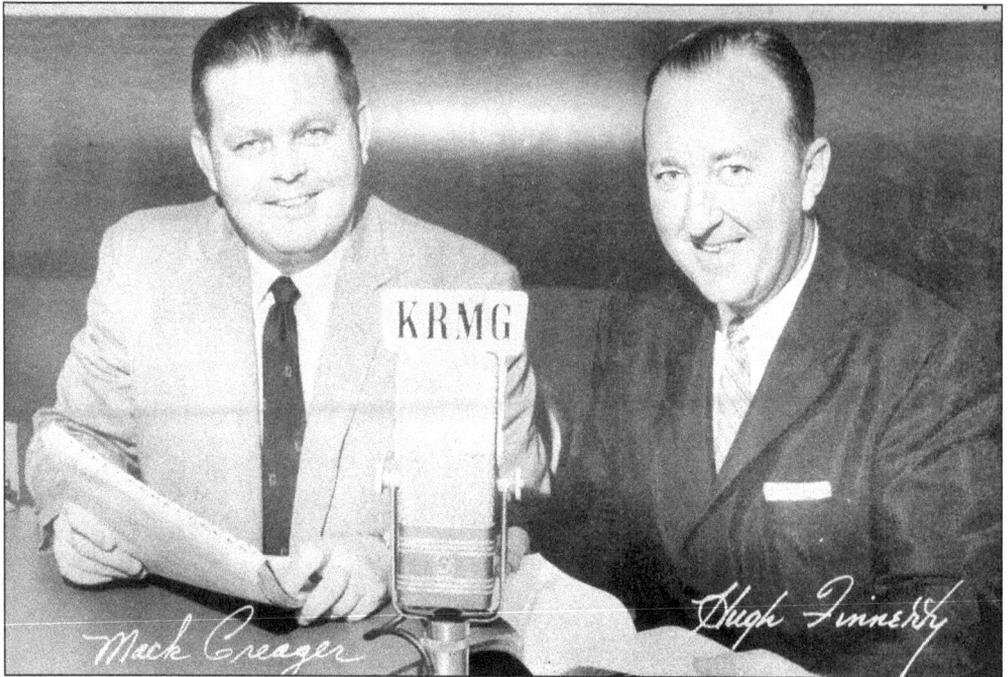

Mack Creager, on the left, broadcast Tulsa Oiler baseball games from 1947 until 1971, and claimed to have seen more Oiler games than anyone else. Hugh Finnerty, right, was general manager, promotional director, president of the Class AA Texas League, and sports director for KOTV television in Tulsa. Finnerty joined Creager in the broadcast booth from 1957 until 1961. (Courtesy Wayne McCombs.)

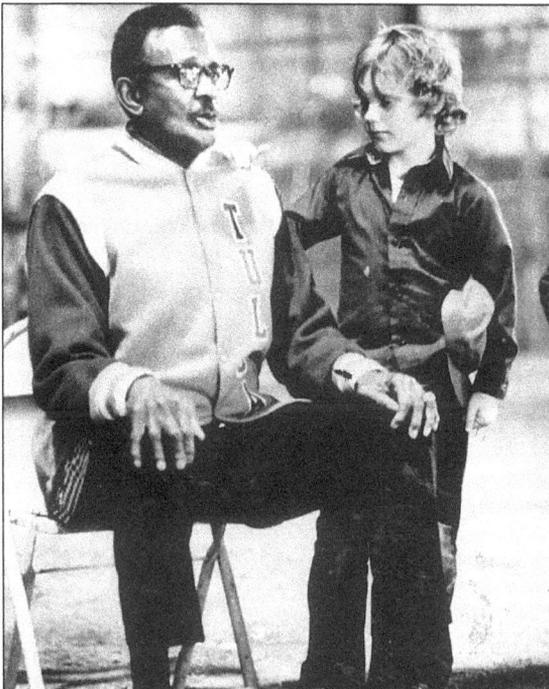

Baseball legend Leroy Robert "Satchel" Paige coached the Tulsa Oilers of the AA Texas League from 1973 until 1976. Paige, who became the first black pitcher in the American League in 1948, is a member of the National Baseball Hall of Fame. Paige is shown here with Jed Smith, the grandson of Tulsa Oiler owner A. Ray Smith. (Courtesy *The Daily Oklahoman*.)

The owner of the Tulsa Oilers baseball team from 1961 until 1976 was A. Ray Smith. The Oilers trace their beginnings to 1907, when they were a part of the Oklahoma-Arkansas-Kansas Class D League. The team became the Tulsa Drillers in 1977. (Courtesy Tulsa Oilers.)

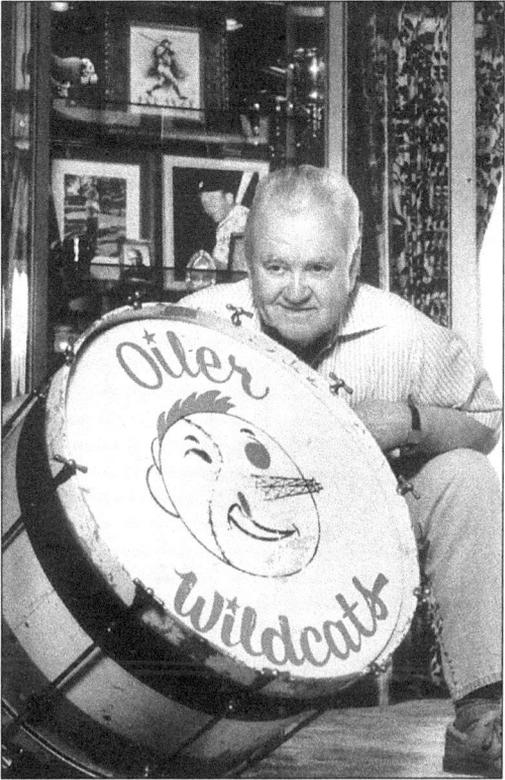

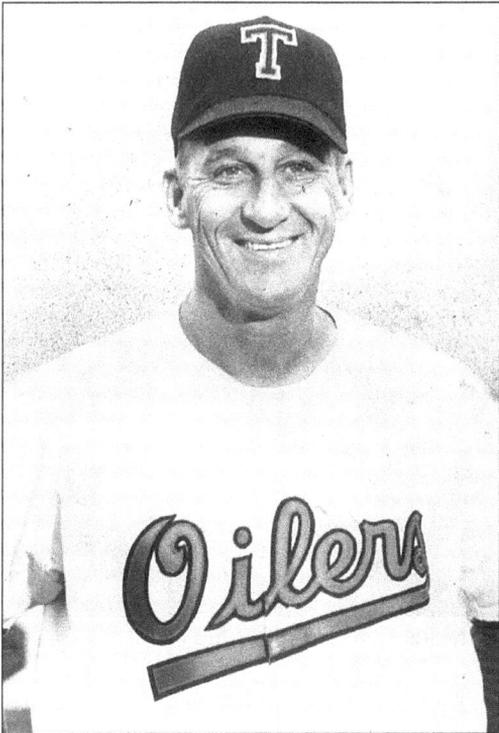

Another manager and player for the Tulsa Oilers was Warren Spahn, who during a 21-year career with the National League, won 363 games. Spahn, who coached the Oilers between 1967 and 1971, also is a member of the National Baseball Hall of Fame. Spahn first came to Oklahoma with the army during World War II, and later settled in Broken Arrow, just southeast of Tulsa. (Courtesy National Baseball Hall of Fame.)

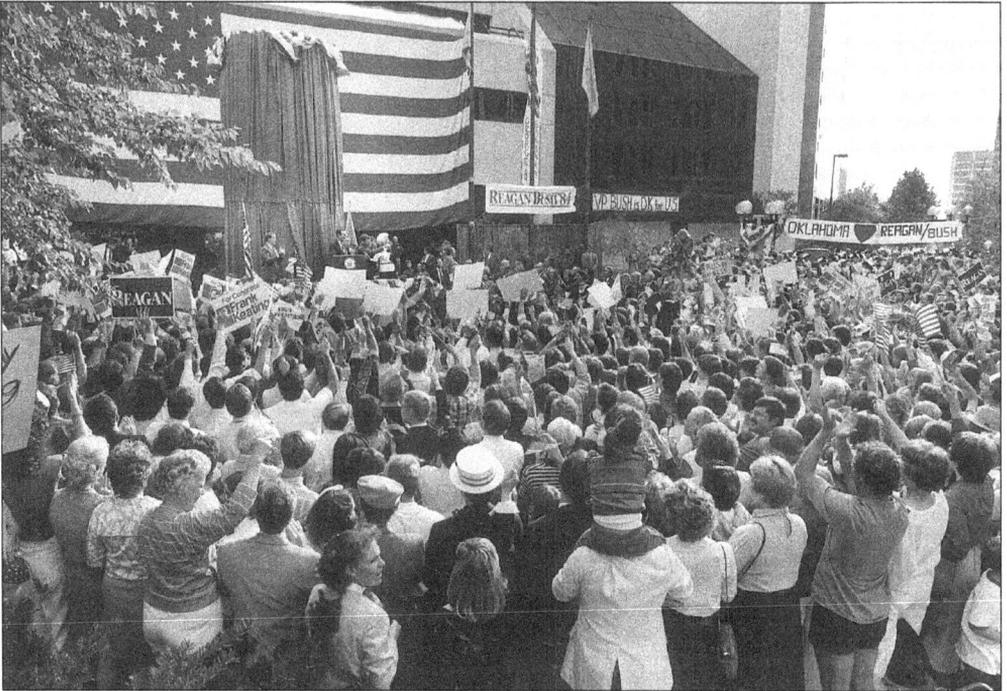

Vice President George Bush and his wife Barbara appeared in downtown Tulsa during the 1984 presidential election campaign. Tulsa always has been a center of Republican power in Oklahoma politics. (Courtesy *The Daily Oklahoman*.)

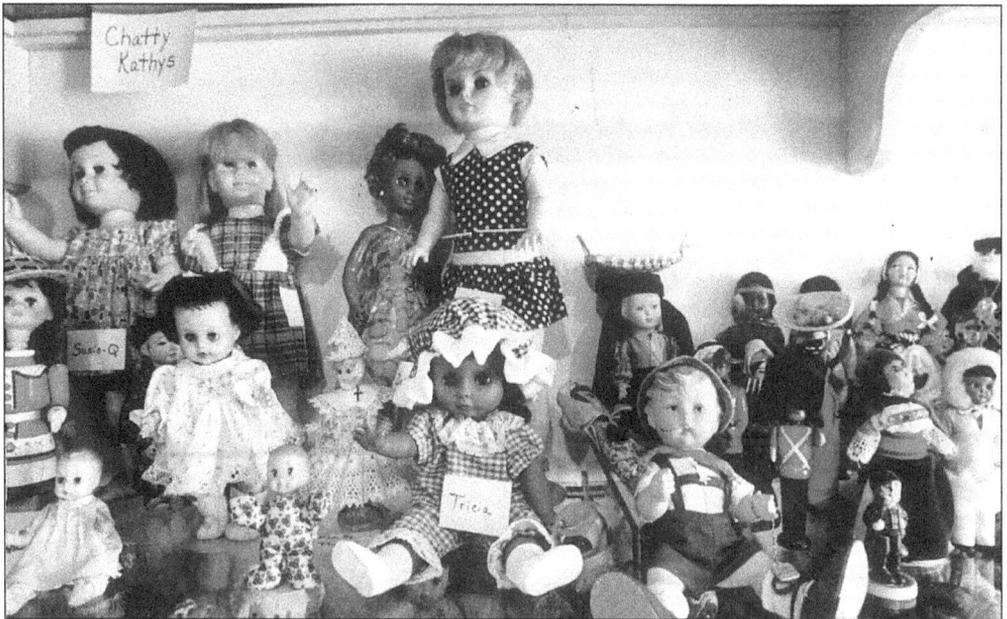

One of Tulsa's most popular collectors' museums is the Ida Dennie Willis Museum of Miniatures, Dolls, and Toys at 628 North Country Club Drive. This is but a portion of the thousands of dolls, of all shapes and sizes, housed in the museum. (Courtesy Oklahoma Department of Tourism and recreation; photograph by Fred Marvel.)

Every June, thousands of music lovers gather in Tulsa for the Greenwood Heritage Festival where they listen to jazz, blues, and gospel music during the annual Juneteenth Celebration. (Courtesy Oklahoma Department of Tourism and Recreation; photograph by Fred Marvel.)

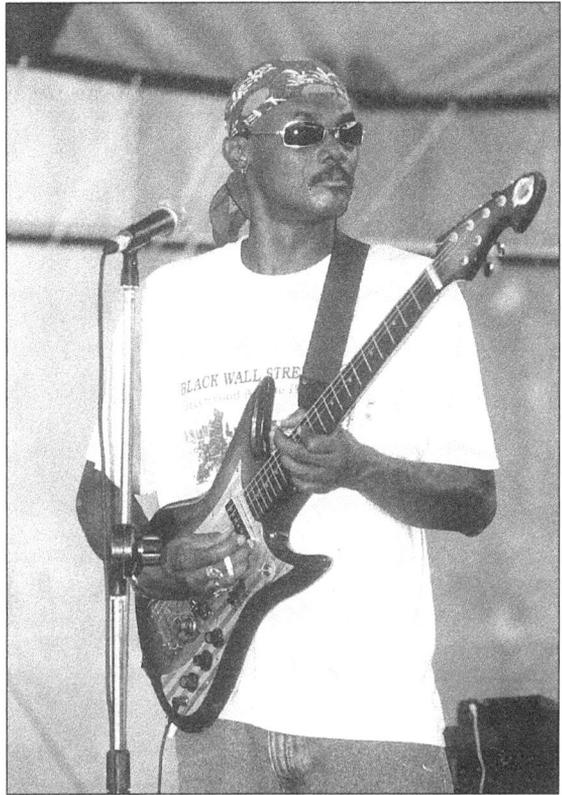

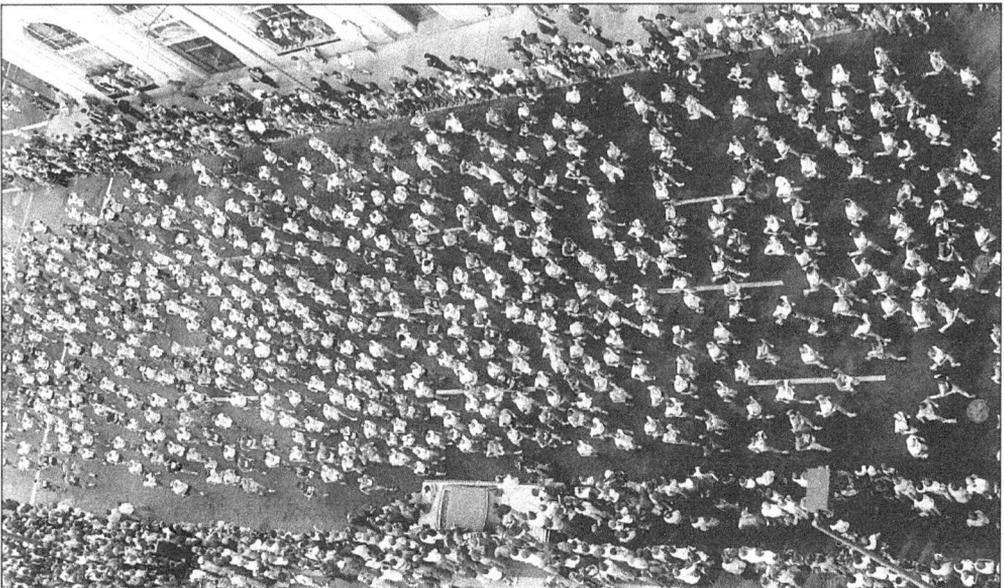

The annual Tulsa Run, a 15-kilometer race and a 3-kilometer fun run, attracts thousands each year to the 9.3-mile-long circuit along Riverside Drive beside the banks of the Arkansas River. This is the start of the 1978 race. (Courtesy *The Daily Oklahoman*.)

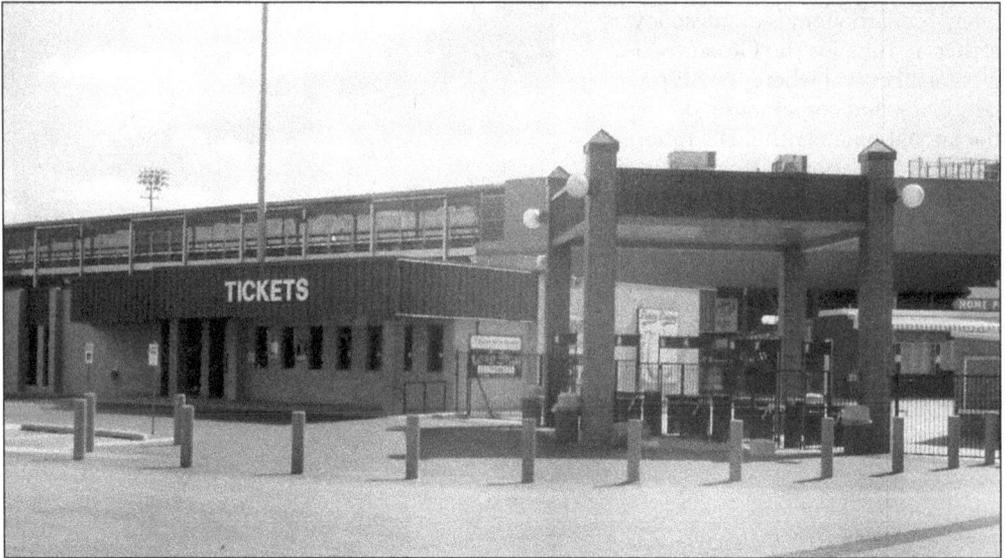

In 1977, a portion of the right field stands in the 43-year-old stadium in Tulsa's Driller Park collapsed, injuring 17 people. It was not until 1980 that the Tulsa County-Tulsa Fairgrounds Authority approved a new stadium. This is a photograph of the entrance to the new Driller Stadium that was made possible by a donation by Tulsa oil man Robert Sutton. (Courtesy Tulsa Drillers.)

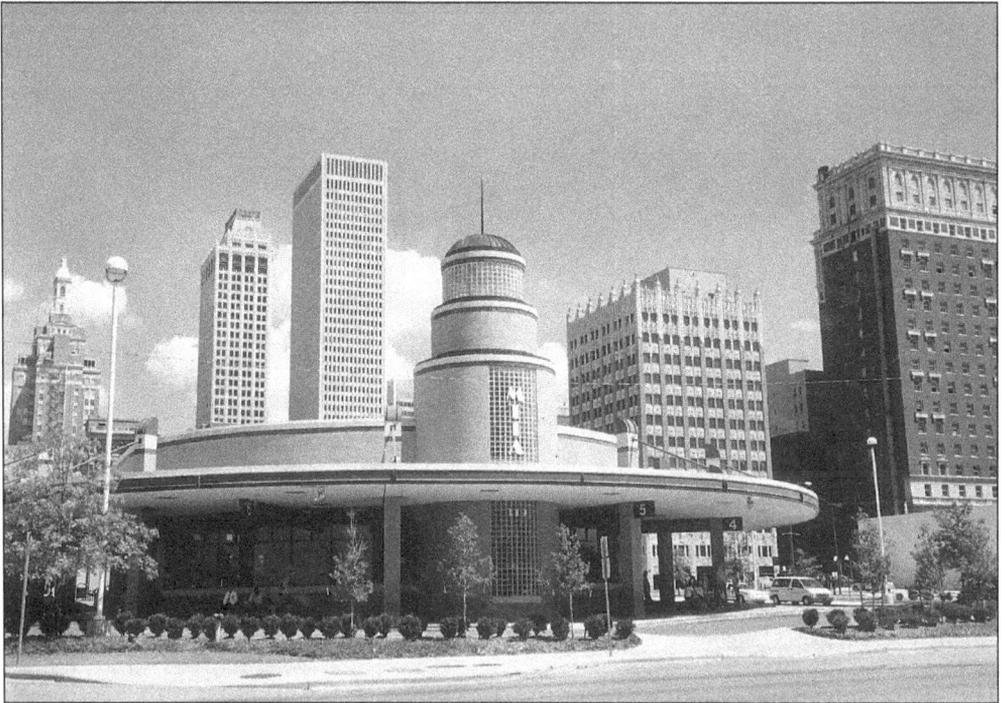

The Art Deco-style Metro Tulsa Transit Authority Building sits in the heart of downtown Tulsa. (Courtesy Judy Dawson.)

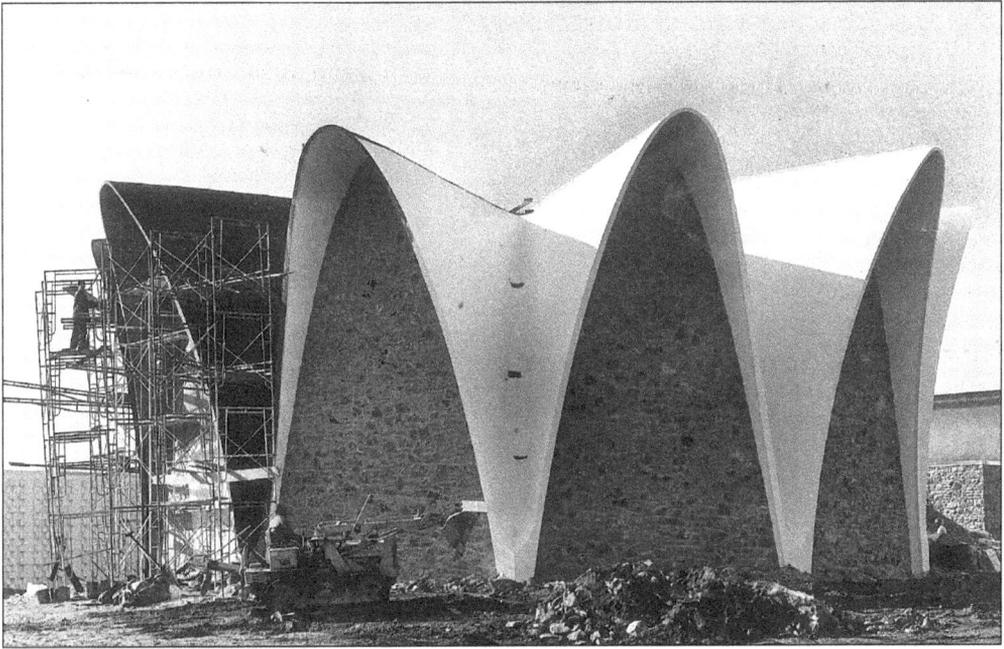

Once the world headquarters of Tulsa-based evangelist T.L. Osborn, this unique building still catches the eye of motorists on I-44 near Peoria Avenue. The building was built in 1963 and contained a "world room," which displayed art and artifacts that Osborn had collected during his worldwide evangelistic travels. (Courtesy *The Daily Oklahoman*.)

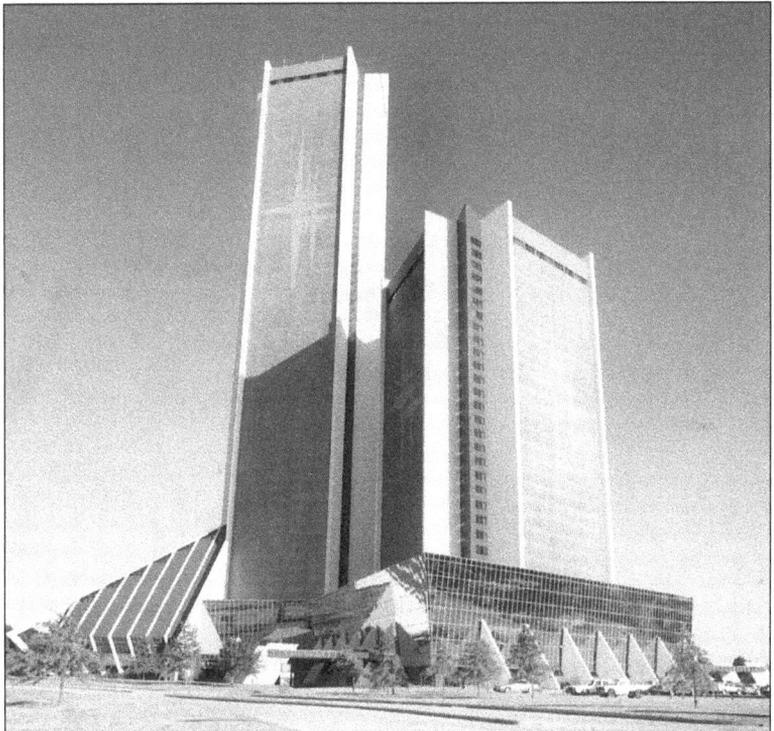

Initially built as a part of Oral Roberts University's City of Faith complex, Cityplex Towers on the ORU campus was converted to 2.3 million square feet of private office space in 1993. (Courtesy *The Daily Oklahoman*.)

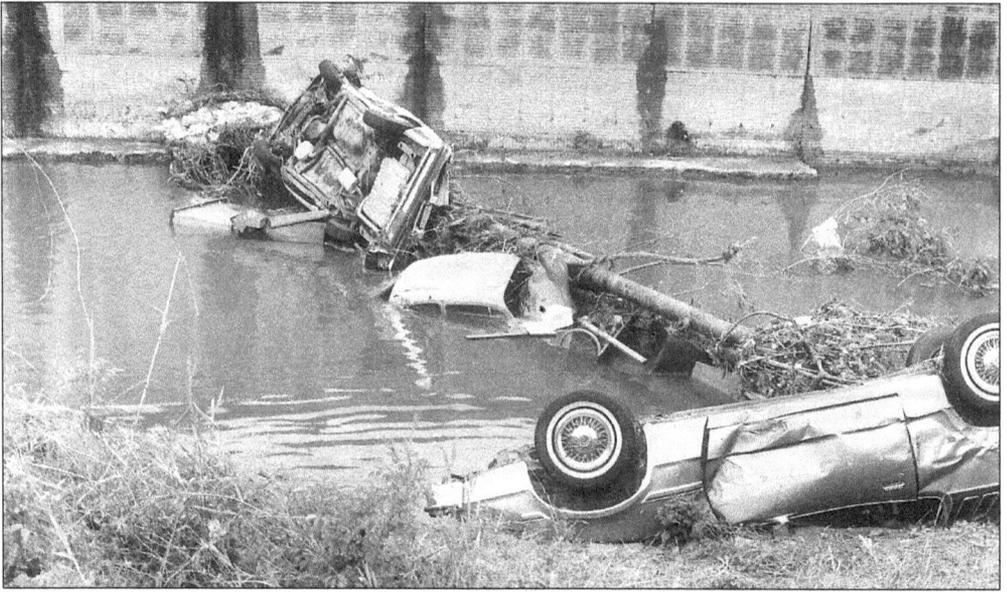

During the Tulsa flood of May 1984, automobiles were thrown about like toys by the rampaging floodwaters. This photograph was taken of a drainage canal near the intersection of I-44 and Harvard Avenue. (Courtesy *The Daily Oklahoman*.)

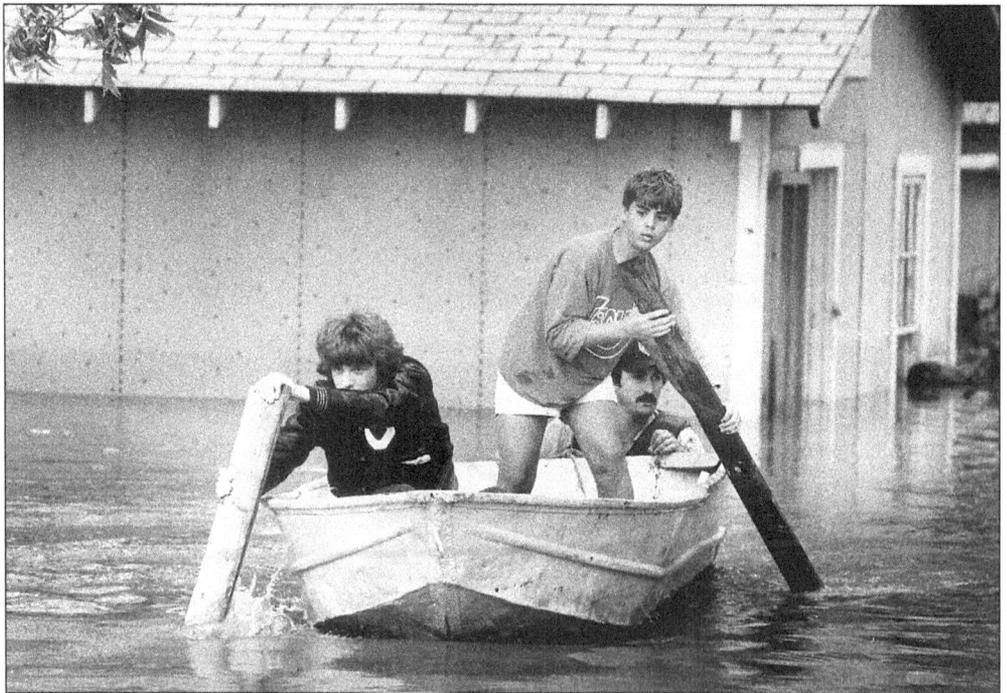

Although the Arkansas River had flooded many times in the past, the construction of upstream flood-control dams was believed to have eliminated the problem. However, in late May of 1984, Tulsa was struck by its worst-ever flood. In this photograph, Mike Evans of the Tulsa Fire Department helps Dewayne Acree and Mike Roger escape the rising waters. (Courtesy *The Daily Oklahoman*.)

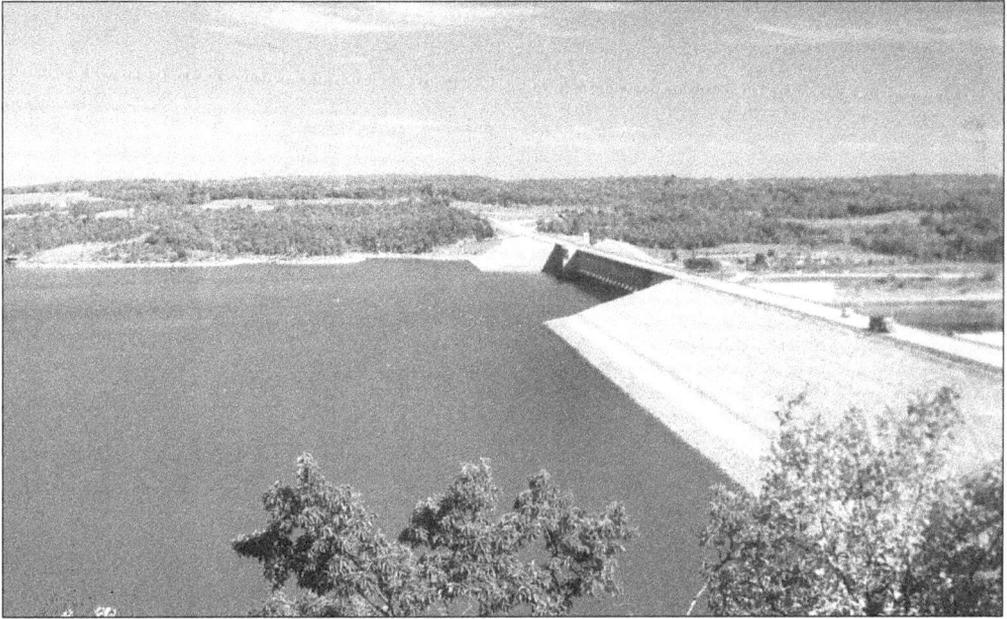

At a height of 221 feet, the Keystone Dam, just to the west of Tulsa on the Arkansas River, impounds Keystone Reservoir, a major recreation center for the Tulsa area. The huge V-shaped lake contains 26,300 surface acres of water with 240 miles of shoreline. (Courtesy Clyda R. Franks.)

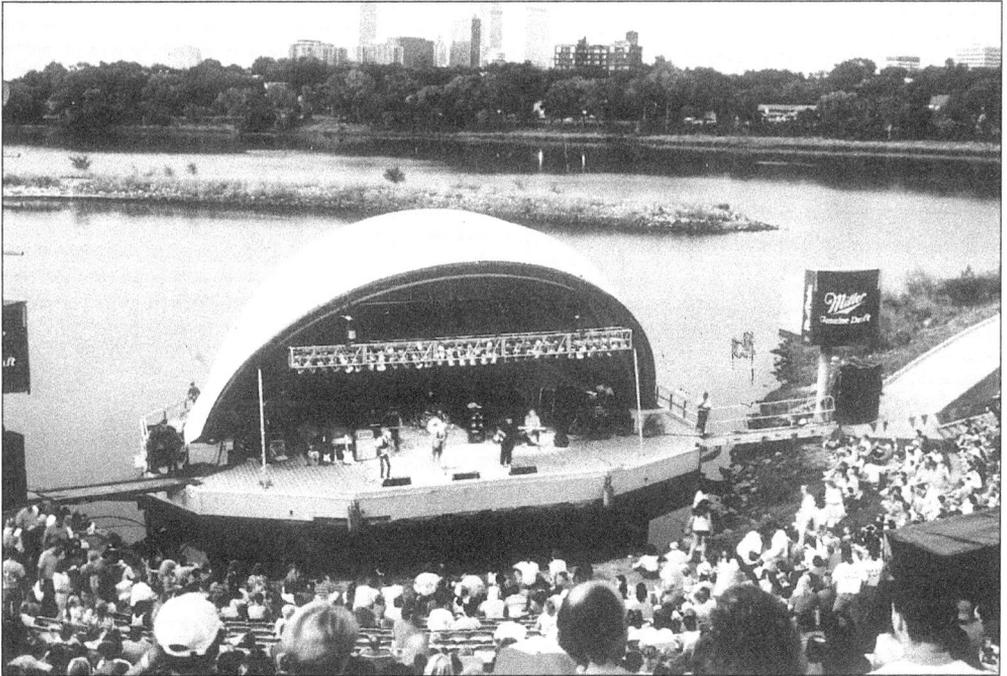

Tulsa maintains almost 20 miles of pedestrian and bicycle trails along the banks of the Arkansas River. The highlights of the system are the floating stage and accompanying amphitheater where a variety of entertainment events are presented. (Courtesy Oklahoma Department of Tourism and Recreation; photograph by Fred Marvel.)

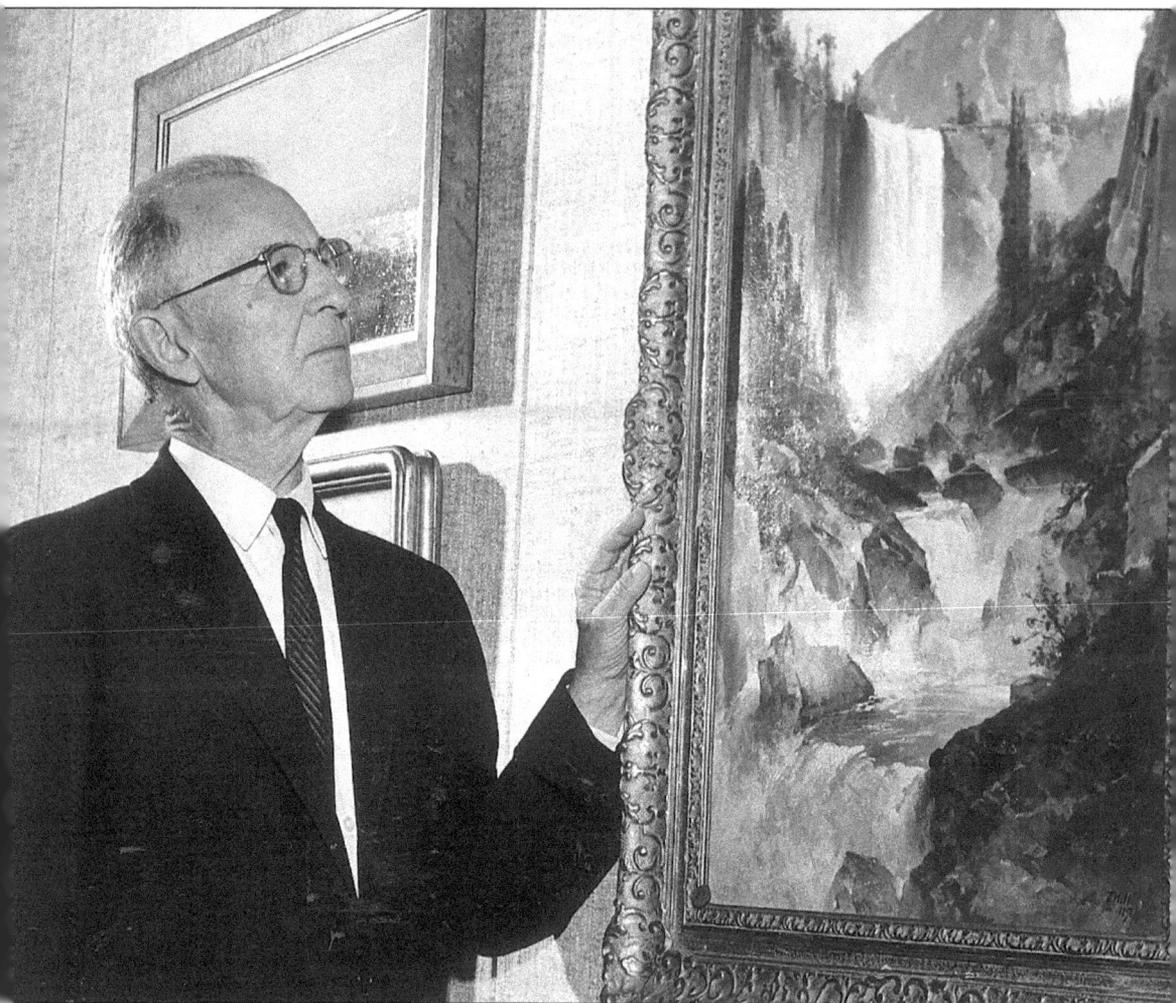

Thomas Gilcrease, the founder of Tulsa's Gilcrease Museum, is seen here viewing one of the museum's more than 5,000 works of art. Recognized internationally as one of the world's great art museums and research libraries, it attracts tens of thousands of visitors annually. (Courtesy *The Daily Oklahoman.*)

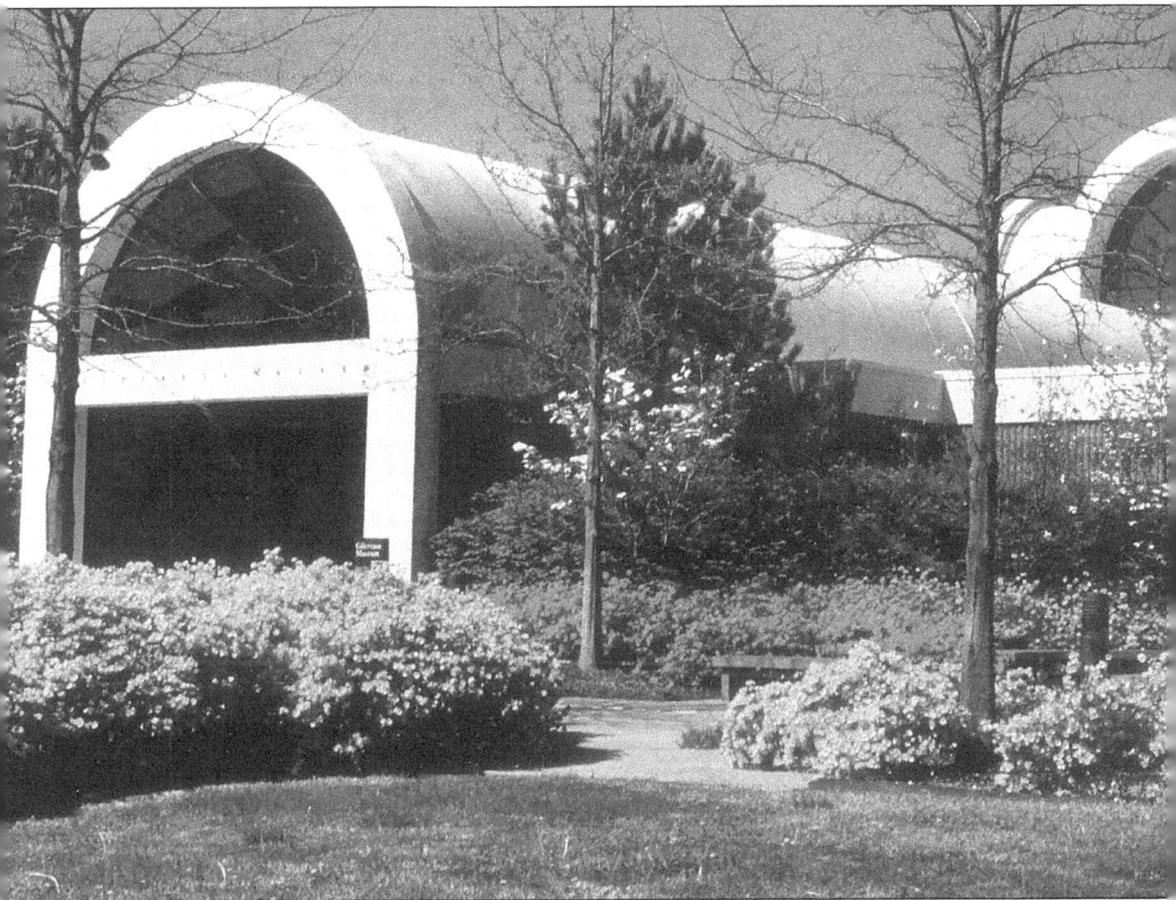

The original cut-stone home of Tulsa oil man Thomas Gilcrease is located on a high hill overlooking the Osage Hills in West Tulsa. Adjoining the home is the Gilcrease Museum, shown here, home of the world's largest and most comprehensive collection of art of the American West. (Courtesy Oklahoma Department of Tourism and Recreation; photograph by Fred Marvel.)

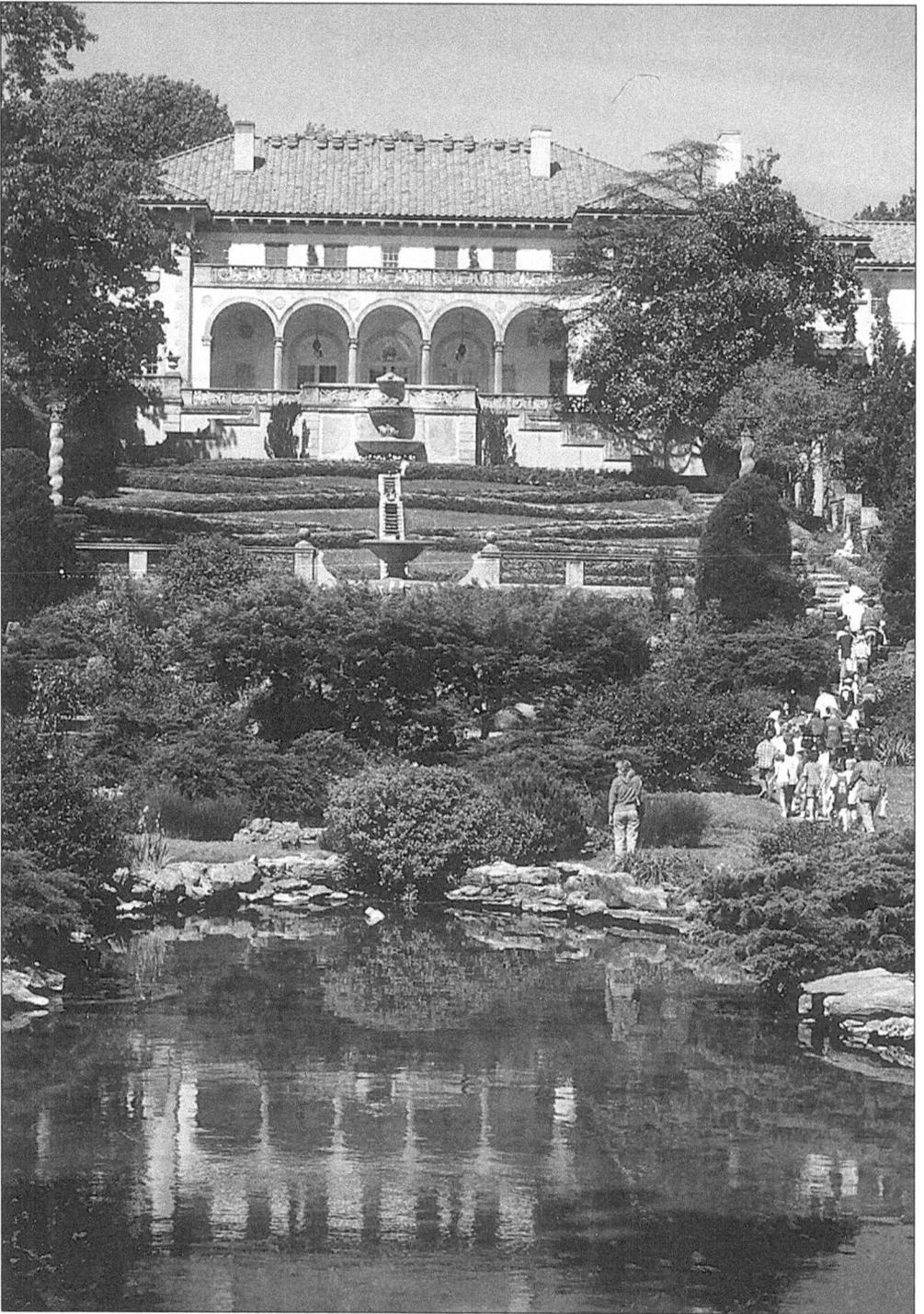

The Philbrook Museum of Art is surrounded by 23 acres of English-style formal gardens, including this lake. The historic Italian-style villa has been featured on the television show America's Castles, and is one of the nation's top 50 art museums. (Courtesy Oklahoma Department of Tourism and Recreation; photograph by Fred Marvel.)

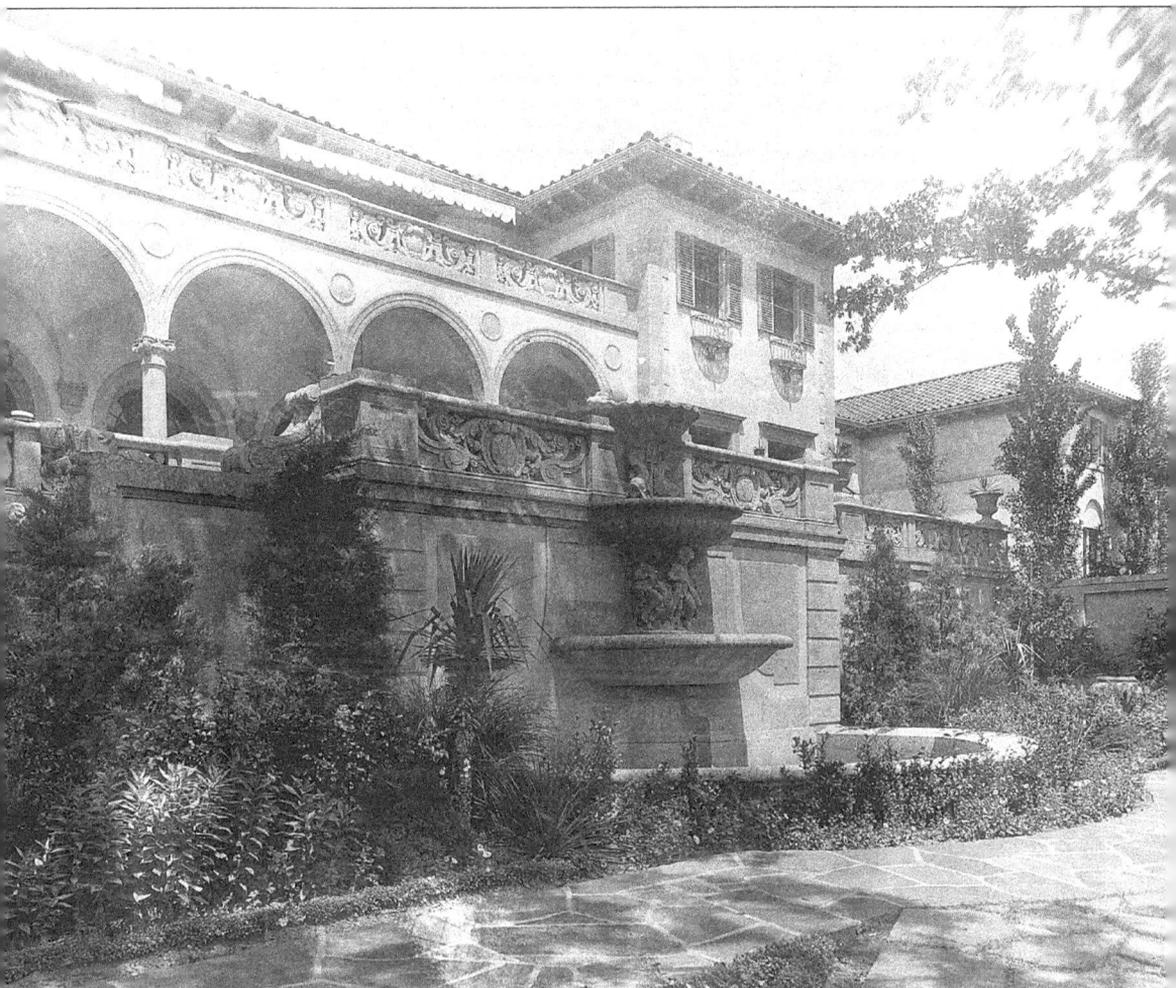

Located at 2727 South Rockford Road, the Philbrook Museum of Art is the former home of oil man Waite Phillips and is listed in the National Register of Historic Places. This view is from the formal garden looking toward the terrace and roofed, open gallery. (Courtesy *The Daily Oklahoman*.)

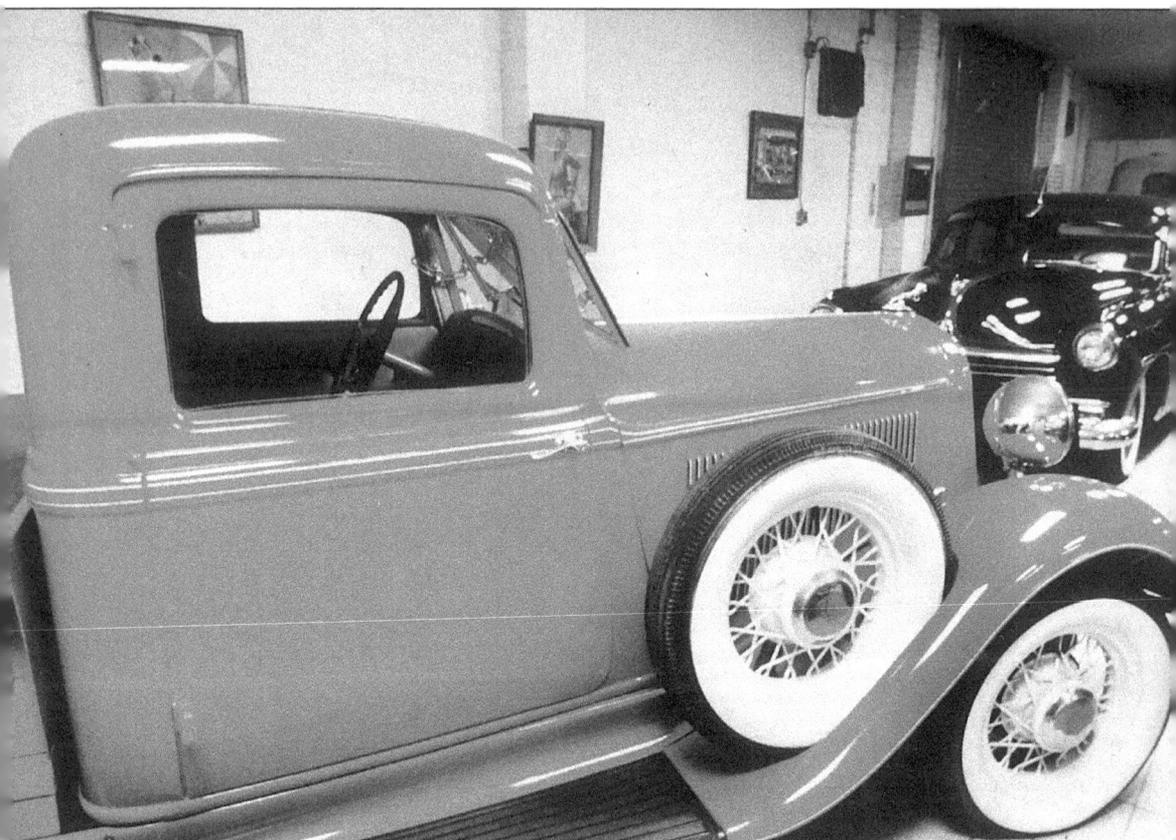

The exhibits at Mac's Antique Car Museum include a model 1918 Tulsa 4 pickup manufactured between 1917 and 1922 specifically for use in the nearby oil fields. The truck was made by the Tulsa Automobile Corporation, headquartered at 14 West Brady Street. (Courtesy Oklahoma Department of Tourism and Recreation; photograph by Fred Marvel.)

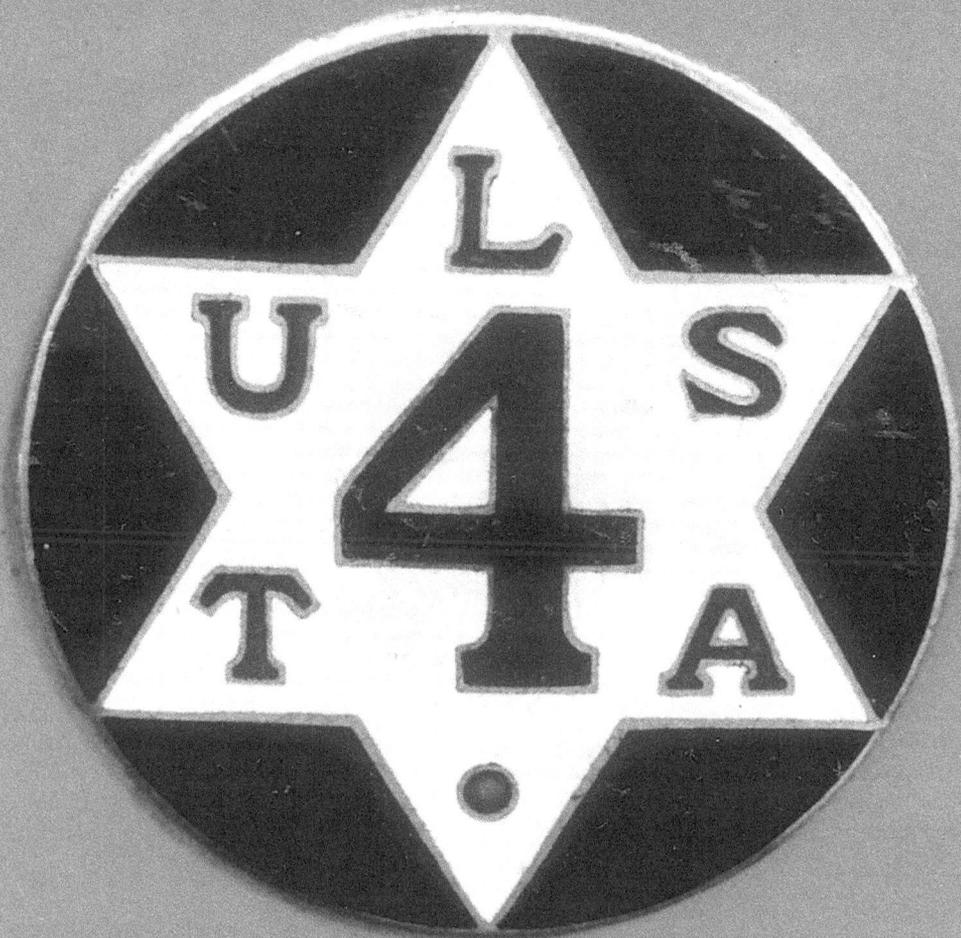

This is the emblem for the Tulsa 4 pickup manufactured in Tulsa between 1917 and 1922. The Tulsa 4 pickup was powered by a Lycoming aircraft engine that gave it more horsepower and performance than most other domestic automobiles. (Courtesy Oklahoma Department of Tourism and Recreation; photograph by Fred Marvel.)

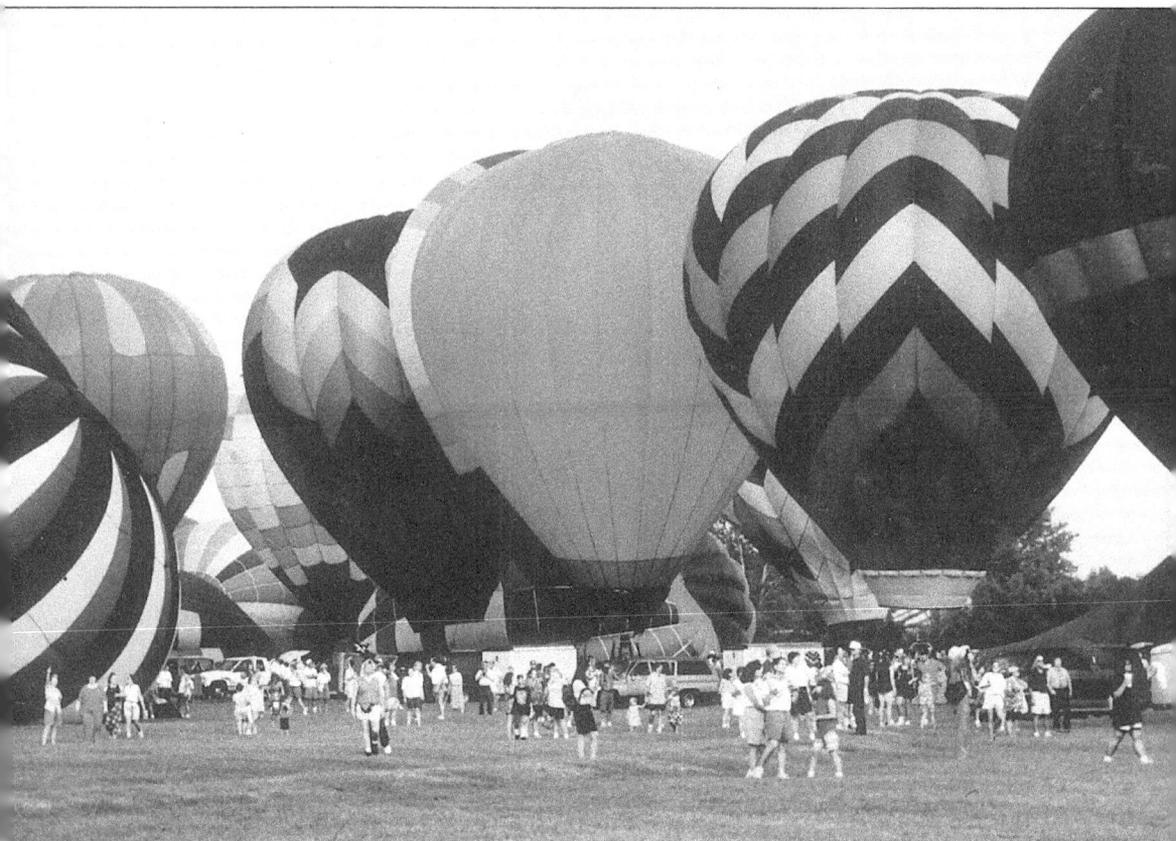

Held each August at the Occidental Center, at South Forty-first Street and 129th East Avenue, the three-day Gatesway International Balloon Festival features more than 100 hot air balloons, live entertainment, children's attractions, plentiful food, and arts and crafts. (Courtesy Department of Tourism and Recreation; photograph by Fred Marvel.)

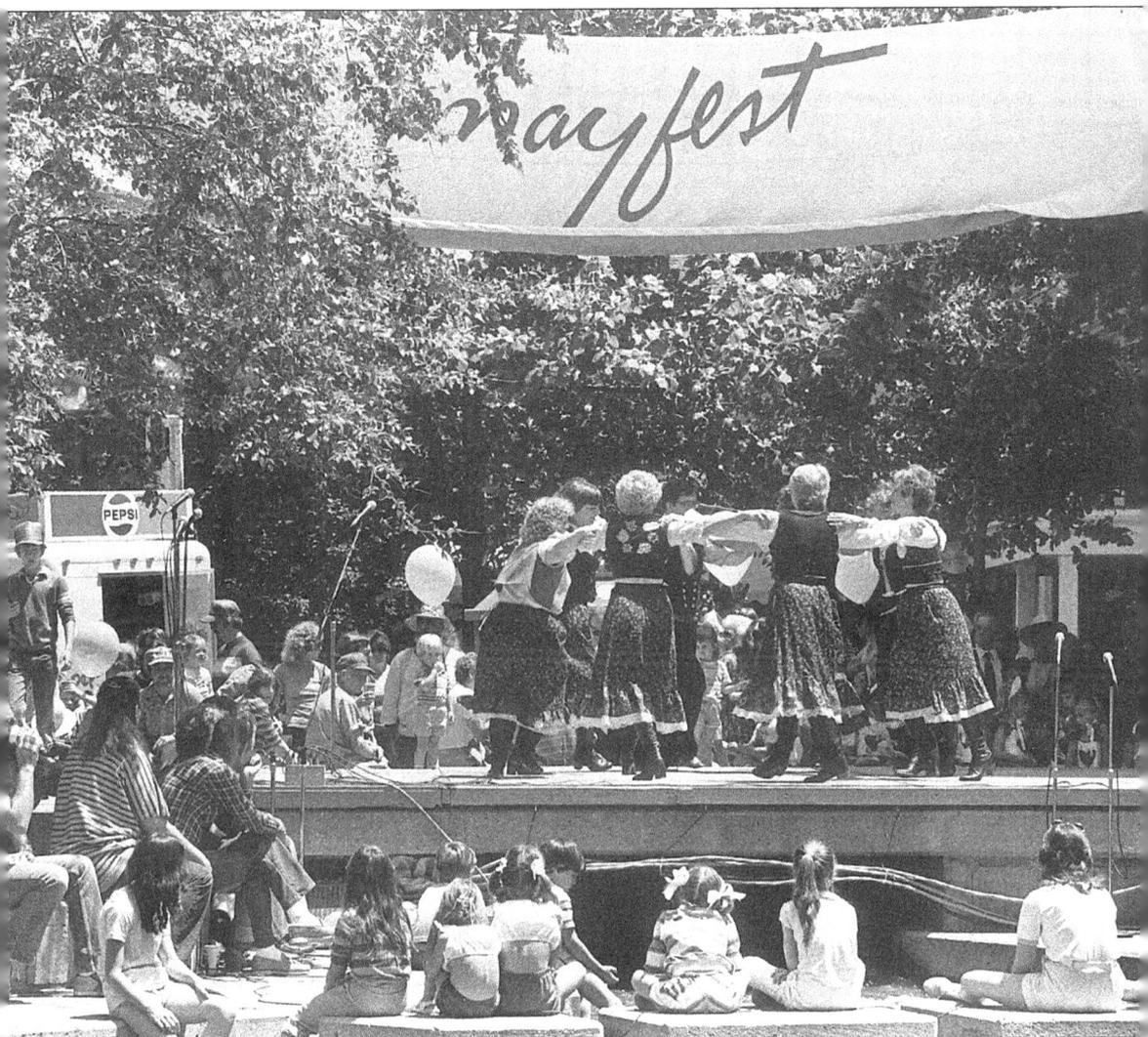

Costumed dancers are shown performing at Tulsa's annual Mayfest. Held each spring, Mayfest attracts thousands of participants and visitors to downtown Tulsa. It is one of Tulsa's most popular events. (Courtesy *The Daily Oklahoman*.)

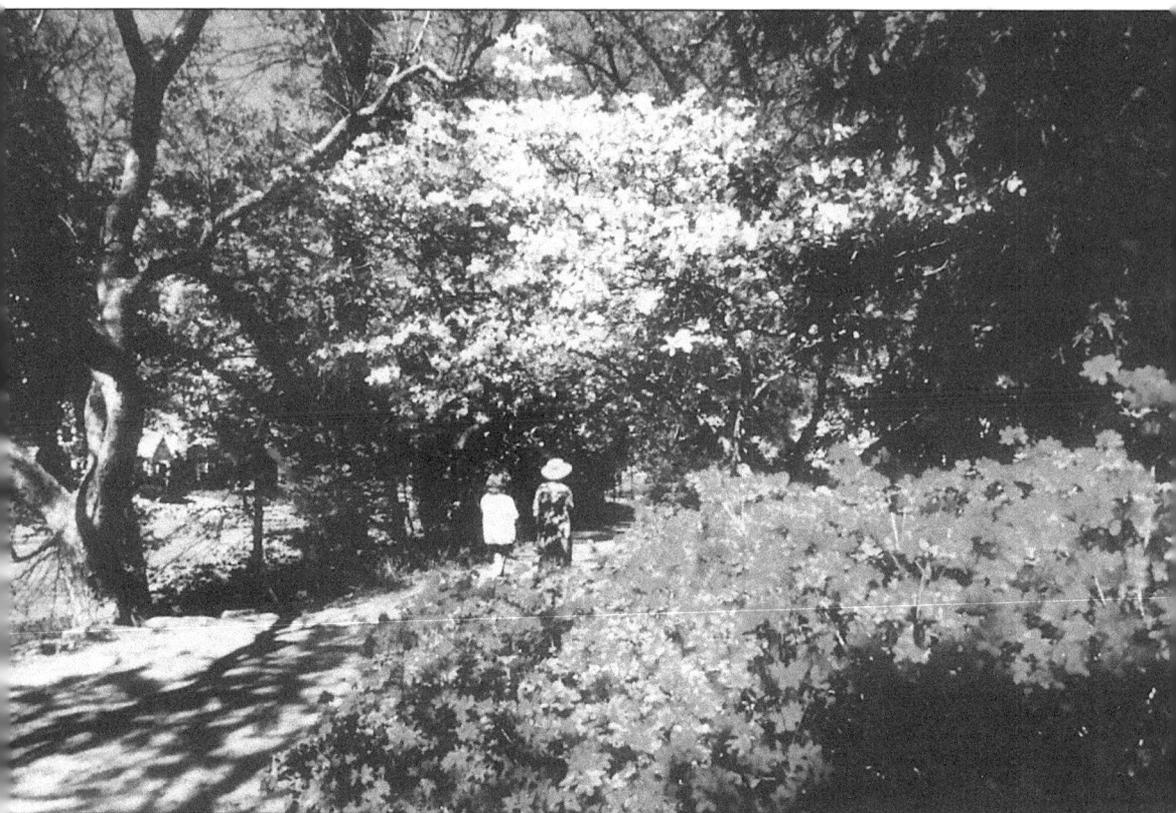

Located at the intersection of Twenty-first Street and South Peoria Avenue, Tulsa's 40-acre Woodward Park is the home to gorgeous azaleas, iris, and numerous other flowers and trees growing alongside a gently flowing stream. It attracts nature lovers year-round. The adjacent Tulsa Garden Center contains a Victorian conservatory and 3-acre arboretum. (Courtesy Oklahoma Department of Tourism and Recreation; photograph by Fred Marvel.)

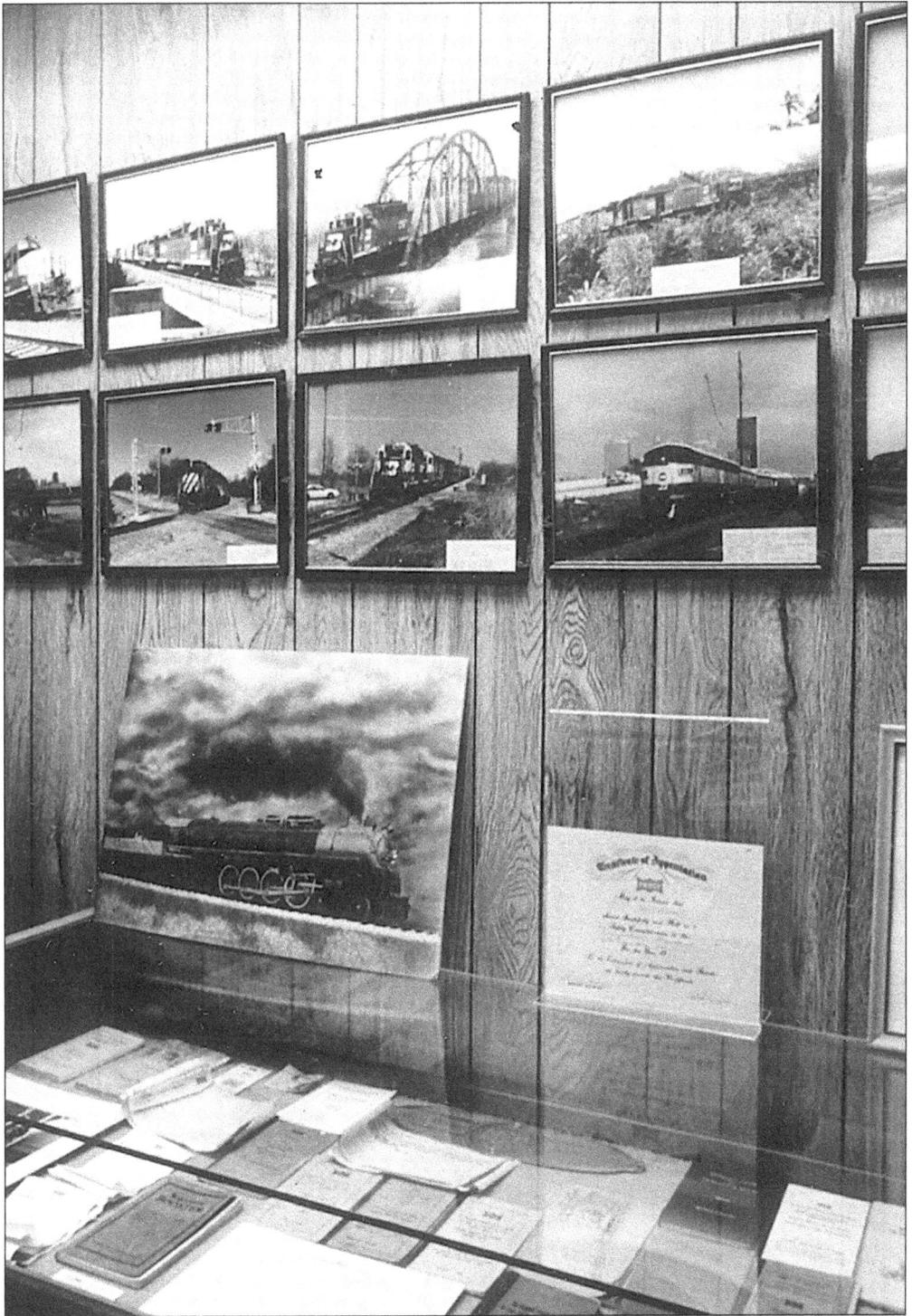

The Sunbelt Railroad Historical Museum at 1323 East Fifth Street in Tulsa is a rail buff's delight. It is filled with historic photographs and memorabilia of the Tulsa area. (Courtesy Oklahoma Department of Tourism and Recreation; photograph by Fred Marvel.)

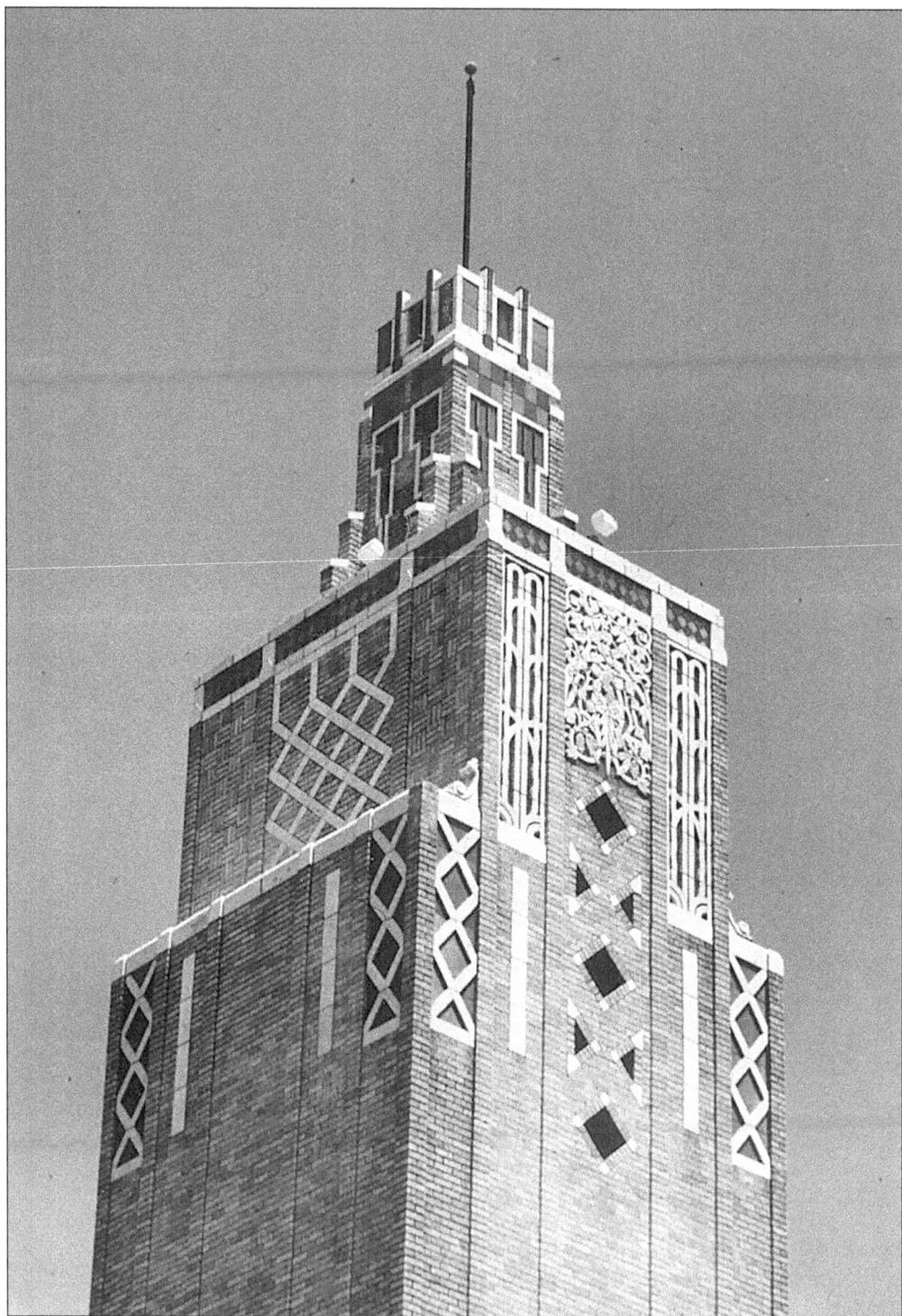

Completed in 1929, the Warehouse Market at 411 East Eleventh Street on old US-66 is in the midst of Tulsa's historic Art Deco district. (Courtesy Oklahoma Department of Tourism and Recreation; photograph by Fred Marvel.)

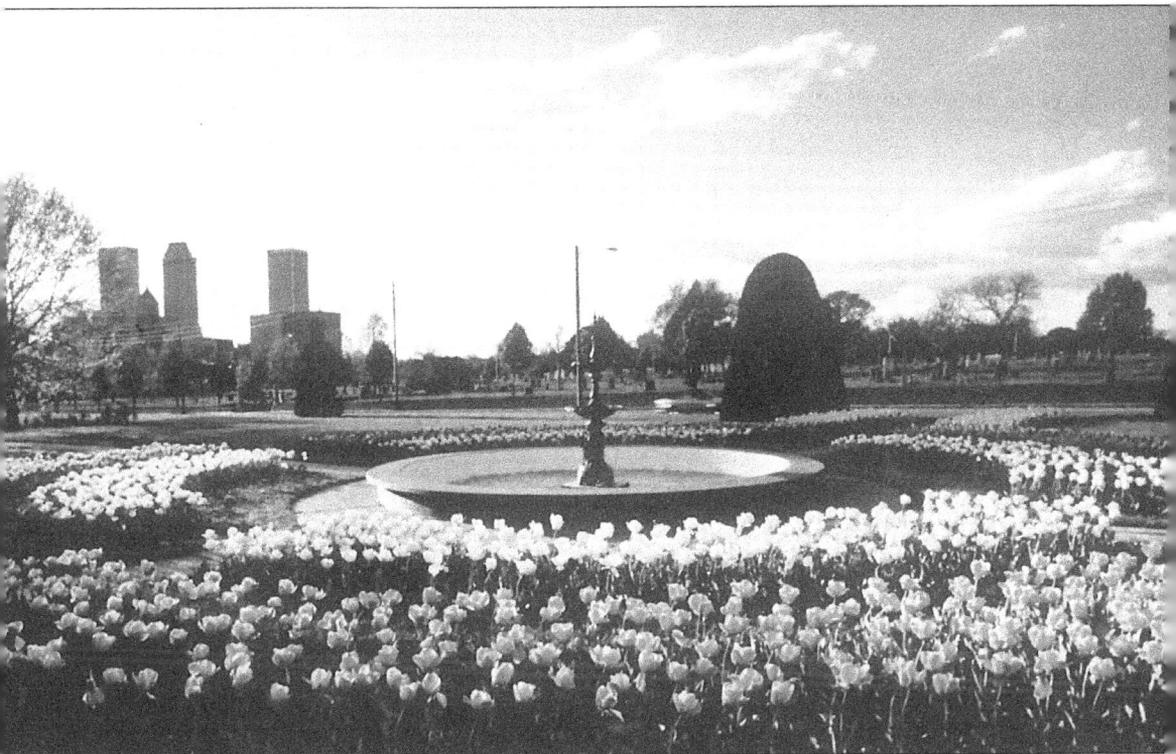

This view looks west at the downtown skyline of modern-day Tulsa from the fountain and flower gardens of Tracy Park, located at the intersection of East Eleventh Street and Peoria Avenue. Much of the park's landscaping was done by the Works Progress Administration in the 1930s. (Courtesy Oklahoma Department of Tourism and Recreation; photograph by Fred Marvel.)

Each October, Tulsa's Chandler Park at 6500 West Twenty-first Street is the site of the state's annual Scottish Games and Gathering, which attracts hundreds of participants and thousands of spectators. This is a photograph of the opening ceremony featuring the Massed Bagpipe Bands and the Parade of the Clan Tartans. (Courtesy Oklahoma Department of Tourism and Recreation, photograph by Fred Marvel.)

Traditional Scottish tunes can be heard for blocks during the Parade of the Massed Bagpipe Bands at Tulsa's Scottish Games. (Courtesy Oklahoma Department of Tourism and Recreation; photograph by Fred Marvel.)

Held at the Williams Center Green Downtown at the intersection of Third Street and Boston Avenue each September, Tulsa's annual Bluegrass and Chili Festival attracts colorful chili chefs from across the country. (Courtesy Oklahoma Department of Tourism and Recreation; photograph by Fred Marvel.)

Located at 7130 East Apache Street, the Tulsa Air and Space Center tells the story of the community's aerospace history using both exhibits and displays of vintage aircraft. In the foreground is the nose of a modern jet aircraft. At the left is a model of an early-day biplane. (Courtesy Oklahoma Department of Tourism and Recreation; photograph by Fred Marvel.)

Sponsored by the Williams Companies and the Bank of Oklahoma, the annual Jazz on Greenwood Festival held each August features local as well as nationally-known jazz musicians. (Courtesy Oklahoma Department of Tourism and Recreation; photograph by Fred Marvel.)

Running from the last of September through the first of October each fall, the Tulsa State Fair offers visitors a ride-filled Midway for all ages. (Courtesy Oklahoma Department of Tourism and Recreation; photograph by Fred Marvel.)

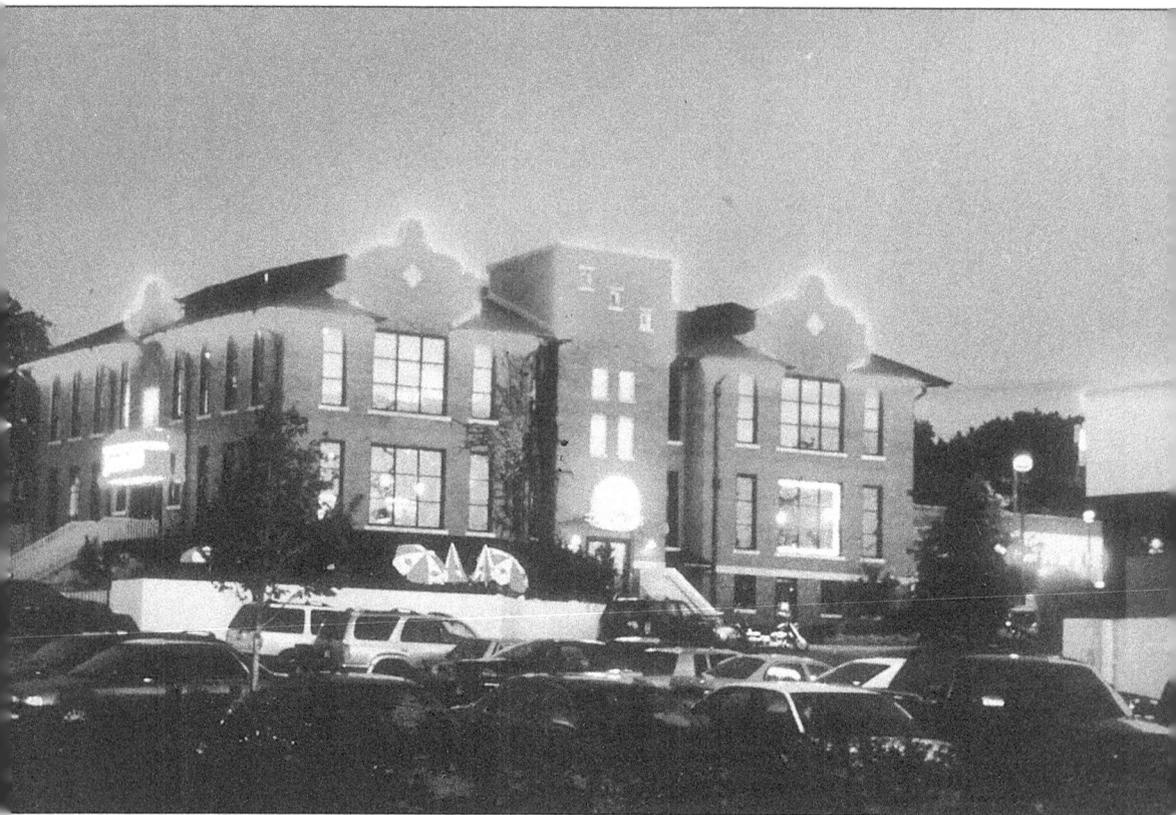

Tulsa's historic Cherry Street stretches along East Fifteenth Street between Peoria and Utica Avenues, and offers a myriad of gift and antique shops. The colorfully lit and popular Lincoln Plaza, above, houses several unique restaurants. (Courtesy Oklahoma Department of Tourism and Recreation; photograph by Fred Marvel.)

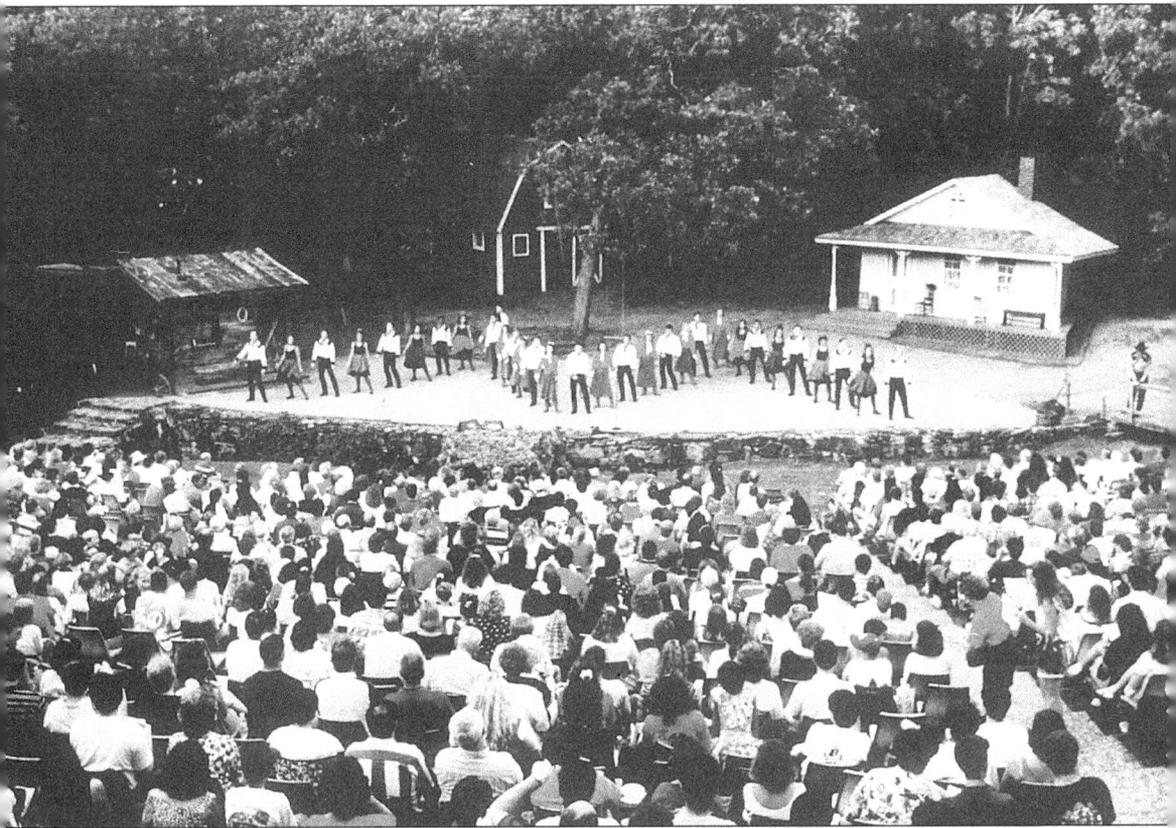

Discoveryland is located just to the west of Tulsa. Its outdoor amphitheater provides a dramatic setting to the internationally acclaimed musical, *Oklahoma!* The play is performed nightly, Monday through Saturday, during the summer months. (Courtesy Department of Tourism and Recreation; photograph by Fred Marvel.)

Tulsans Robert E. Lorton, left, Ernestine Dillard, center, and Keith E. Bailey, right, visit at the 1996 Oklahoma Hall of Fame Ceremony held in Tulsa's Performing Arts Center. Lorton, the CEO of Tulsa World Publishing, and Bailey, CEO of the Tulsa-based Williams Company, were honored for their contributions to the State of Oklahoma. Dillard, a well-known singer, performed at the event. (Courtesy Tom Gilbert.)

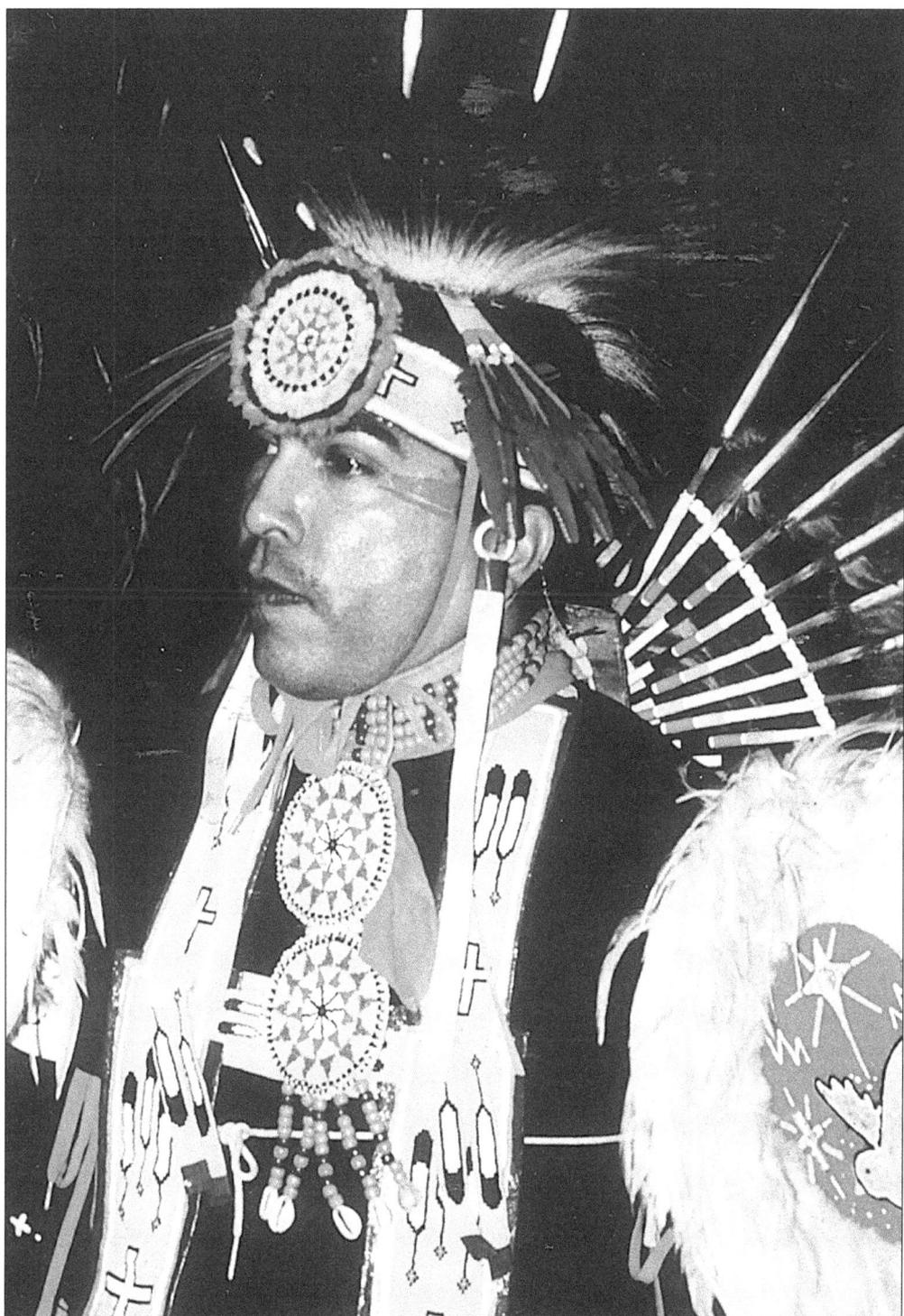

Each February Tulsa hosts one of the nation's premier Indian Arts Festivals, which features Native American food, dancers, and art. (Courtesy Oklahoma Department of Tourism and Recreation; photograph by Fred Marvel.)

Held each November 11, on Veteran's Day, the annual Tulsa Veteran's Day parade attracts thousands to downtown Tulsa to pay homage to the nation's military veterans. (Courtesy Oklahoma Department of Tourism and Recreation; photograph by Fred Marvel.)

Both United States Senator Jim Inhofe, on the left, and Oklahoma Governor Frank Keating, on the right, claim Tulsa as their hometown. Inhoff is the former mayor of Tulsa. (Courtesy Tom Gilbert.)

Often described as the "nation's largest small town," Tulsa embraces the American values of patriotism, citizens, and family values. Here, Old Glory flies over the old Exchange National Bank Building in downtown Tulsa. (Courtesy Oklahoma Department of Tourism and Recreation; photograph by Fred Marvel.)

www.ingramcontent.com/pod-product-compliance
Lightning Source LLC
Chambersburg PA
CBHW080909100426
42812CB00007B/2224